The Genius of Japanese Design

THE GENIUS OF

JAPANESE DESIGN

text by Sherman E. Lee

Kodansha International
Tokyo, New York and San Francisco

publication of this book was assisted by a grant from the Japan Foundation

selection of illustrations: Kodansha International
photography: Kenji Miura, Takeshi Nishikawa, Korinsha
editing: Michael Brase, Yoko Takaya, Takako Suzuki

Illustrations on title and half-title pages: Sketches by Ogata Kōrin. Ink on paper.
Edo Period. Osaka Municipal Museum of Fine Art.

distributed in the United States by Kodansha International/USA,
Ltd., through Harper & Row, Publishers, Inc. 10 East 53rd Street,
New York, New York 10022

published by Kodansha International Ltd., 12-21 Otowa 2-chome,
Bunkyo-ku, Tokyo 112 and Kodansha International/USA, Ltd., 10 East
53rd Street, New York, New York 10022 and 44 Montgomery Street,
San Francisco, California 94104

copyright in Japan 1981 by Kodansha International Ltd.
all rights reserved
printed in Japan
first edition, 1981
LCC 79-66246
ISBN 0-87011-395-x
JBC 0072-789174-2361

Library of Congress Cataloging in Publication Data

Lee, Sherman E.
 The genius of Japanese design.

 Bibliography: p.

 1. Design—Japan—History. I. Title.
NK1484.A1L43 745.4'4952 79-66246
ISBN 0-87011-395-X AACR2

Contents

The Genius of Japanese Design

Japanese Art Periods

Pre-Buddhist	−552 A.D.
Jōmon −200 B.C.	
Yayoi 200 B.C.−200 A.D.	
Kofun (Haniwa) 200–552	
Asuka (Suiko)	552–645
Nara	645–794
Hakuhō 645–710	
Tempyō 710–794	
Heian	794–1185
Early, Jōgan 794–897	
Late, Fujiwara 897–1185	
Kamakura	1185–1333
Nambokuchō (North-South Schism)	1336–1392
Muromachi (Ashikaga)	1392–1573
Momoyama	1573–1615
Edo (Tokugawa)	1615–1868
Early 1615–1716	
Late 1716–1868	
Modern Japan	1868–

The Genius of Japanese Design

Sherman E. Lee

Anyone attempting to identify the genius of Japanese design is confronted at once with a major problem—the relative unity of Far Eastern culture, of the arts of China, Korea, and Japan. East Asia has always been dominated in area, population, and economic and social power by the land mass of China. To ignore this can only lead to isolated concepts incapable of more than insular defence. And it can only lead to an underestimation of the Japanese artistic achievement in the face of what might seem to have been overwhelming odds.

The Far Eastern situation was quite different from that of the Western world. There the baton of creative achievement was passed from one region to another, from Greece to Rome; from Italy to France and back again, or creativity took quite different forms as we see in comparing Netherlandish and Italian art of the fifteenth century, or Dutch and Spanish art of the seventeenth century. In the Far East Chinese written characters, governmental organization, and China's own art or versions of Buddhist art imported from India through Central Asia, dominated the area from the sixth century, ebbing or flowing as Chinese power fluctuated.

Why then does so much Japanese art look so different from Chinese art? The proof that this is so, if we should doubt what we see through modern eyes, comes from numerous ancient Chinese references to Japanese painting and other arts. Though occasionally respectful, most of the old Chinese reactions vary from uneasiness to downright condemnation. The art of the island foreigners was different from and hence inferior to that of the Middle Kingdom. "Different from" is important, for all of our judgments of quality or preference are based upon comparison. Where Chinese art reveals balance and rational sequence, the art of Japan delights in asymmetry and intuitive placement. Where the Chinese tended to rely upon the purity and separation of color, the Japanese delighted in mixtures, off-tints, and blending. These characteristic distinctions are evident even at times when Chinese artistic influences are clearly dominant. While the lute decoration of inlaid mother-of-pearl (*nacre*) is tenaciously balanced in the Chinese manner prevalent in the Nara period (fig. 1), the scepter of just a century later begins to stray from the balanced path (fig. 2)—the flying swallows number six on the right, seven on the left, and their

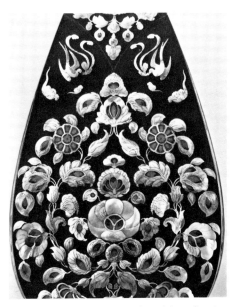

Figure 1 Body of five-stringed lute (back) with design of floral scrolling vines, stylized floating clouds, and birds. Mother-of-pearl and amber inlay on rosewood. Nara Period. Shōsō-in Repository, Nara.

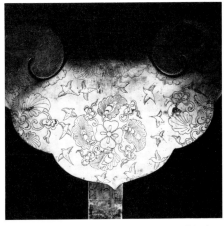

Figure 2 Head of priest's scepter with design of floral scrolling vines and swallows. Hairline engraving on gilt bronze. Heian Period. Daigo-ji, Kyoto.

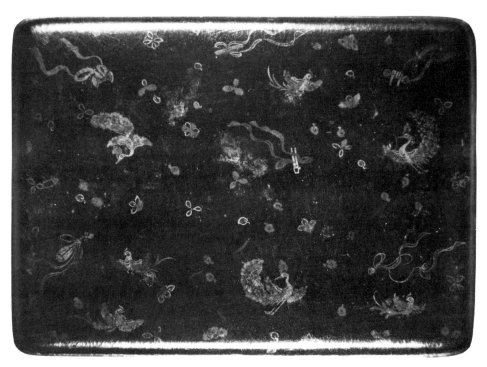

Figure 4 Lid of sutra box with design of lotus flowers, phoenixes, and musical instruments. Lacquer and gold on wood. Heian Period. Fujita Art Museum, Osaka.

Figure 3 Dish with lotus design. Gray Shino ware. Momoyama Period. Hatakeyama Museum, Tokyo.

disposition is intuitive and irregular rather than rational and evenly measured. Such examples can be multiplied by even the most cursory examination of works of the Chinese-dominated Nara period when compared with the increasingly deviant Japanese works of the early Heian period. Clearly inner tensions are being worked out and their release reveals the special nature of Japanese aesthetic design.

Numerous attempts have been made to specify the unique characteristics of Japanese art, but most founder on generalities—whether those of prewar or contemporary Japan. Jiro Harada's proposals (*A Glimpse of Japanese Ideals*), offered with his customary modesty, only serve to demonstrate the point. Purity, grace and quiet, valor and activity, nature, dexterity, simplicity and reticence, among others, seem as applicable to Chinese art or to that of the Shaker communities of New England, as to the art of Japan. What is needed are particularities—and these are not hard to come by if one studies the illustrations here.

One is struck first by the dominance of asymmetric composition—everything is off-center, often in daring, even self-conscious, ways (figs. 3, 47, 50, for example). Then there is the apparent dominance of the material of the work of art over the carefully reticent hand of the artist (figs. 8, 35, 36, 39). Pattern, not as in China incorporated in subsidiary borders, is a dominant element of design; and textile design, always agreeable to patterning devices, spills over into other media (figs. 4-6, 53). There is the domination of motif, often traditional and with literary overtones that demand intimate knowledge of

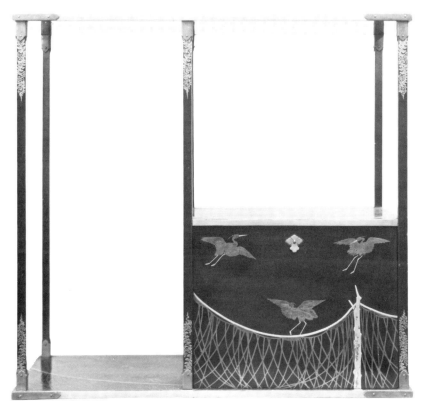

Figure 5 Cabinet with design of drying nets and herons. Lacquer and gold on wood. Edo Period. Tokyo National Museum.

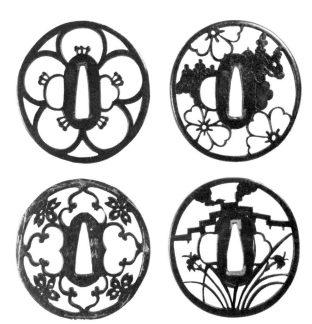

Figure 6 (clockwise from top left) Sword guards with (a) plum blossom design, by Tōhei, Edo Period; (b) design of cherry and paulownia blossoms, by Tōhei, Edo Period; (c) design of eight-plank bridge and paired irises, by Matashichi, Edo Period; and (d) cherry blossom design, by Fukanobu and Rakuju, Edo Period.

the past as well as willing nostalgia so characteristic of Japanese literature, especially poetry (figs. 7 & 47; 9 & 10; 11; 12 & 13; 29). Further these motifs are used as if they were part of a pattern book. They are kept intact within their perimeters but moved about, rotated and adjusted until they seem "right" to the artist in relationship to the same or other motifs. The decision for the final location of the motif is intuitive or subjective and almost always based on the assumption of asymmetric balance or tension (figs. 11, 13–16, 29–30).

The natural and social environment of the islands can be correlated with at least some of these artistic means of the Japanese artist. Nature is close-by in Japan, for the hemmed-in valleys and the limited extent of the land encourage the close examination of nature, revealing its patterns in discrete units. Nature, despite the earthquake, is generally lush and gentle. The hills and mountains are low and rolling with repetitive and undulating rhythms that must impress one as decorative and pleasant. The Shinto faith particularizes nature with its many thousands of *kami* personifying selected individual units—rocks, noble trees, streams and falls, caves, groups of related flora. Rather than organizing all this into a grand design, the Japanese accept the uniqueness of individual units, the natural order of motifs. With this there is a respect for the motifs and for their composition. These materials are a part of the multitudinous and complex aspects of nature. The inherent and natural inclinations of clay, ash, wood, bamboo, lacquer, and fiber are respected and encouraged to become major factors influencing the appearance and design of artifacts.

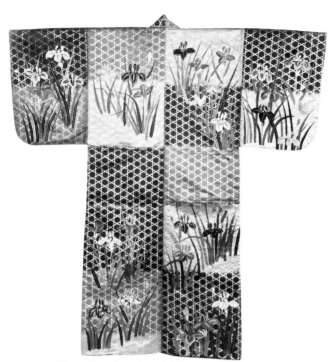

Figure 7 Nō robe with irises against basket-work pattern. Embroidery and gold-leaf imprint on silk. Edo Period. Tokyo National Museum.

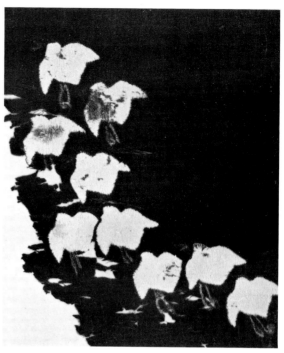

Figure 8 Fragment with design of plovers in flight. Tie-dyeing on silk. Momoyama Period. Tokugawa Reimeikai Foundation, Tokyo.

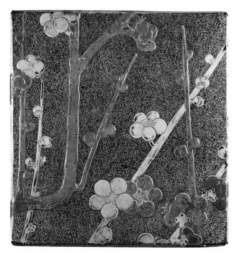

Figure 9 Lid of writing box with plum branch design. Lacquer and gold on wood with lead inlay. Edo Period.

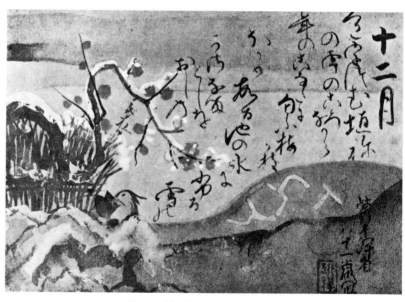

Figure 10 *December* (one of twelve paintings on the months of the year), with design of mandarin duck, snow-laden plum tree and fence, distant mountains, and poem. Color on paper. By Ogata Kenzan. Edo Period.

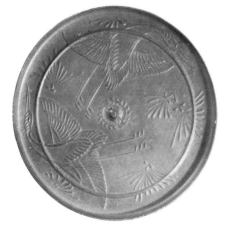
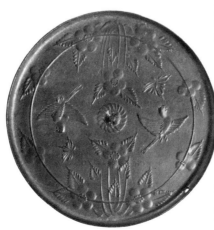

Figure 11 Backs of mirrors with (left) design of cranes flying over pine trees and (right) design of birds in flight around wild yellow roses. Bronze relief. Late Heian Period. Tokyo National Museum.

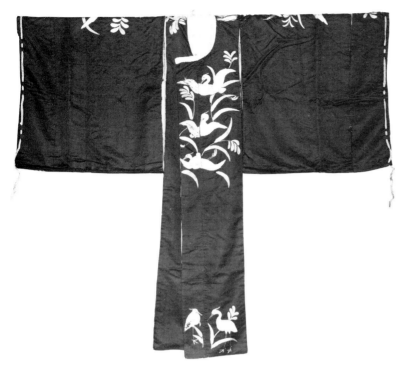

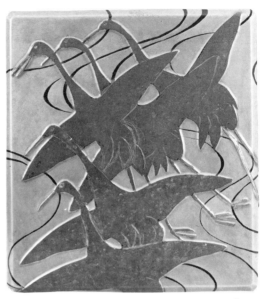

Figure 12 Nō robe with design of herons among rushes. Embroidery on silk. Momoyama Period. Hakusan Shrine, Gifu Prefecture.

Figure 13 Lid of writing box with design of cranes flying over water. Lacquer on wood with lead and silver inlay. Edo Period. Tokyo National Museum. Gift of Mr. Yasuzaemon Matsunaga.

Figure 14 Plate with design of opened and closed fans and bamboo leaves. Ko-Kutani ware. Early Edo Period.

Figure 15 Cabinet with bullet mold design. Lacquer and gold on wood. Momoyama Period.

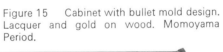

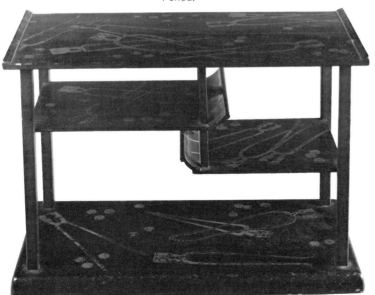

Figure 16 Tiered food box with umbrella design. Lacquer and gold on wood. Late Edo Period.

The tightly knit social order, essential for a small country with limited arable and livable acreage, developed the necessary instincts for self-preservation—conservative traditions, accommodation, and dedicated social and artistic craftsmanship. At the same time the rigid stratification of the social order provided opportunities for the technical and aesthetic exploitation of the things necessary and appropriate to each class. Pleasure could be had from small things; the unimportant could be emotionally and aesthetically significant. And in the few but inevitable times of social displacement there could be an easy aesthetic cross-fertilization between high and low—as was true in many of the most creative times of native Japanese inspiration, the Heian, Kamakura, Momoyama, and Genroku periods.

While one could rationalize the ancestry of Japanese design to as far back as the pre-Buddhist period (−552 A.D.), the effort is a dangerous one and hindered by any evidence of clear connections between the dominant design motifs of the archaic world in Jōmon pottery, Bronze age bells and Haniwa figures, and those of later times. One can propose connecting links in ceramics, particularly in their exploitation of the naturalness of clay, but the simplicity of the cast bronze relief designs of bells (fig. 17), for example, is of a different order from that of Kōetsu's lacquer design (fig. 50). One really must begin with the experience of the Japanese of the Asuka (552–645), Hakuhō (645–710), and Tempyō (710–94) periods in absorbing the manifold influences from the mainland—Buddhism and its artistic vocabulary, the Chinese language systems, and the Chinese political order.

This exposure was overwhelming and the absorption complete. One can compare the process with that used in most traditional art schools. The Japanese students, with their Korean or Korean-descended colleagues, quickly learned and excelled in the vocabulary of ornament and design provided by the most civilized and aesthetically accomplished world power of the time—China. The carefully balanced, continuous and logical sequences or ornamental motifs used in the halos of Buddhist images (fig. 18), silver and gilt bronze objects (fig. 19), musical instruments (fig. 1), and other works, were a rigorous schooling in the rational organization of symbols and ornamental devices. Through China the Japanese also received the design heritage of the Near East by way of Central Asia (figs. 1, 20). Most modernists would agree that this logical method of design would be a good grounding in the basic principles of art. What remained at issue was the future use of such a foundation, and here the Japanese artists provided advanced and subtle answers, moving into what a school curriculum would describe as "advanced design." Their daring dependence upon taste or intuitive rightness, their willingness to be subjective and ineffable, makes the post-Nara Japanese artists' achievement analagous to the discoveries of artists of the modern West; hence, the marked influence of Japanese design on later Western art from the "Japonisme" of the late nineteenth century on, and the widespread admiration for Japanese art in general and architecture in particular, on the part of Western artists of the twentieth century.

It should be added that the numerous controversies as to which objects of the Nara period in Japan (645–794), the contents of the Shōsō-in in particular (figs. 1, 21), are of native or mainland origin are, in the larger sense, beside the point. Whether they are the models or the copies and variants of models, does not affect the overriding fact that the new figural and decorative vocabulary, just as that of language or political organization, was absorbed and became an

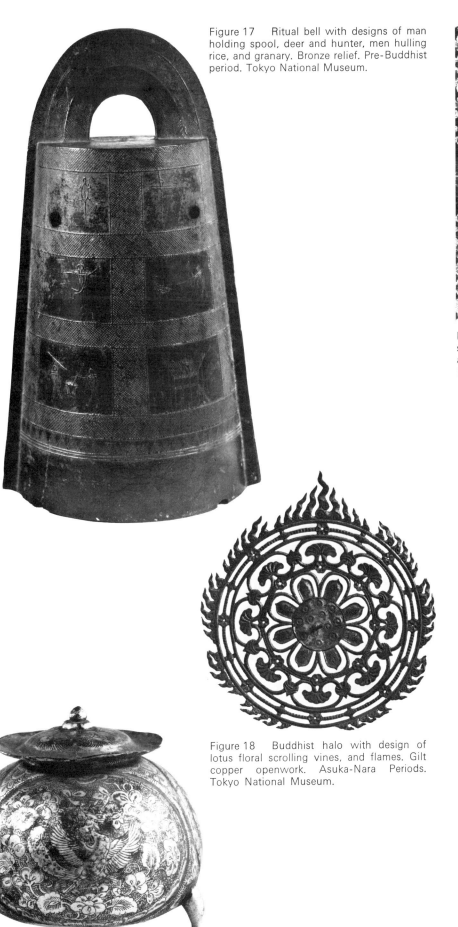

Figure 17 Ritual bell with designs of man holding spool, deer and hunter, men hulling rice, and granary. Bronze relief. Pre-Buddhist period. Tokyo National Museum.

Figure 18 Buddhist halo with design of lotus floral scrolling vines, and flames. Gilt copper openwork. Asuka-Nara Periods. Tokyo National Museum.

Figure 19 Water container with design of phoenix and floral scrolling vines. Gilt bronze in relief. Nara Period. Hōryū-ji Treasure House, Tokyo National Museum.

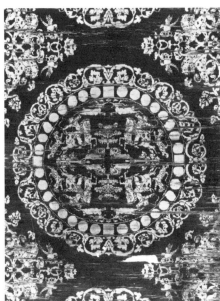

Figure 20 Fragment with design of hunting scene in medallion of scrolling grapevines and circles. Brocade. Nara Period. Shōsō-in Repository, Nara.

Figure 21 Buddhist banner with design of flowering tree, peacock, and lilies. Embroidery on plaited-weave silk. Nara Period. Shōsō-in Repository, Nara.

15

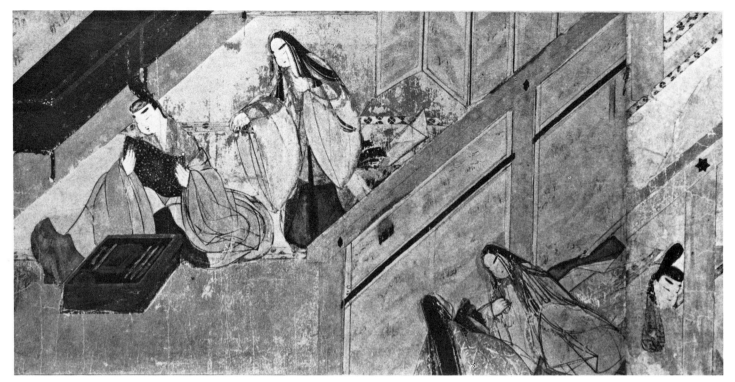

Figure 24 *The Tale of Genji* handscroll (scene from the "Yūgiri" chapter). Color on polychrome paper. Late Heian Period. Gotō Art Museum, Tokyo.

Figure 22 Jewel box with design of long-tailed cocks, small bird, and floral scrolling vines. Lacquer, gold, and silver on wood. Heian Period. Ninna-ji, Kyoto.

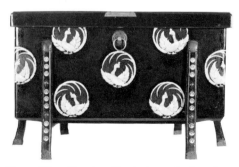

Figure 23 Chest with design of phoenix medallions. Lacquer on wood with mother-of-pearl inlay. Heian Period. Tokyo National Museum.

accepted part of the native heritage. The significant question is: What happened next?

Specifically, the early metamorphosis of imported design language into a new and different one can be read in the famous lacquer box from Ninna-ji (fig. 22) and the lesser known gilt bronze scepter from Daigo-ji (fig. 2). We have already noted the incipient asymmetry in the scepter. The box can be seen, on close examination, to be symmetrical—that is, the five birds on the side are carefully balanced, one in the center, the others at the four corners, against an allover pattern of silver and gold leaves, themselves placed against a much smaller scale background of gold powder. What both objects share is a reduction in the scale of design—a kind of "miniaturization"—and a less realistic, more decorative look than their Chinese counterparts. A further modification towards a decorative goal is to be seen in the apparently carefully balanced and logical design on the clothing box with inlays of mother-of-pearl from Hōryū-ji (fig. 23). The middle section is clearly balanced, but the two phoenix medallions at either end are cut by the corners; they "wrap around" the shape of the box in an arbitrary but thoughtful way that reveals a rapidly advancing design technique.

By the late Heian, or Fujiwara period (897–1185), an original and inventive Japanese decorative style was at full tide. It was exemplified in almost all of the arts, with the possible exception of sculpture, though even there some examples of decorative development can be found. The confident new style was aristocratic and well named in pictorial art—*yamato-e* (Yamato, or Japanese, picture). The supreme examples of Fujiwara *yamato-e* are, of course, the remaining *Tale of Genji* scrolls of the early twelfth century now shared by the Tokugawa Reimeikai Foundation and Gotō Art Museum (fig. 24). I have else-

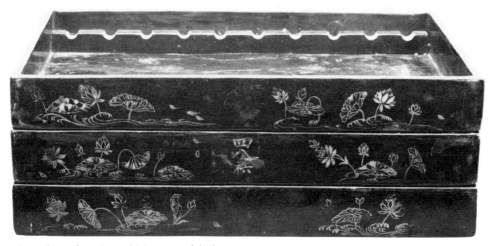

Figure 25 Sutra box with lotus pond design. Lacquer and gold on wood. Heian Period. Nanatsu-dera, Aichi Prefecture.

where (*Japanese Decorative Style*, Cleveland, 1961) argued that the term *yamato-e* should be used only for the highly self-conscious, aristocratic, and decorative style epitomized by Lady Murasaki's great novel itself, the illustrations of the period, related paintings, and especially the all-pervasive style of decoration and design found in the useful arts of the period (figs. 11, 25–27, 30). The alert and observant style of other narrative scrolls, such as the *Legends of Shigi-san,* seems to me to belong to a different and emerging tradition based in realism and largely aimed at an audience outside the imperial court and its immediate dependents.

The *yamato-e* style of the Fujiwara period and its continuation in courtly contexts during Kamakura (1185–1333) and even later periods, uses the asymmetric on a small scale with subtly blended color as well as recurrent and peculiarly Japanese motifs we have seen developing in early Heian, but in an integrated and mastered design context. *The Tale of Genji* itself is full of delightful and subtly worded appreciations of the variegated colors of a page's costume, of the accoutrements of the more tasteful members of the court, of a "fence of wattles, of a deliberately rustic appearance," "tastefully arranged food"—the images are scattered on almost every page. The awareness of informal and intimate aspects of nature is particularly poignant; and these are just some of the motifs carried over into the so-called minor arts—garden fences and marsh reeds cast on mirror backs (figs. 26–27) to cite only one instance. The old and holy Buddhist motifs were continued as well, respectfully, but in a delicate and informal way, using the sacred lotus as an allusion to a formal past while at the same time making it "up to date" (one of Murasaki's favorite phrases) and part of the new decorative style, scarcely distinguishable as religious art without its contents of holy Buddhist sutras (fig. 25).

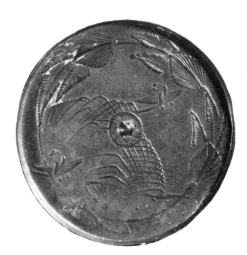

Figure 26 Back of mirror with design of birds among reeds. Bronze relief. Late Heian Period. Tokyo National Museum.

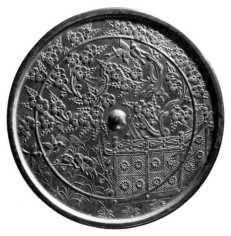

Figure 27 Back of mirror with design of cypress fence, plum trees, reeds, and sparrows. Bronze relief. Nukisaki Shrine, Gumma Prefecture.

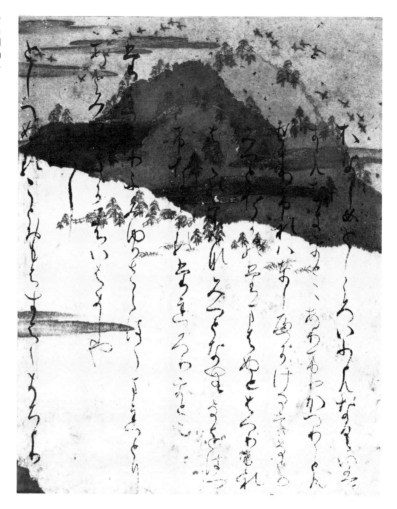

Figure 28 Page from the *Anthology of the Thirty-six Poets*, with design of pine trees on distant mountains (one of the so-called *Ishiyama-gire*). Paper collage flecked with gold and silver. Heian Period. Yamato Bunka-kan, Nara.

Figure 29 Cosmetic box with design of plovers in flight. Lacquer and gold on wood. Kamakura Period. Tokyo National Museum.

Figure 30 Cosmetic box with design of plum trees, wild geese, and water. Lacquer and gold on wood with silver inlay. Kamakura Period. Mishima Shrine, Shizuoka Prefecture.

Certain motifs with a long future history seem to be Fujiwara inventions—irises, autumn grasses, the half-submerged wagon wheel, fishing nets set up to dry, the tortoise-shell pattern, and the plover or *chidori*. This latter motif was used with particular effectiveness, leading the eye, now swiftly, now haltingly, back and forth across the surface of dark lacquer lightly sprinkled with gold.

The decorative use of various materials was particularly imaginative in Fujiwara times. Cut gold-leaf squares, powdered gold, sprinklings and fibers of silver were used in lacquer as well as imbedded in the papers designed for painting and calligraphy. These latter sheets were also made in collage with different colored papers, some with cut, others with artfully torn edges (*Ishiyama-gire*; fig. 28). Ceramics, still rough and natural in shape and texture, were now more carefully glazed with an ash catalyst and incised with decorations derived from usually humble motifs such as reeds or grass. The gilt bronze fittings of boxes (figs. 29–30) were cast and tooled in the shape of relevant single motifs from the now complex vocabulary of Japanese design.

It is important to stress that *yamato-e* was a unified and comprehensive way (rather than method) of design. One senses the same aesthetic and representational assumptions prevading almost all the arts of the period, certainly those closely associated with the court. !t is this comprehensiveness of a decorative style that elevates the Japanese contribution above a merely applied method for minor arts and crafts to a place with the great decorative styles of the world— Islamic and Rococo art. These share an approach to style that unifies almost all artistic production in all media to a degree where visual recognition is instantaneous and complete. By contrast, in other styles,

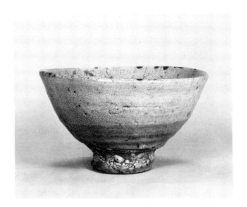

Figure 31 *Ido* tea bowl (known as "Kizaemon"). Brought from Korea to Japan in 1590s. Kohō-an, Daitoku-ji, Kyoto.

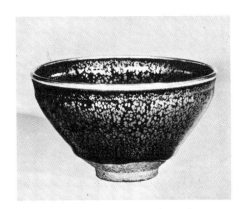

Figure 32 *Chien* tea bowl. Sung Dynasty.

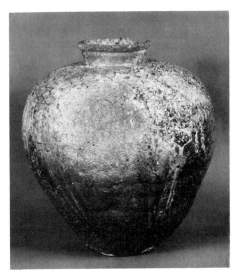

Figure 33 Shigaraki jar with incised design and natural ash glaze. Muromachi Period.

Classical, Renaissance, or Modern, however much all production may be seen to be related, that relationship is recognized to be divisible, however slightly, into primary and secondary realizations. To oversimplify: Japanese decorative style, Islamic ornamental style, and Rococo style are immediately grasped as a whole; other sophisticated styles must be analyzed to reveal the underlying structural relationships of their parts.

The vocabulary of Japanese decorative style was both chastened and enriched by the prevailing interests of the Muromachi period (1392–1573). While the courtly arts continued with only modifications of the old ways of seeing and feeling, the artists associated with the new shoguns and their warrior retainers and Zen monk supporters learned that less could be more, that rudeness and humbleness had aesthetic connotations of a high and refined order. Having mastered and developed the sophisticated aesthetic language of *yamato-e*, the artists now found an almost perverse, or at least daring, stimulation in a deliberate primitivism—a stimulus not unknown to the modern movement in the West in the work of Gauguin, Picasso, and Dubuffet for example.

The rise of the tea ceremony was the major factor in this reorientation of Japanese design. The tea masters' admiration for the simple and rough pleasures of such Korean folk ceramics as the *ido*-type tea bowls (fig. 31), or the only slightly more sophisticated Chinese *chien* ware (fig. 32), led to the exploitation of naturalness in the use of materials. The native ceramic tradition was reexamined in this light and the peasant stoneware storage jars of Shigaraki (fig. 33), Bizen, Tokoname, Seto, Tamba (fig. 34), and Echizen, the "Six Old Kilns," began

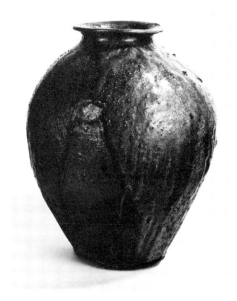

Figure 34 Tamba storage jar. Kamakura Period. Tamba Pottery Museum, Hyōgo Prefecture.

Figure 35 Hanging lantern with design of plum blossoms and bamboo leaves. Bronze openwork. Muromachi Period.

Figure 36 Shino tea bowl with bridge design (known as "Hashihime"). Momoyama Period. Tokyo National Museum.

Figure 38 Gray Shino dish with design of rushes and geese in flight. Momoyama Period.

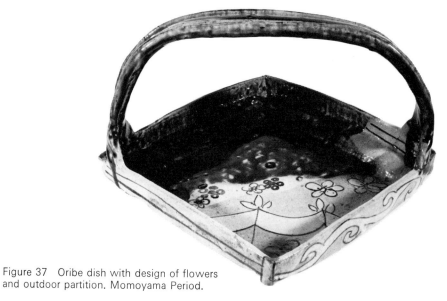

Figure 37 Oribe dish with design of flowers and outdoor partition. Momoyama Period.

Figure 39 Karatsu plate with iris design. Momoyama-Edo Period.

to be used and emulated. The high technology and sophistication of the bronze worker was turned to the production of seemingly rustic products such as the dated (1550) lantern with its openwork design of plum and bamboo (fig. 35) exploiting the flaws evident in a casting left *au naturel* with its unevenly serrated edges and clinging nodules of quartz left from the mold. The old descriptive terms from *yamato-e* —*sabi* (old and desolate), *yūgen* (profound but suggestive)—take on new meaning as used by the tea masters. Where before Japanese design carefully evoked such moods with evident skill and refinement, the new taste of Muromachi, Momoyama, and early Edo induces such reactions with the simplest but secretly artful means. By the Momoyama period new kilns, Mino (fig. 36), Karatsu, Oribe, as well as old Shigaraki and Seto, were making marvelous wares with roughly indicated asymmetrical designs using many of the old motifs of *yamato-e* (figs. 37–39). These new and old kiln productions have had a substantial and continuing impact on the artist-potters of Europe and America for the last one hundred years. It should be emphasized that the principal contribution of tea taste to Japanese design was in the choice and use of materials, rather than, as in *yamato-e*, a total language of design.

Yamato-e and tea taste combined with yet a third major design mode to provide a spectacular and extended rebirth of a Japanese decorative style. This element was, oddly enough, common to both the ruling class of newly powerful *daimyō* and warriors and to the newly rich and increasingly powerful merchant class. Its first appearance was in the

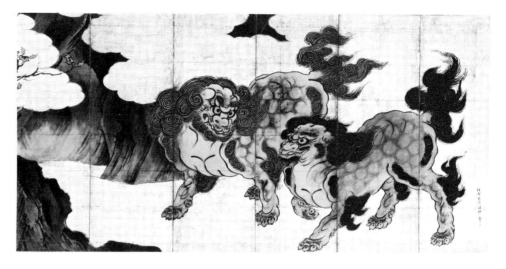

Figure 40 *Chinese Lions* (six-fold screen). Color on gold-leafed paper. By Kanō Eitoku. Momoyama Period. Imperial Household Collection.

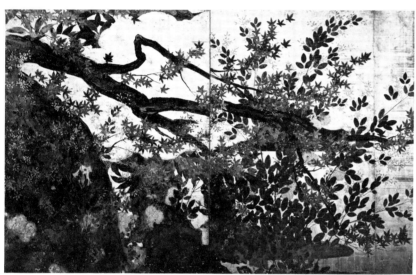

Figure 41 *Maple Tree* (two of four sliding panels). Color on gold-leafed paper. Attributed to Hasegawa Tōhaku. Momoyama Period. Chishaku-in, Kyoto.

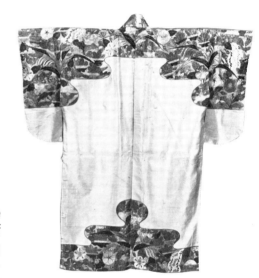

Figure 42 Nō robe with design of the flowering plants of the four seasons. Embroidery and gold-leaf imprint on silk. Momoyama Period. Tokyo National Museum.

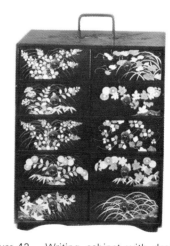

Figure 43 Writing cabinet with design of autumn flowers. Lacquer and gold on wood. Momoyama Period. Kōdai-ji, Kyoto.

screen paintings commissioned by Hideyoshi and others during the Momoyama period (1573–1615) for the decoration of the castles of the new ruler of Japan. Though based on the Chinese-style painting of the preceding Muromachi period, the new and "gorgeous" decorative manner completely transformed the style of the ancestors. The paintings had to be large in scale, appear rich and sumptuous (hence the use of gold-leaf backgrounds), and capable of rapid execution, for there was an enormous quantity required. The three well-known masters of the new style, Kanō Eitoku (fig. 40), Kanō Sanraku, and Hasegawa Tōhaku (fig. 41), shared these qualities and often can be distinguished from each other only by the most careful examination of nuances of brush and habits of delineation. This large scale, clarity, and bravura technique flowed over only slightly into the useful arts. Traces of the first two elements can be found in costume design (fig. 42) and most especially in a class of lacquer design (fig. 43) named after the site of its original invention, Kōdai-ji in Kyoto.

Only slightly later, the costumes and decorative panels commissioned by the wealthy merchants of Osaka, Kyoto, and Edo began to rival the "high art" of the rulers in gorgeousness and quantity. Recurring sumptuary laws, reinforcing the original *Buke Hatto* (*Laws of Military Houses*) of 1615, vainly attempted to restrain the now flourishing arts associated with the urban merchants described with such brilliance by the novelist Saikaku (d. 1693).

The great decorative style inheriting all that had gone before is

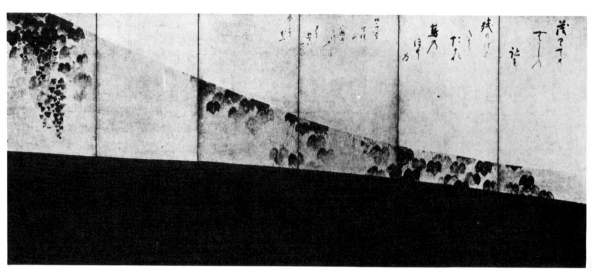

Figure 44 *Ivy Lane* (pair of six-fold screens).
Ink and color on gold-leafed paper. Attributed
to Tawaraya Sōtatsu. Early Edo Period.
Manno Family, Hyōgo Prefecture.

designated *rimpa*—the first syllable from the last of the name of Kōrin,
once the most famous practitioner of the style; the second syllable
meaning "school"—school of Kōrin. However its founding must be
shared by Kōetsu (1558–1637) and Sōtatsu (d. *ca.* 1643), the former
by his taste, largely expressed through the reinvigoration of the com-
bined calligraphy and decorated paper tradition, the latter by his
extraordinary and original synthesis of the *yamato-e* and Momoyama
painting styles. *Rimpa*, since it was above all an art of almost abstract
design, had a major impact on the decorative arts, and no really original
and fine *rimpa* work looks at all like an earlier prototype except in the
most general and symbolic way—a jar is a jar (fig. 46), a box is a box
(fig. 47).

If Kōetsu is now seen as founder, it must be admitted that his influ-
ence was a general one of taste and direction—an arbiter with a touch
of status, his ancestors were sword connoisseurs and hence close to
high military circles. It was Kōetsu who conceived the original idea of
an artists' colony at Takagamine, a suburb of Kyoto, and this certainly
gave impetus and unity to the new movement. But it was Sōtatsu,
of uncertain but surely lower origins, who most completely invented
and developed the *rimpa* artistic vocabulary and language. Having
restored and partially replaced the Fujiwara-period *yamato-e* sutras at
Itsukushima Shrine, and copied in 1630 a classic thirteenth-century
yamato-e handscroll of the life of Priest Saigyō, Sōtatsu was intimately
familiar with the early flourishing of Japanese decorative style. The
Momoyama achievement was all about him, and his monochrome

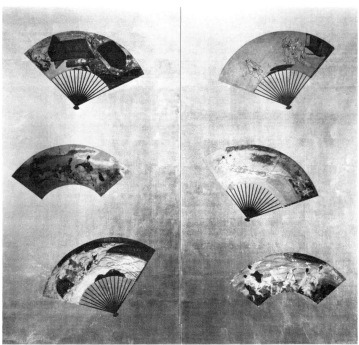

works reveal a mastery of Chinese brush techniques. His genius was to meld these techniques but to use them for a new manner of design. He realized that the large-scale painting of Momoyama was hindered by the retention of smaller scale considerations of interior modeling and representation and that the dim light of most Japanese interiors made flatness effective on a large scale. Thus he took old Fujiwara motifs such as those from the *Tales of Ise* and enlarged them to the scale of Eitoku's patches of nature, simplified them and removed all unnecessary detail (fig. 44). He made the units flat, but modified them, not by interior detail, but by wet and blended modulations of ink and color. Many of Sōtatsu's designs seem almost collage-like in their appearance; some of his fan-shaped designs were applied by collage to gold or sprinkled gold and silver backgrounds on screens (fig. 45). As we have seen, collage techniques had been used in the Fujiwara period for the preparation of luxury writing paper; and it can be found in rudimentary form on some of the lacquer wares of the Muromachi and Momoyama periods. These various effects satisfied the still powerful tea taste by their roughness and simplicity and by allowing the paint and ink to be more "natural"—wet and flowing. While his subsequent followers, Kōrin, Roshū, Hōitsu, and Kiitsu, for example, produced marvelous things, they seldom did more than play variations on the themes of Sōtatsu. While no authentic useful objects even designed by the founder are known, the adaptation of *rimpa* design to the decoration of ceramics, lacquer, wood, and textiles represented a fruitful area for the use of these daring new design methods.

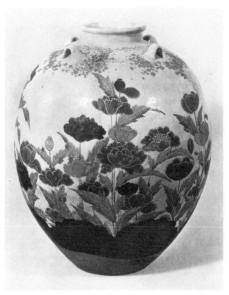

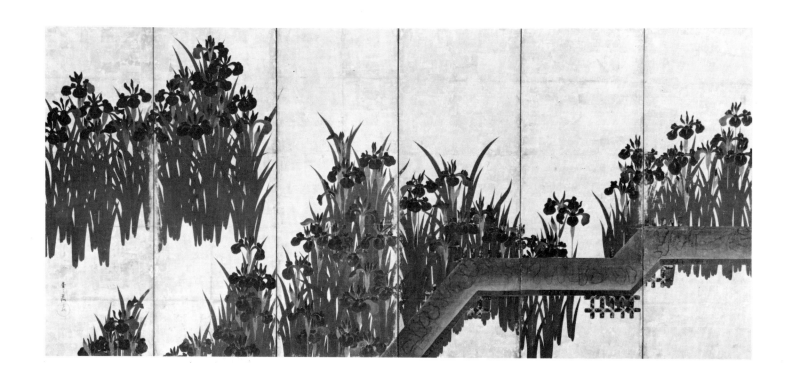

Figure 47 Writing box with design of eight-plank bridge and irises. Lacquer and gold on wood with lead, silver, and mother-of-pearl inlay. By Ogata Kōrin. Edo Period. Tokyo National Museum.

Ninsei (d. after 1677), the Kyoto artist-potter, was active a generation later than Sōtatsu but his works reveal firsthand knowledge of the original *rimpa* style. While Ninsei is justifiably most famous for his richly decorated jars, it is significant that he also worked in simple tea-taste wares as well. The jar with poppy decoration (fig. 46) follows Sōtatsu's screens of the same subject in Boston and adapts the design to the traditional swelling ovoid shape of the tea-leaf storage jar. The use of sprinkled gold-leaf squares in the shoulders of the jar witnesses for the first time the adaptation of lacquer and writing-paper design techniques to the ceramic medium. Obviously the rich and decorative tastes on the body have effectively dominated the older tea taste represented by the shape.

Perhaps the single most famous and original object embodying *rimpa* design is the lacquered writing box (fig. 47) by Ogata Kōrin (1658–1716). On a relatively small scale it sums up the achievement of the school begun by Sōtatsu and continued by Kōrin. The latter is best known for his screens (fig. 49), including two pairs (one in the Nezu Art Museum, Tokyo, the other in the Metropolitan Museum of Art, New York) displaying a common motif—irises derived from the Heian-period *Tales of Ise* (fig. 48). The irises are an indispensable part of the motif on the writing box, despite the title, and they were previously used as decoration on a lacquered box

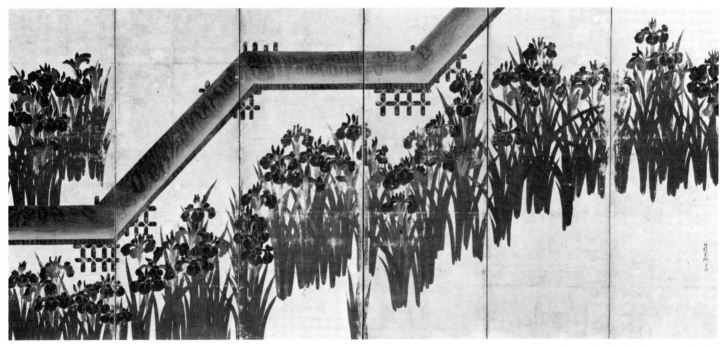

Figure 48 *Eight-plank Bridge* (pair of six-fold screens). Color on gold-leafed paper. By Ogata Kōrin. Edo Period. Metropolitan Museum of Art, New York. Purchase, Fletcher Fund, 1926.

of the twelfth century. Mother-of-pearl inlay is an essential part of the new design, but this, too, is traditional. The use of lead inlays for the bridge planking was a relatively recent innovation, probably first used as a major design element in a box traditionally thought to be designed by Kōetsu (fig. 50). But the audacity of the design is the essence of *rimpa*. It cuts across the sides of the box in a bold but logical way with the bridge elements, while the gold and *nacre* elements of the lid are seen as a single scene, but related to equally discrete scenes on the four sides. The bridge seems to wrap and contain the box; while the irises exist separately above and beneath the level of the planks. The result is a complex double image, readable in various ways, but always within the bold and decorative intentions of the artist.

If we see tea taste modified by Ninsei and transformed by Kōrin, it is also true that the *rimpa* style adapted itself to tea taste, particularly in those ceramic wares used directly in the tea ceremony. Kōrin's brother, Kenzan, made numerous trays and bowls, sometimes in collaboration with Kōrin, but the tea bowl with plum motif and poem (fig. 51) demonstrates the metamorphosis of *rimpa* style into one suitable in appearance and spirit to the classic rusticity of the tea ceremony. The adaptability of *rimpa* to a wide range of tastes and media is one measure of its universality as a decorative style.

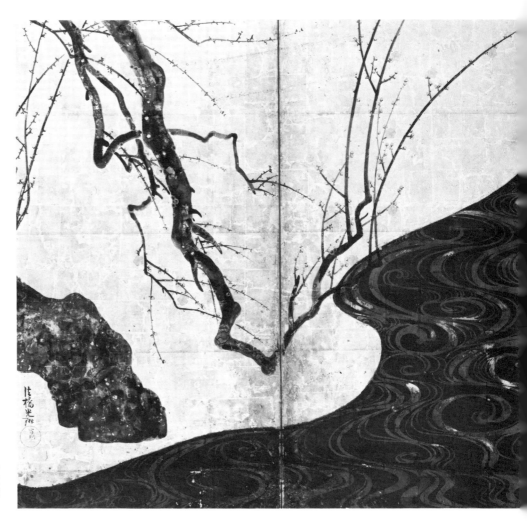

Figure 49 *Red and White Plum Trees* (pair of two-fold screens). Color on gold-leafed paper. By Ogata Kōrin. Edo Period. Kyūsei Atami Art Museum, Shizuoka Prefecture.

Figure 50 Writing box with design of bridge, boats, water, and calligraphy. Low-relief lacquer and gold on wood, with lead and silver inlay. By Hon'ami Kōetsu. Edo Period. Tokyo National Museum.

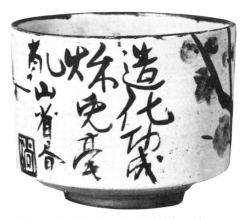

Figure 51 Tea bowl with design of spear-stemmed plum branches and calligraphy. By Ogata Kenzan. Edo Period.

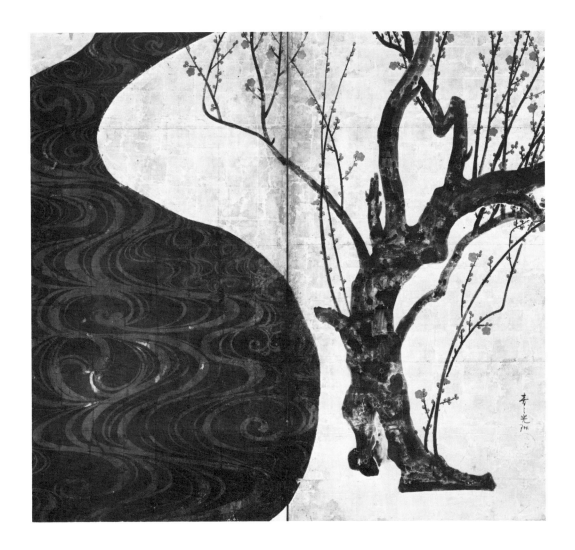

The counterpart of *rimpa* on lower social levels was *ukiyo-e*—just as significant as *rimpa* but with the further appeal of forbidden fruit for the devotees of high taste. The origins of *ukiyo-e* in the narrative scrolls and folk representations of the Kamakura and later periods are as well known as its subsequent flourishing in the mass art of Japanese woodblock prints with subjects for all tastes. One of the major achievements of *ukiyo-e* artists was the recognition that subjects drawn from the peasants and the urban proletariat could be decorative and part of a grand design. If the initial impetus, as is now known, was aristocratic curiosity, the ultimate result was the absorption of lower-class representational units into the vocabulary of the increasingly sophisticated language of traditional Japanese decorative style. This brought certain new elements into play—more vigorous movement as implied in the silhouettes of wrestlers or dancing girls (fig. 52); "vulgar" representational details to be found in the more realistic appraisal of deglamorized types, most notably the increasingly unemployed samurai class (fig. 53); a revived interest in textile patterns exemplified in the simpler geometric and repetitive patterned clothing worn by the commoners (fig. 54). While the collage-like placement of the new units followed the intuitive bent of earlier Japanese designers, the units themselves were different from the more formal and static motifs inherent in the slowly moving and ritualistic habits of the courtly inhabitants of *yamato-e* and *rimpa*. *Ukiyo-e* managed to combine the two most congenial Japanese artistic attitudes, the decorative and the realistic.

Figure 52 Tiered food box with design of dancing and disporting figures. Painting on lacquered wood. Edo Period. Imamiya Shrine, Kyoto.

Figure 53 Bowl with design of samurai and follower. Kakiemon porcelain. Early Edo Period. Osaka Municipal Museum of Fine Art.

Figure 54 Detail of summer robe with design of curtain and hollyhocks. Embroidery and dyeing on hemp. Edo Period.

But if we say this we must admit that the decorative mode is dominant. Whether in the erotic art of *ukiyo-e* (*shunga*), or in Hiroshige's scenes along the Tōkaidō (fig. 55), we admire the composition, the placement, the juxtapositions of patterns, the boldness of tonal contrasts, the resonance of colors, before we enquire about who, what, where, or when. If we analyzed the faces of the sing-song girls, the samurai, or the townsfolk of *ukiyo-e* as individuals, we draw a blank. They are typified and lost in the patterns of their garments or the silhouettes of their actions. These human or landscape units exist as part of a design that we perceive to be dominated by taste and aesthetics.

We know then why the Western love-affair with Japanese art began in the late nineteenth and early twentieth century when "aesthetic movement," "art for art's sake," and "significant form" were the catchphrases of the day. But we also should know why the Western appreciation of Japanese art began with the relative compromise embodied in *ukiyo-e* and moved to the earlier achievements of *rimpa* and the Fujiwara courtly version of decorative style. Just as the way of Western art veered to emphases on abstraction in painting and sculpture and to geometric clarity of design in the useful arts, so the understanding of Japanese art emphasized its design elements. The debt of modern Western architecture and landscape design to Japanese prototypes has been cheerfully acknowledged.

Perhaps the validity of such a phrase as "the genius of Japanese

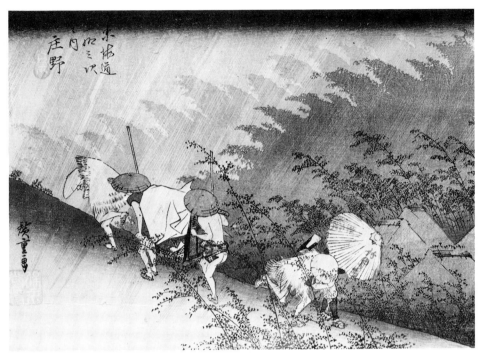

Figure 55 *Shōno: A Shower*. Woodblock print. By Andō Hiroshige. Late Edo Period.

design" is most evident in the art of the garden (figs. 56–57). While eighteenth-century Europe experimented with its concept of the "Chinese garden," natural, or at least representing the character of nature, the twentieth-century West adapts the controlled or designed aspects of the Japanese garden to its own uses within the modern idiom. Garden art is at one with the synthesis of the past that is Japanese decorative style. Using the raw units of nature, rock, bush, tree, earth, sand, moss, reed, and grass, the garden artist first selects, then places, and finally forms these elements in an asymmetric and decorative design—impossible to perceive as either untamed nature or as the heavily corseted and carefully balanced arrangements of traditional European gardens.

The selective process in this aspect of Japanese design corresponds to the process of the tea master in finding, or better, recognizing the superbly appropriate bowl or jar. The placement of the units is analagous to the careful adjustment of intervals in the collage-like manner we have seen to be characteristic of Japanese design in general and of *rimpa* in particular. The forming is a continuous process in garden art and no one who has observed the Japanese garden artisan at his semiannual pruning and cleaning operation can doubt the care and attention to carefully designed silhouette and massing characteristic of his activity.

The all-embracing character of Japanese design was earlier equated

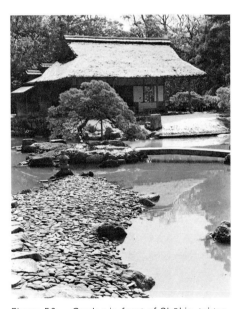

Figure 56 Garden in front of Shōkin-tei tea house. Edo Period. Katsura Detached Palace, Kyoto.

Figure 57 Stepping stones in front of the Music Room. Edo Period. Katsura Detached Palace, Kyoto.

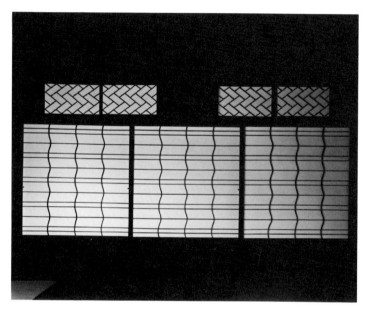

Figure 58 Sliding screens and transoms at the Sumiya brothel, Kyoto. Edo Period.

with other such styles—Islamic and Rococo. The latter was short-lived, the Islamic long lasting, but limited in variety by the de-emphasis of figural art and of the representation of everyday activity. The Japanese contribution is extended in time, complex as well as varied. Here the strong traditional elements in a close-knit society must have their due. The deep penetration of Japanese design into all levels of the people and the continuing discipline inherent in such omnipresent art forms as ceramics, textiles, the tea ceremony, gardens and its miniature counterpart, flower arrangement, has insured a continuing aesthetic education for a very large proportion of the population (fig. 58). The results of this discipline are still to be seen in the fine and applied arts as well as in everyday life of the Japanese despite the increasing industrialization and "modernization" of the islands. A visit to any textile, ceramic, or lacquer shop in Japan reveals an abundance of all kinds of seductive designs in a living language. The combination of traditional and creative style, a skillful means of production, and a built-in and socially sanctioned aesthetic educational system creates the genius of Japanese design.

Color Plates

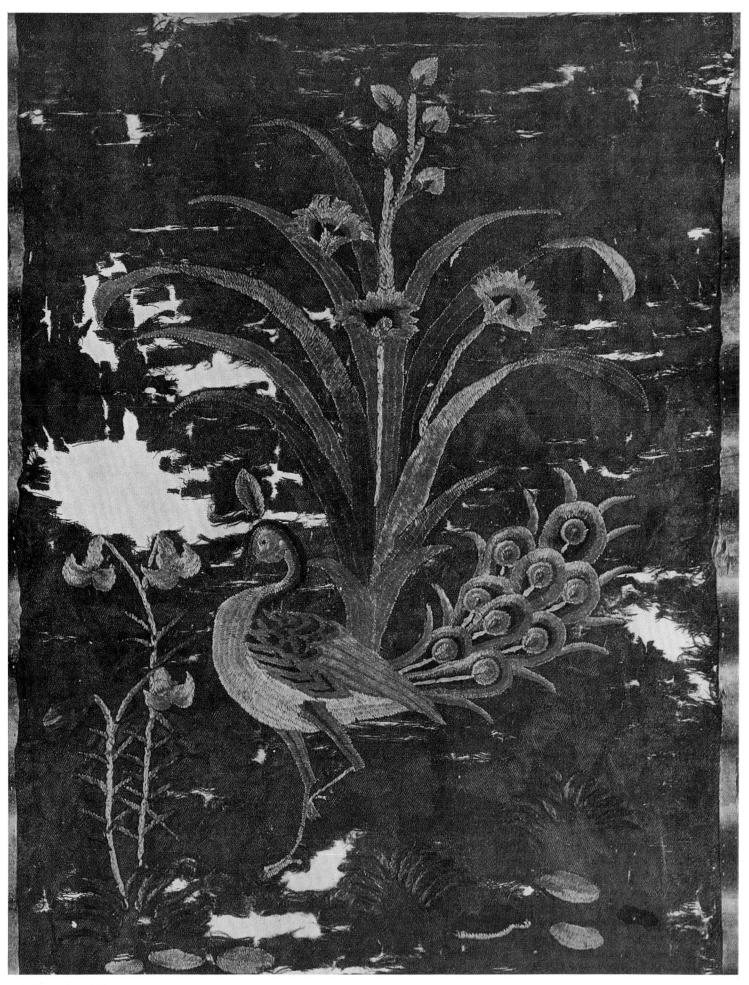

1 Peacock and lilies

2 (overleaf) Flowering cherry trees, willow tree, and three girls playing musical instruments ▷

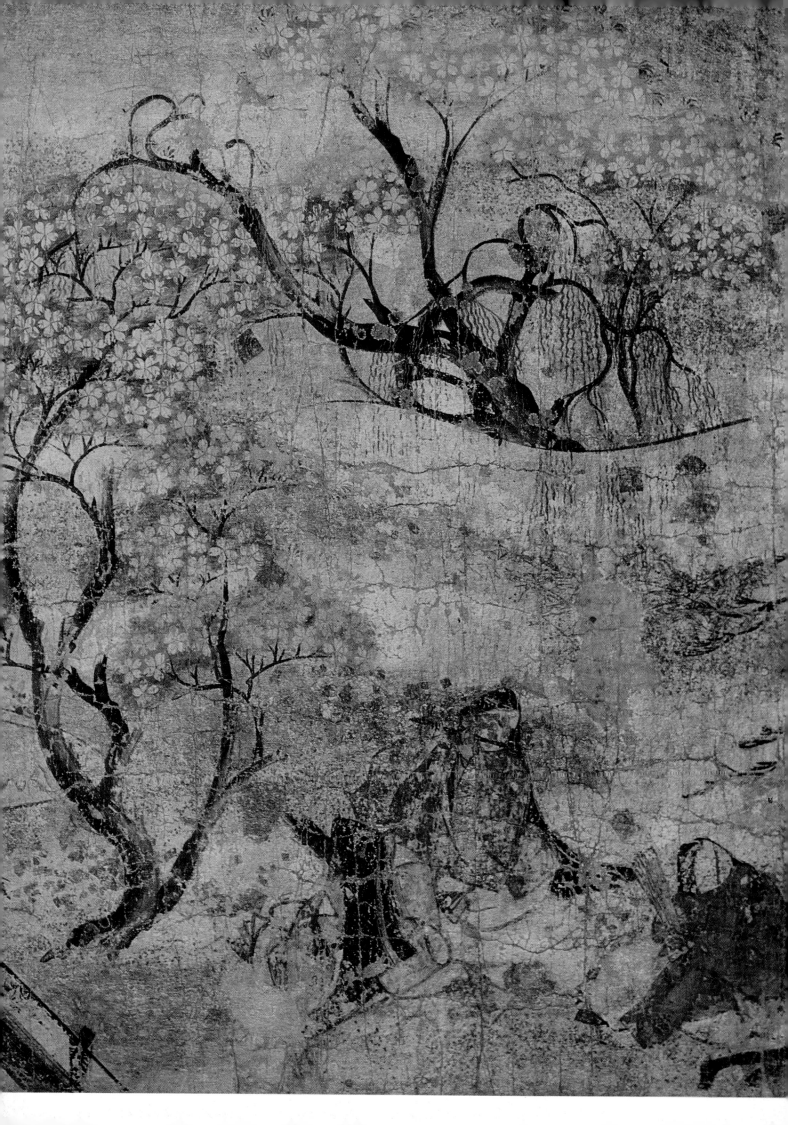

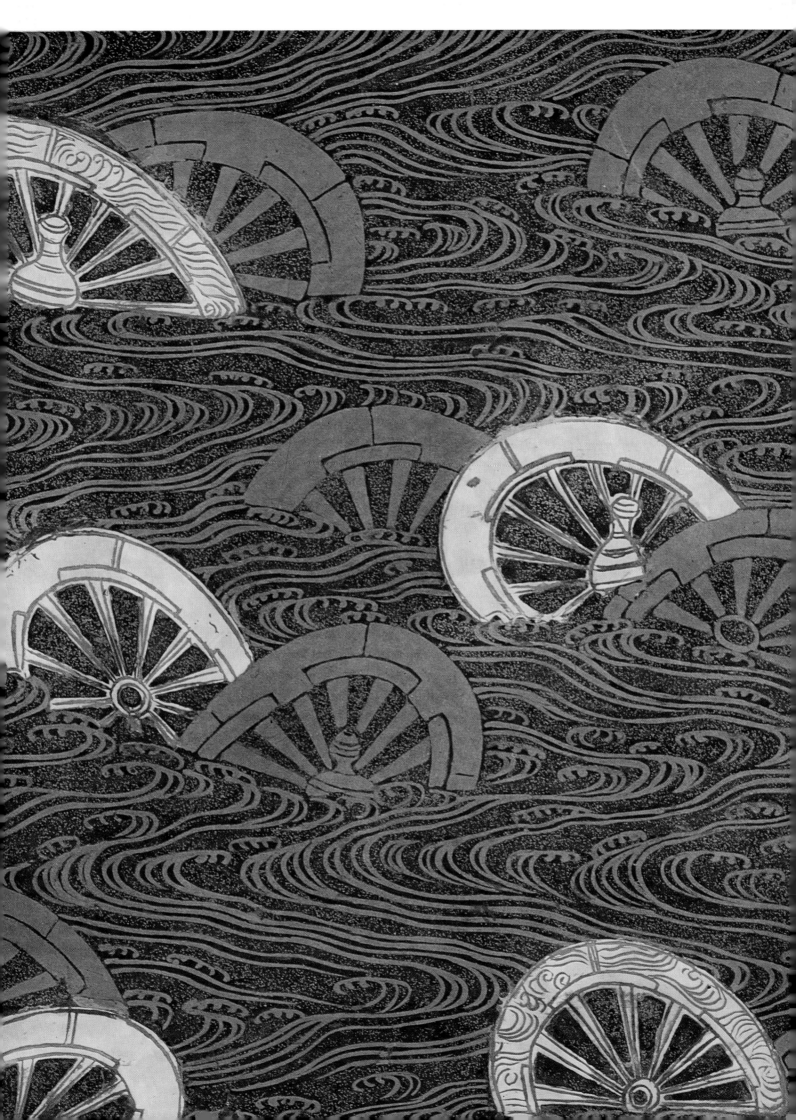

◁ 3 (preceding page) Half-submerged wheels

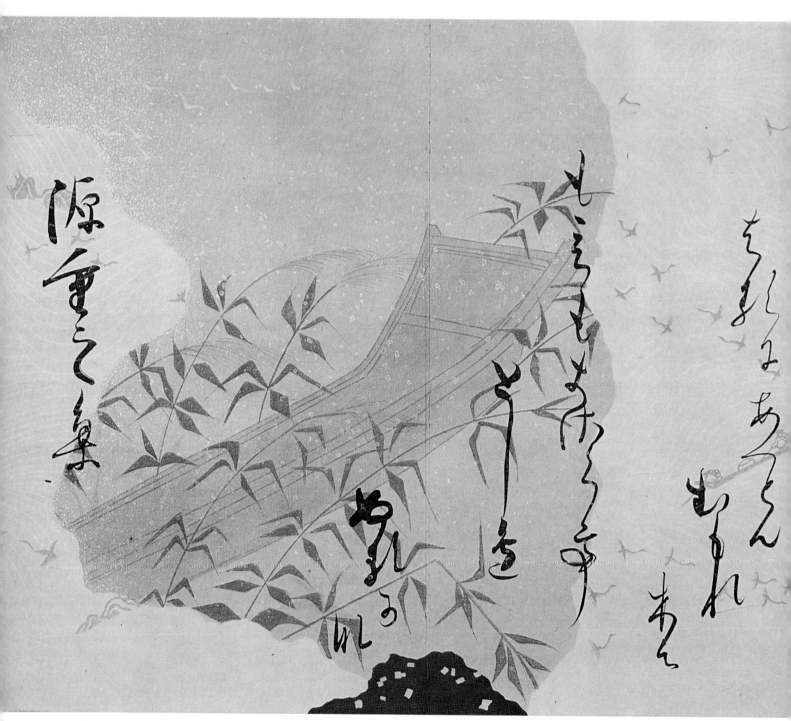

4 Page from poetry anthology with design of boat among reeds and
 geese on wind-swept shore

5 Gong, hand drum, canopy, and Buddhist banner ▷
6 (overleaf, left) Lid of writing box with design of cormorant
 on rock and groups of plovers ▷
7 (overleaf, right) Flowering cherry tree, crane, and tortoise ▷

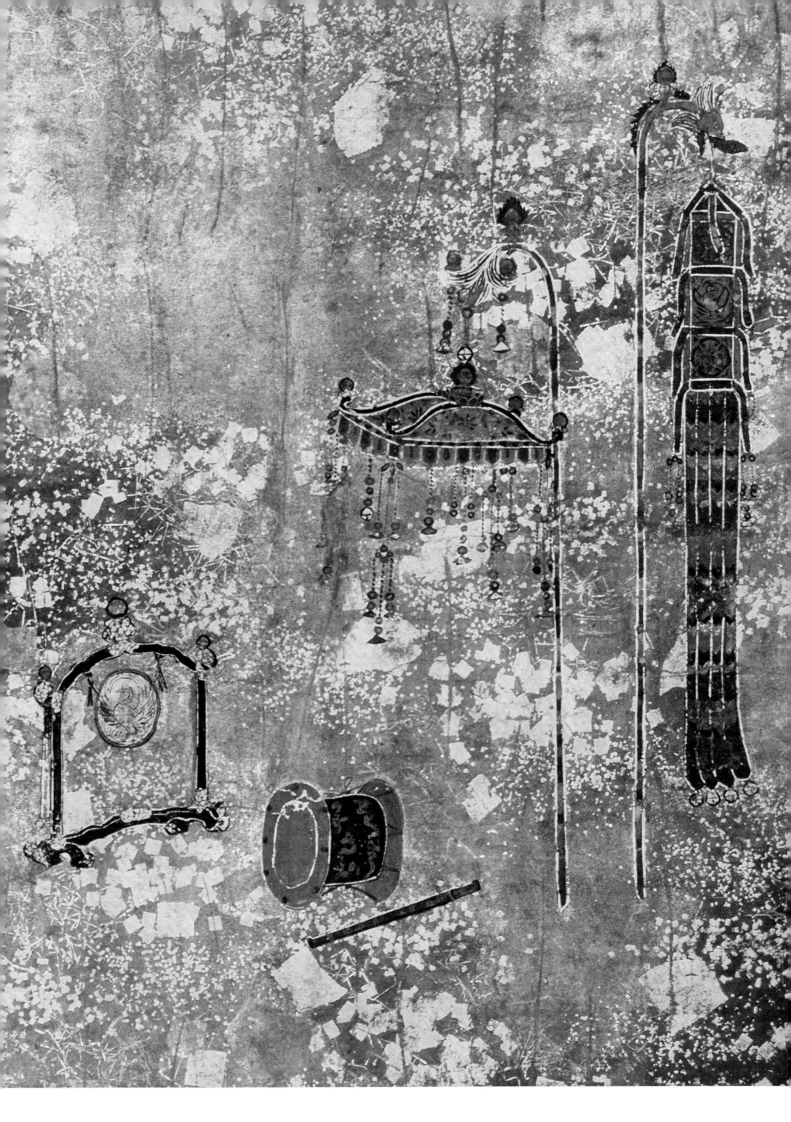

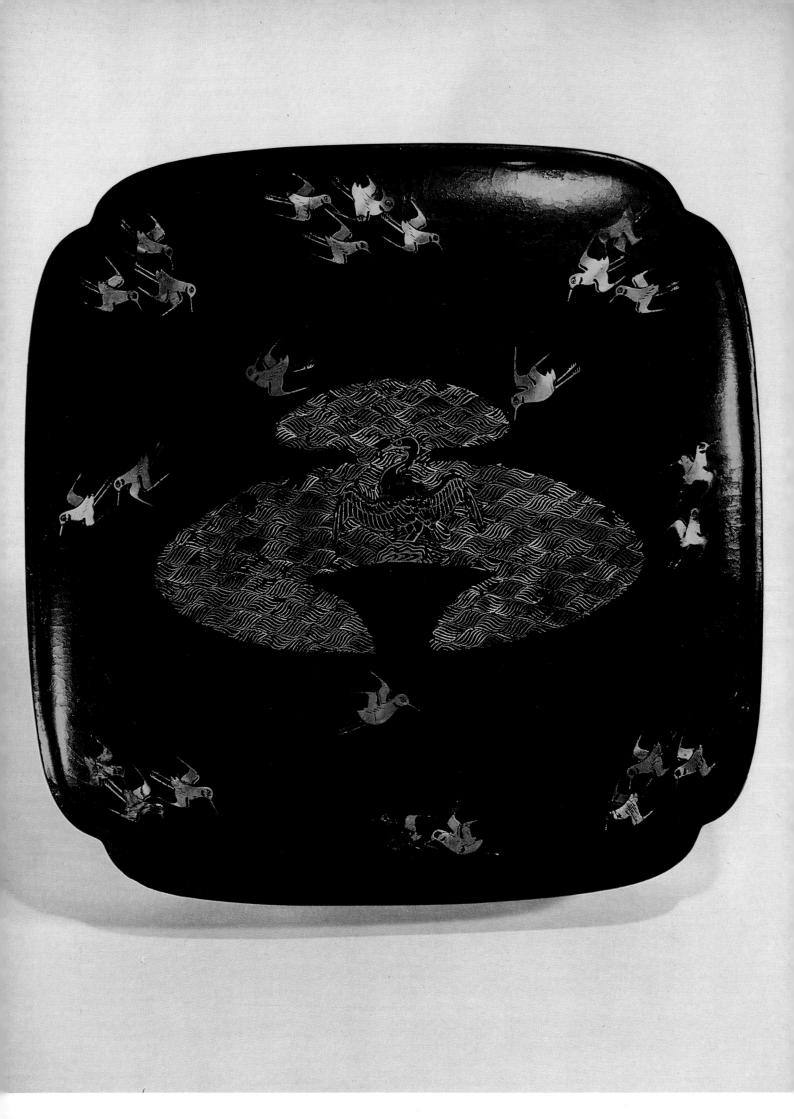

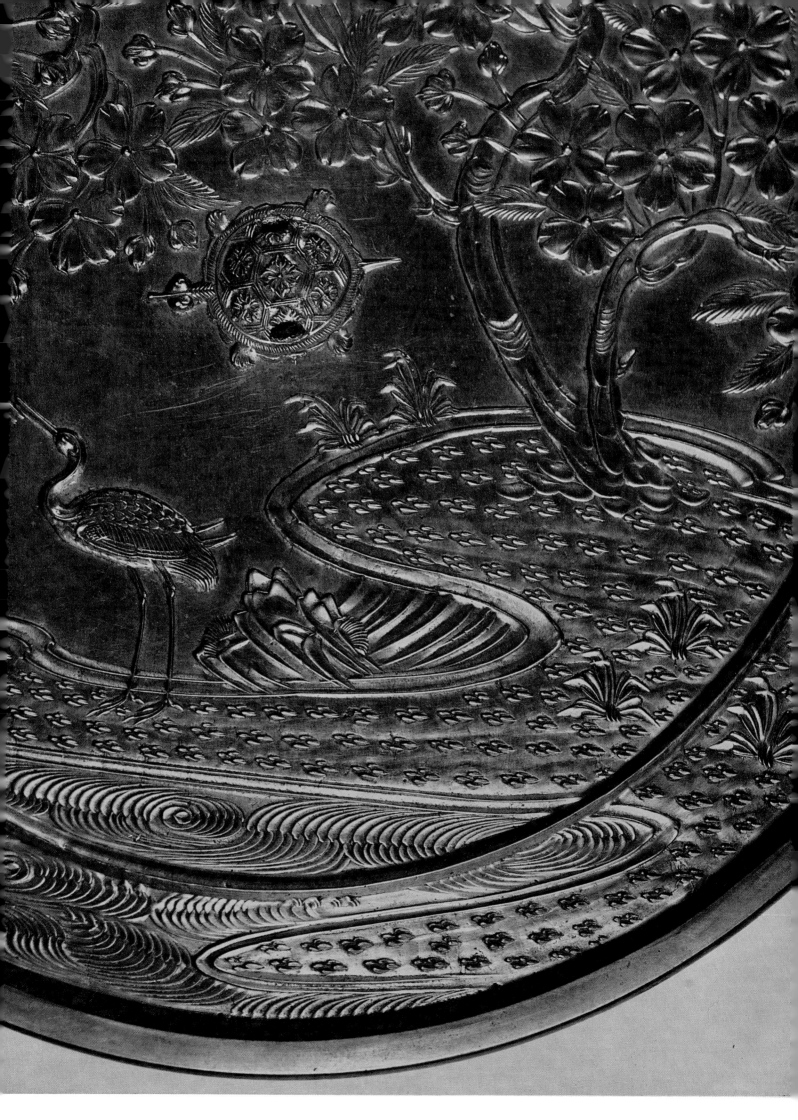

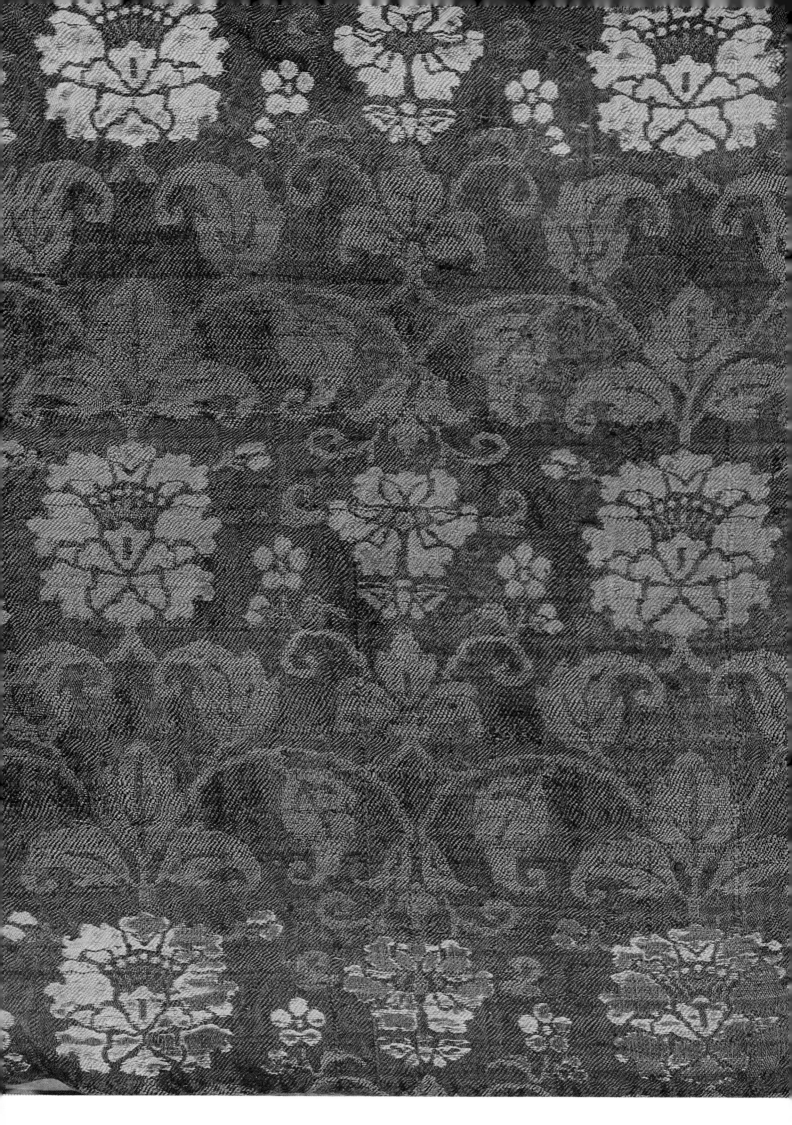

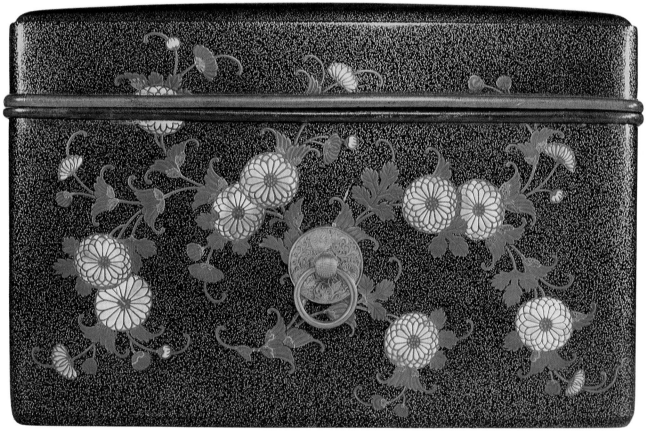

9 Cosmetic box with design of chrysanthemums and scrolling vines

10 (overleaf) Camellias ▷

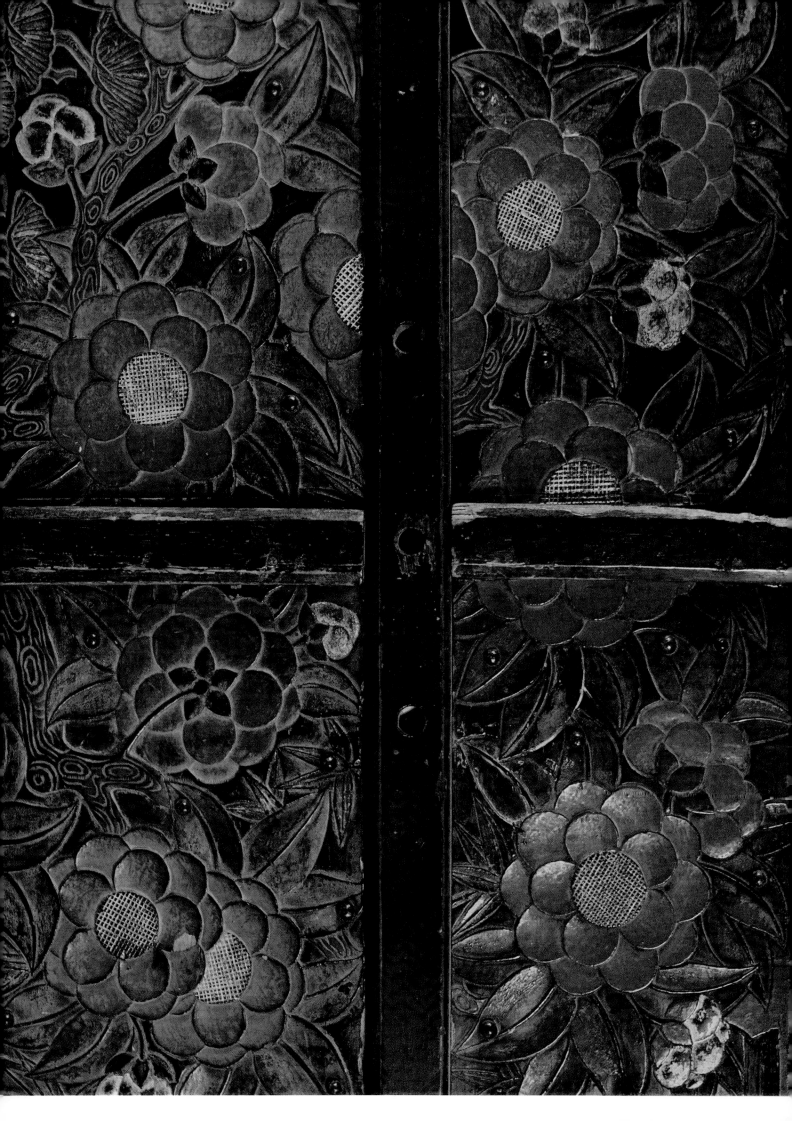

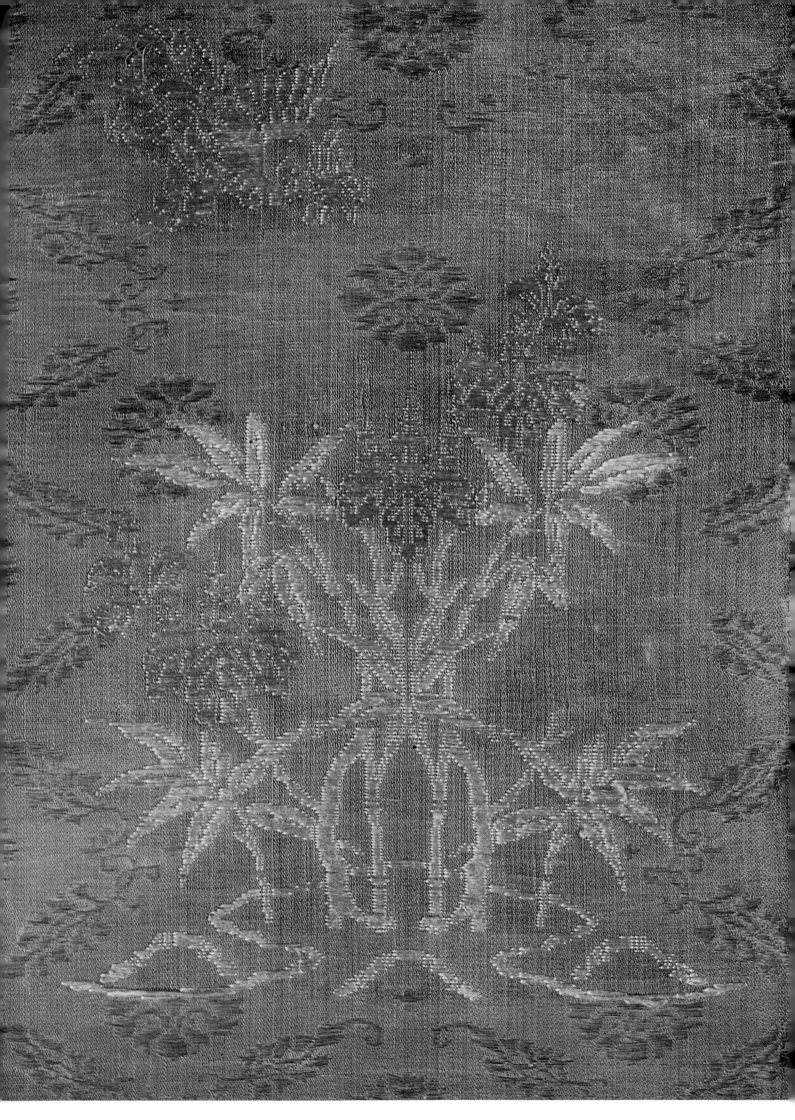

◁ 11 (preceding page) Paulownias, bamboo, and phoenix against hollyhock pattern

13 Willow branches laden with snow ▷

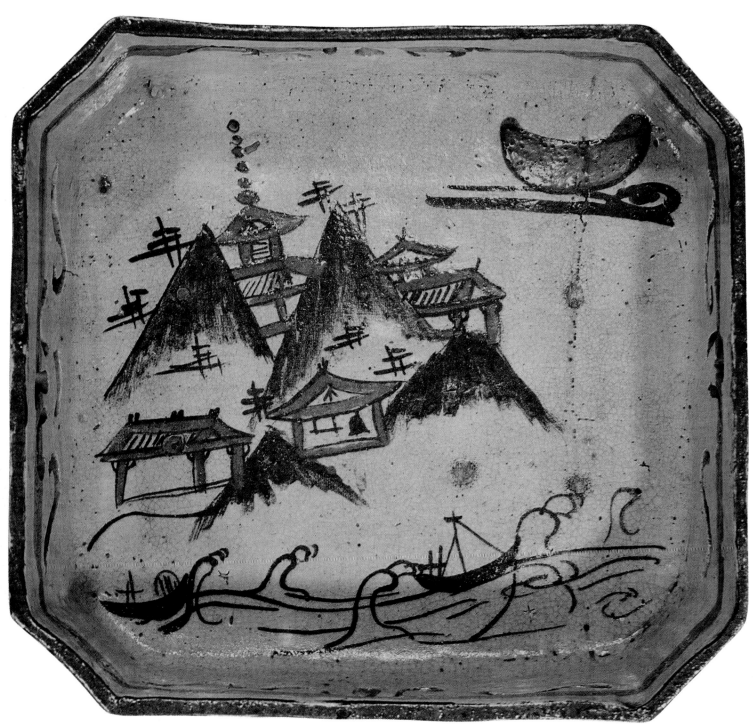

12 Rectangular dish with design of moon, mountain temple, and boats on waves

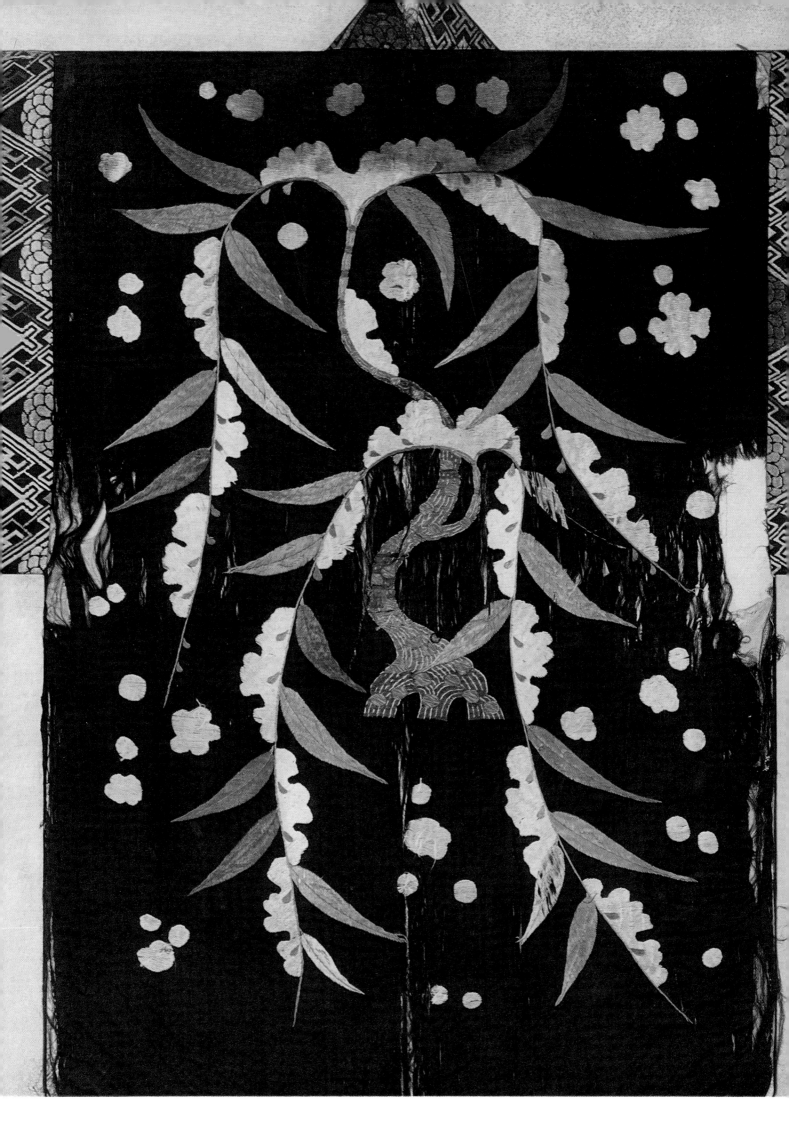

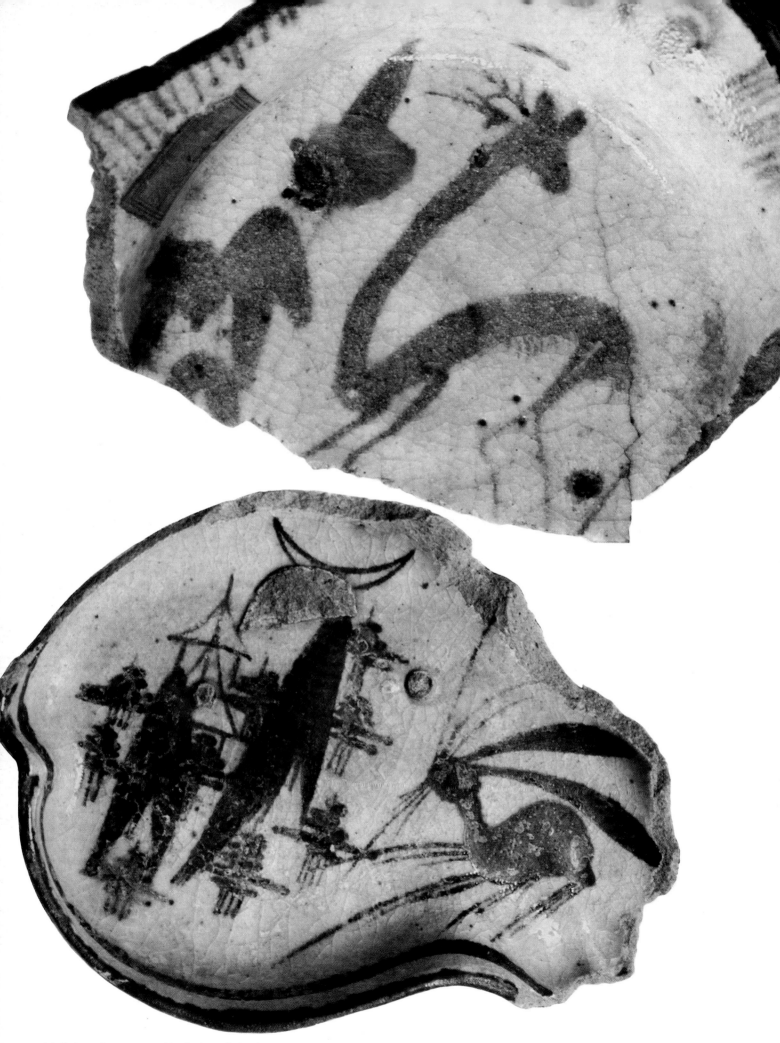

14 Pottery fragments with design of (top) autumn grasses and deer; (bottom) mountain temple, hare, and moon

15 Sun and moon ▷

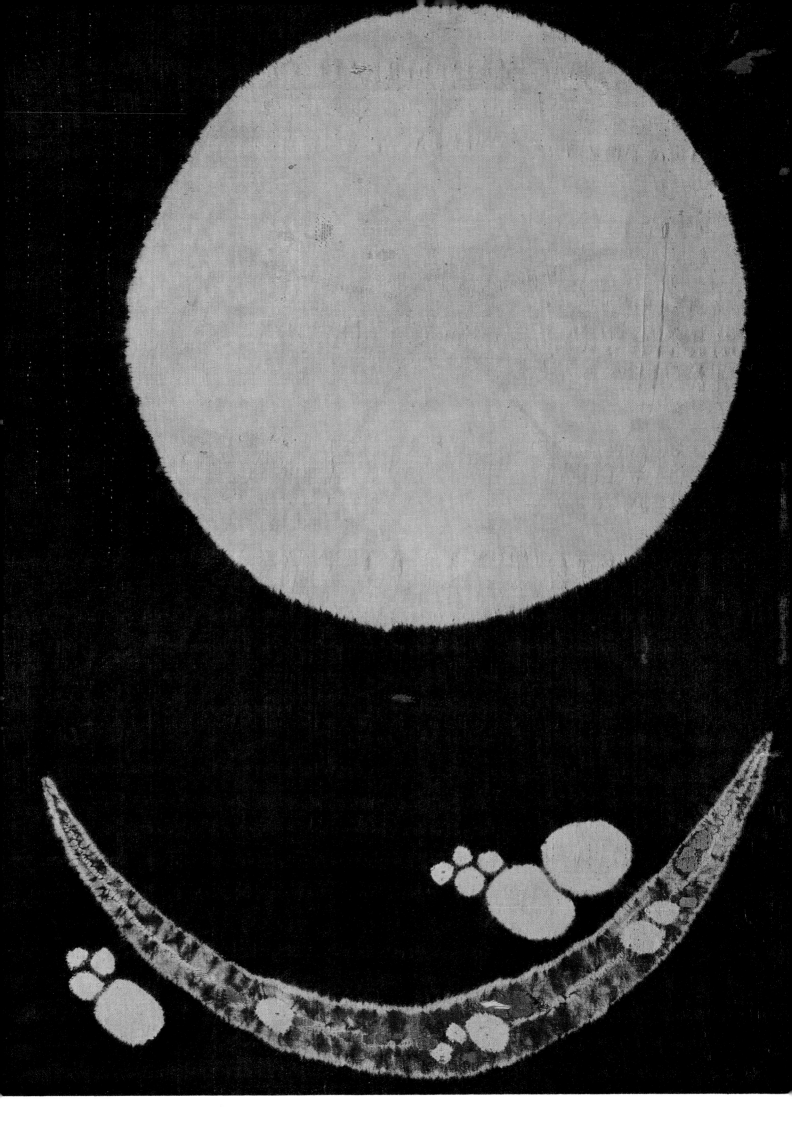

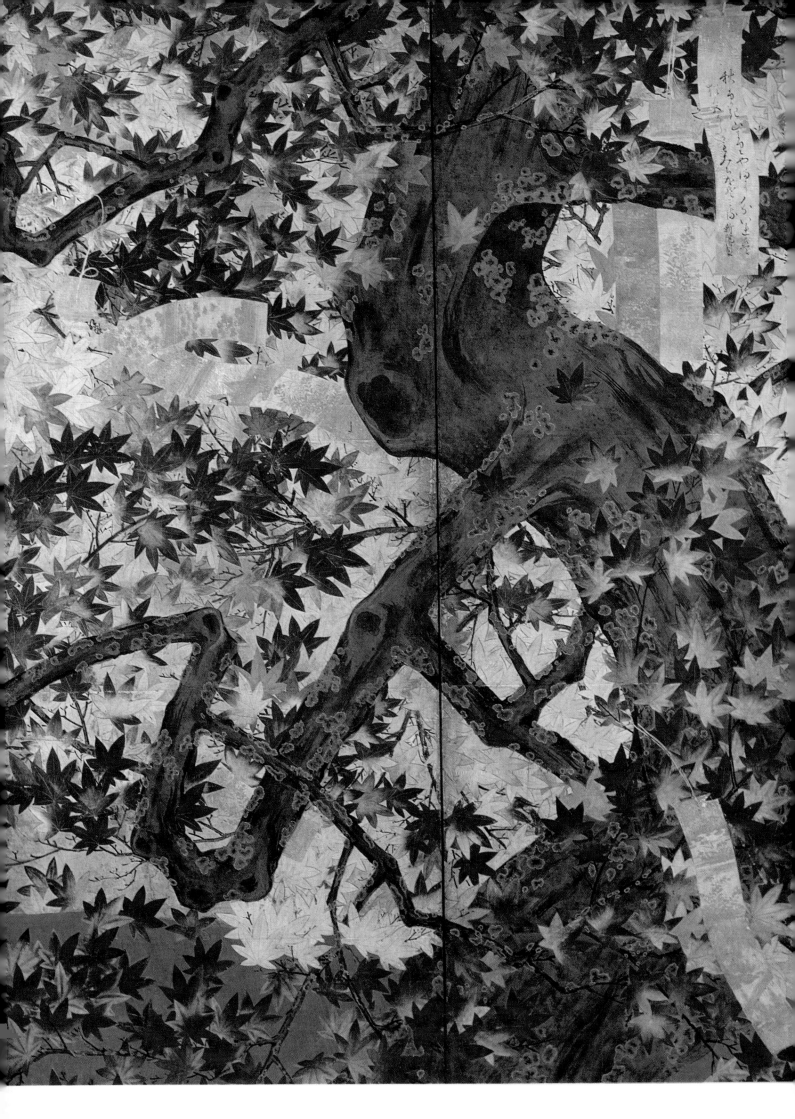

法華經

17 Sutra box with design of floral scrolling vines

◁ 16 Maple tree

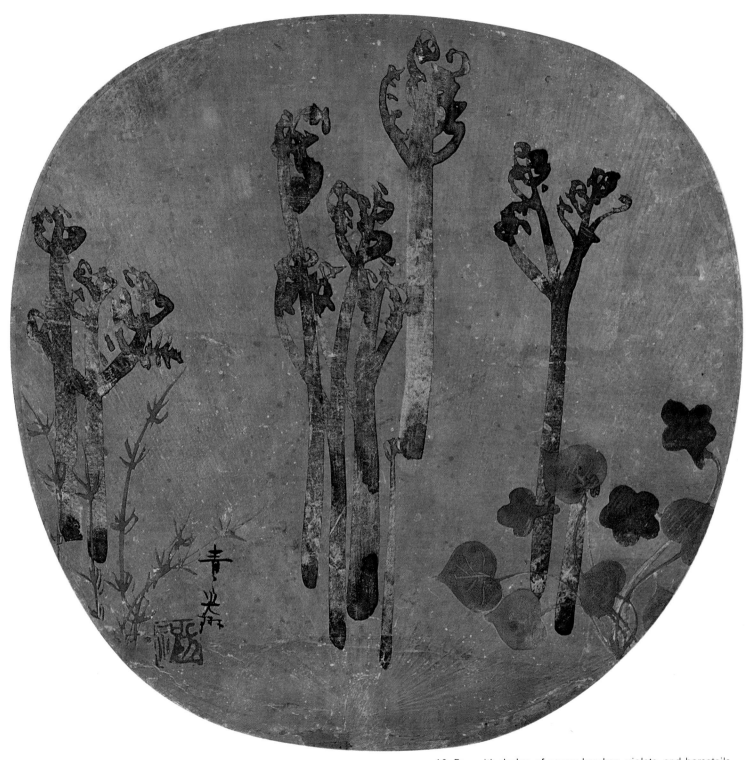

19 Fan with design of young bracken, violets, and horsetails

◁ 18 Bamboo and calligraphy

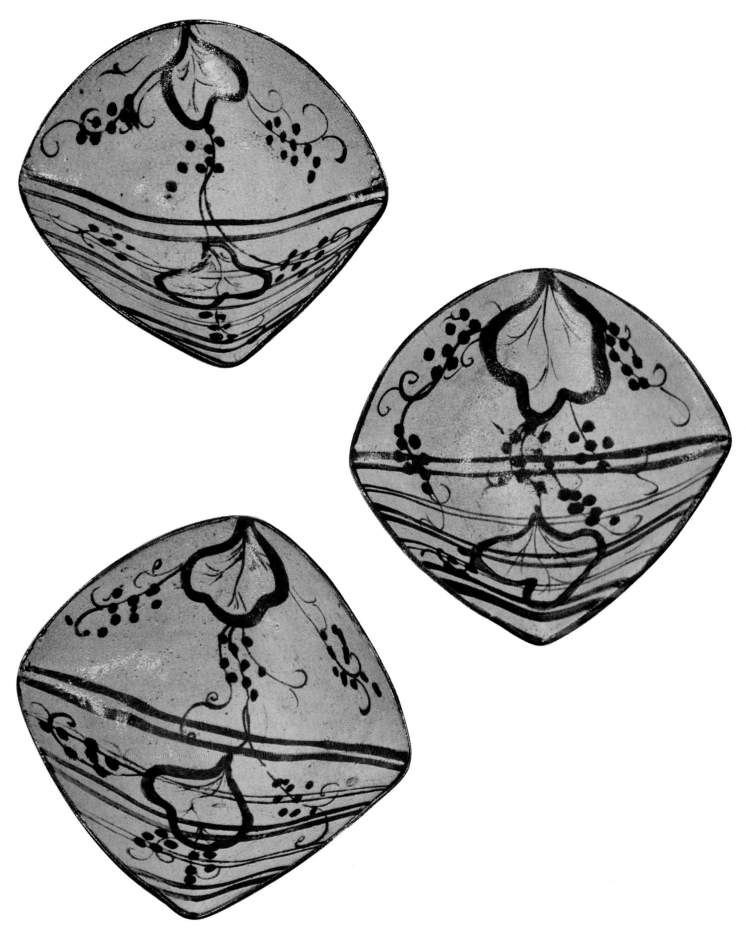

20 Small dishes with design of grapevines and stripes

21 Butterflies ▷

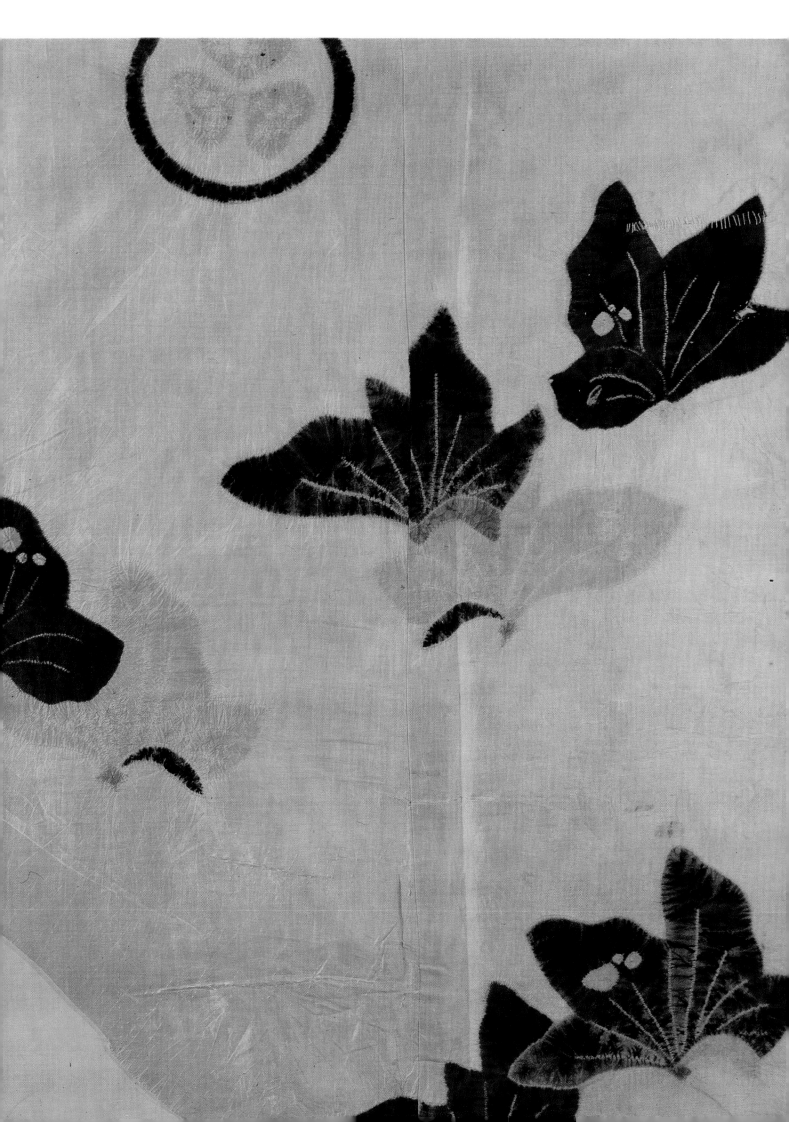

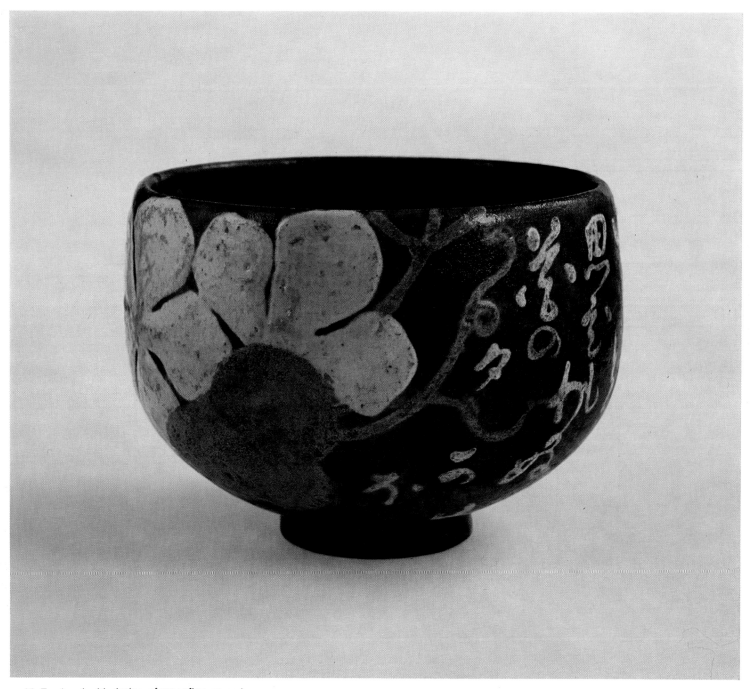

22 Tea bowl with design of moonflowers and poem

23 Tea storage jar with design of wisteria sprays ▷
24 (overleaf) Two women and flowers ▷

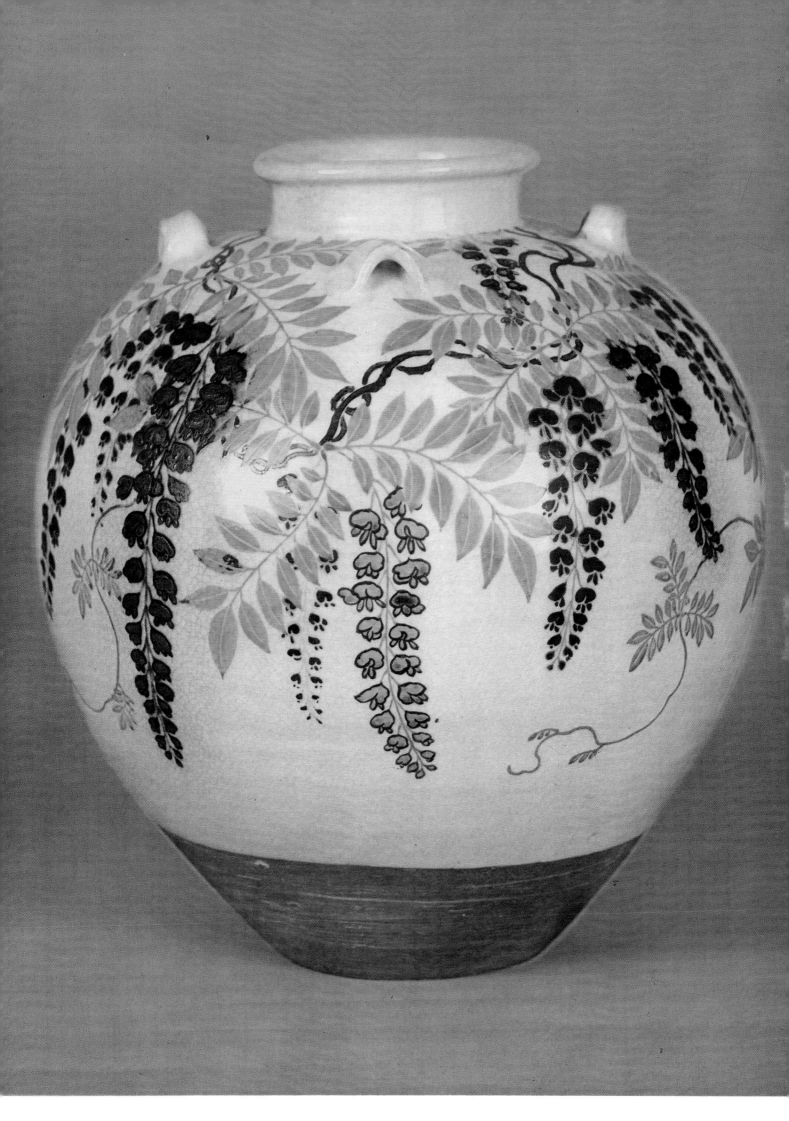

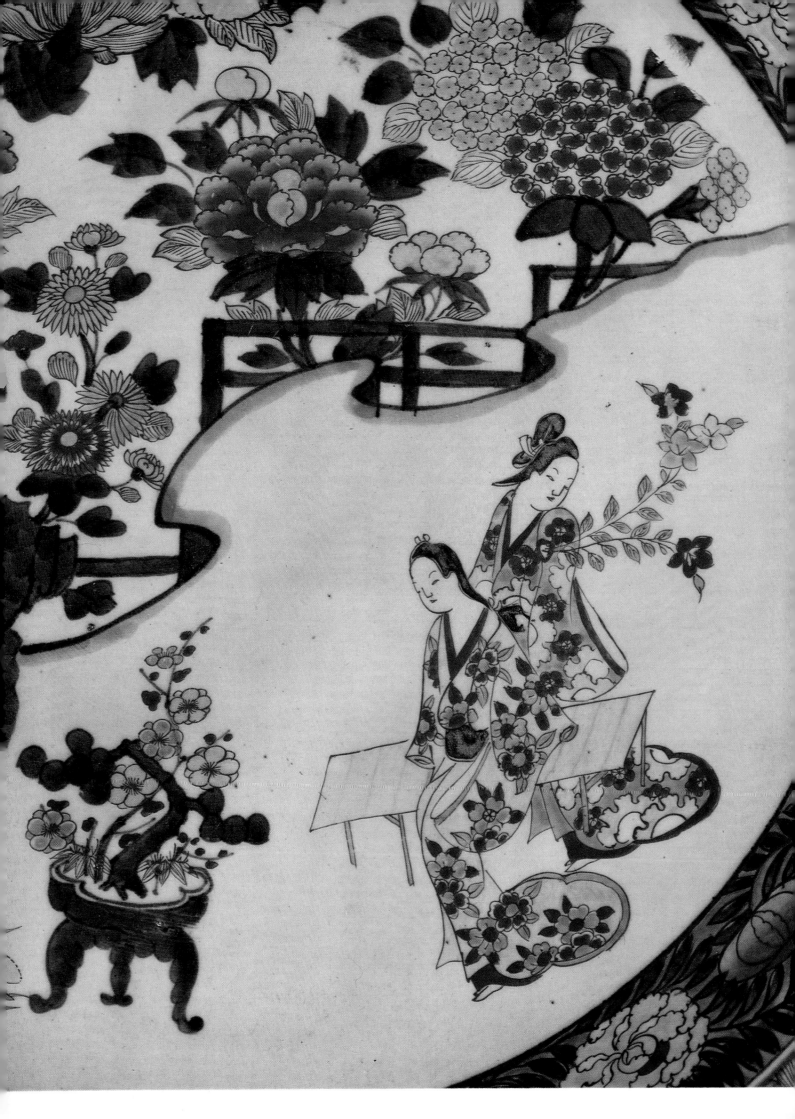

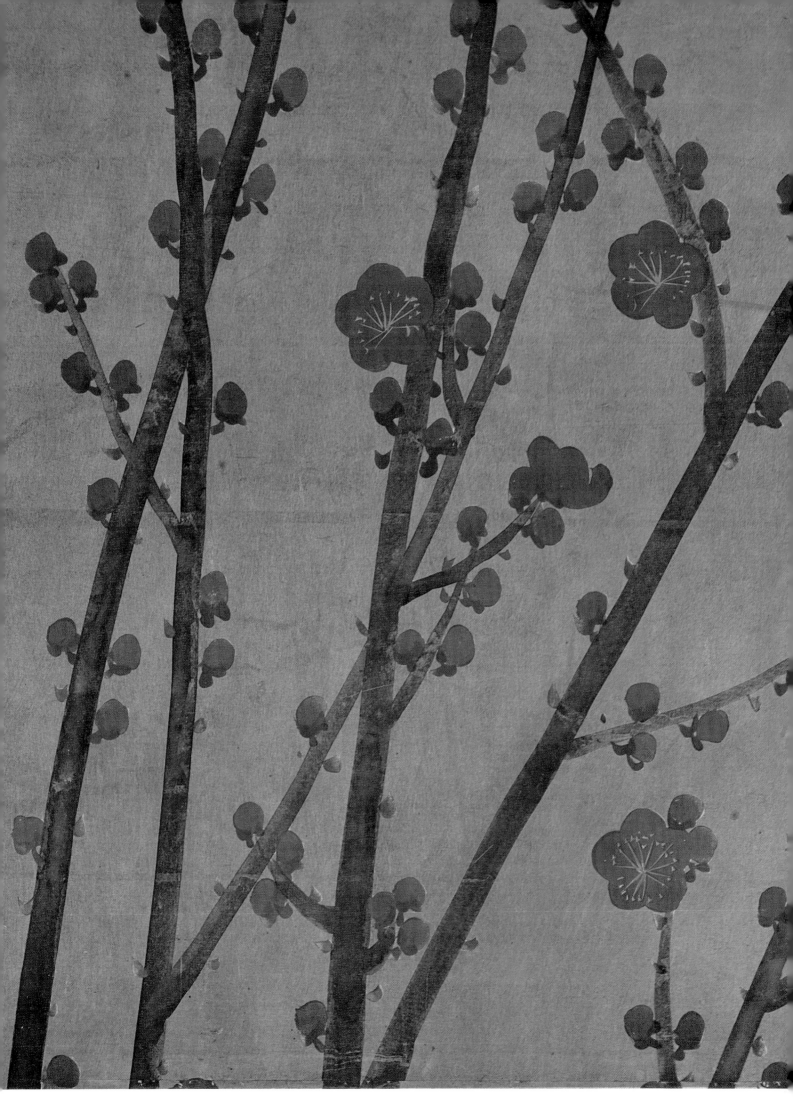

◁ 25 (preceding page) Red plum sprays

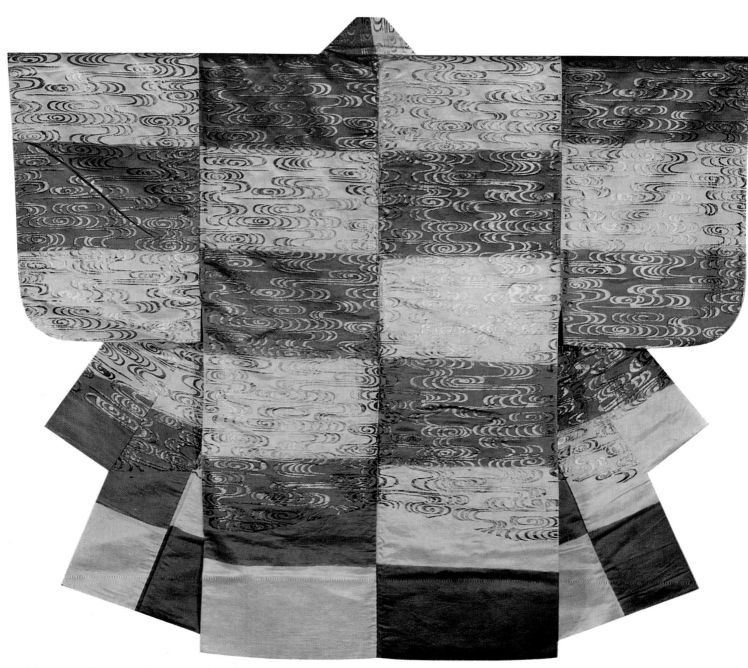

26 Nō robe with design of waves in alternating colors

27 Moon, Chinese bellflowers, and miscanthuses ▷

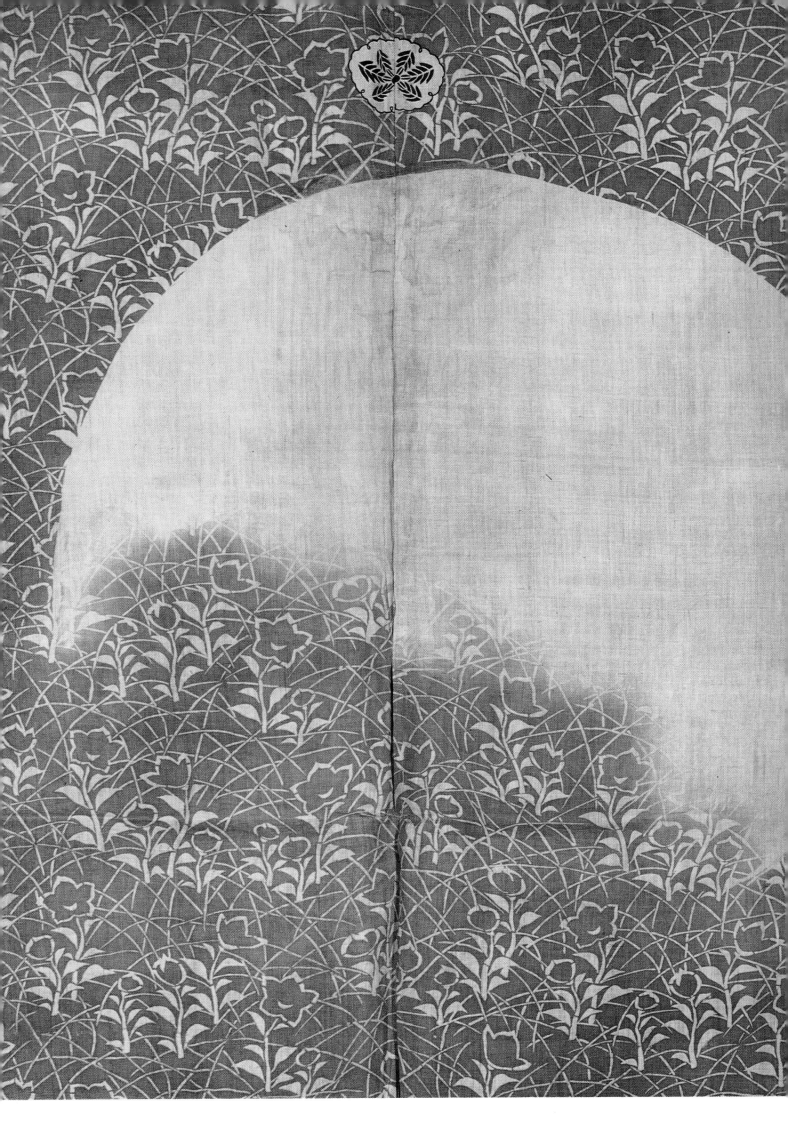

28 Nō headbands with designs of pine trees

29 Water landscape ▷

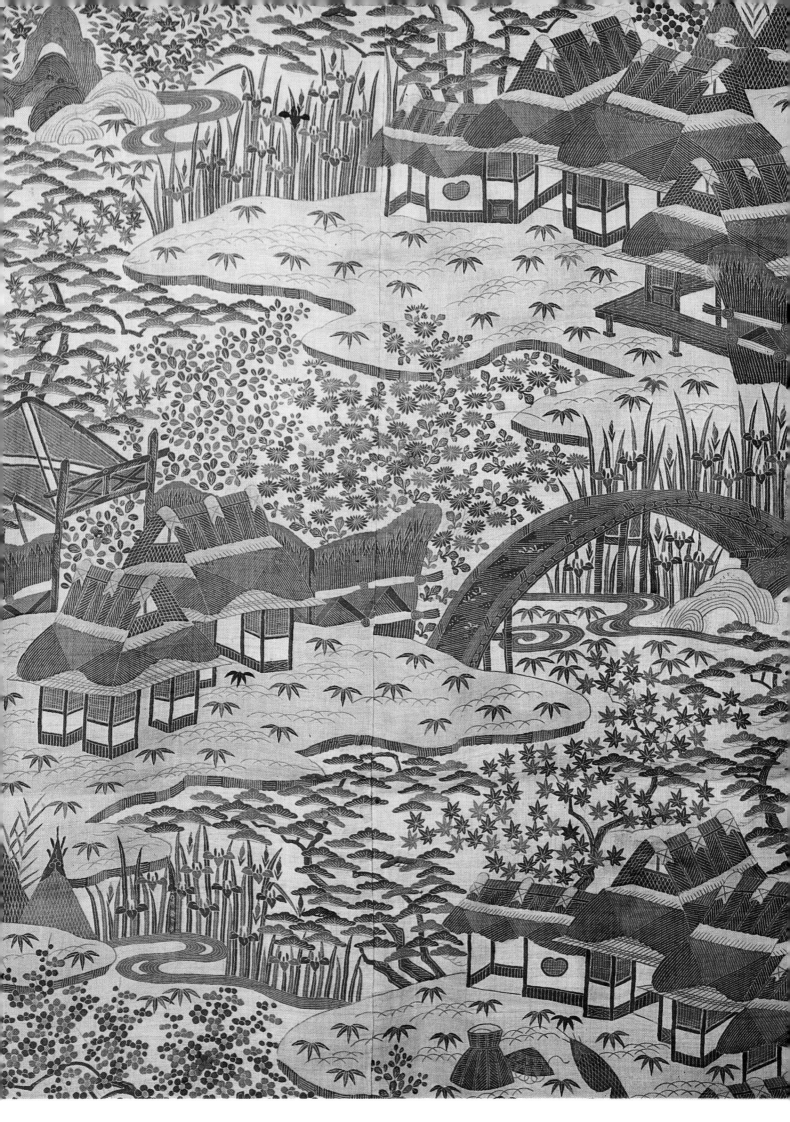

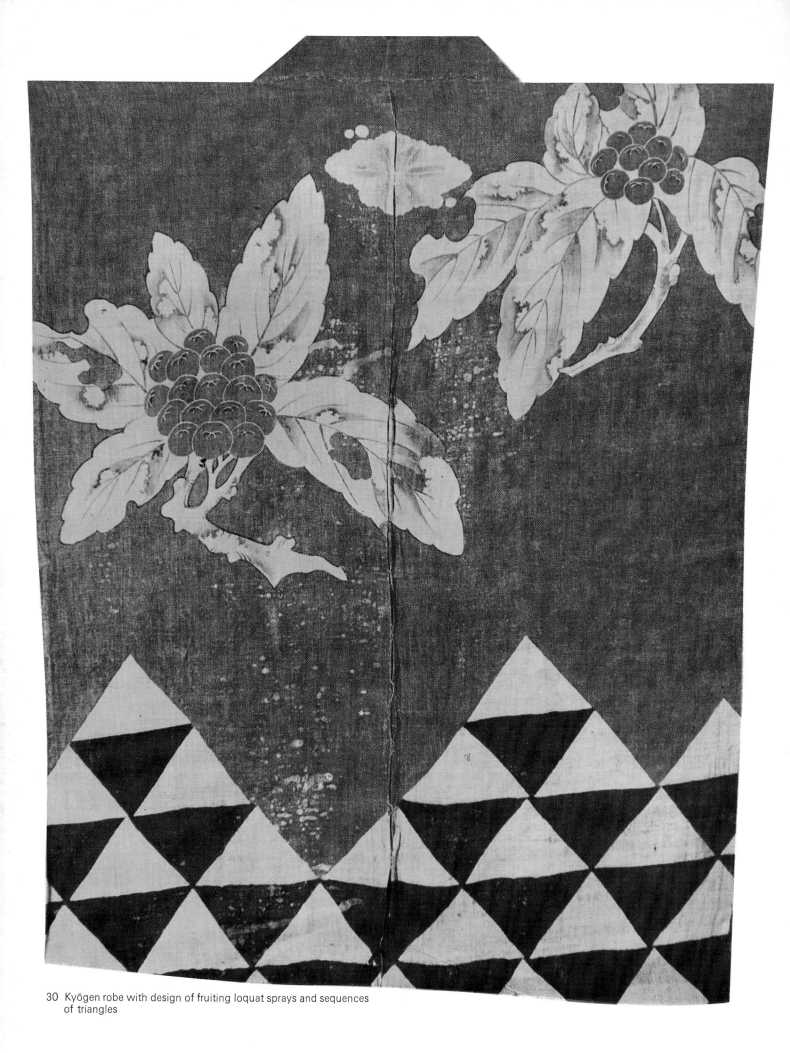

30 Kyōgen robe with design of fruiting loquat sprays and sequences
of triangles

31 Stone wall and arrows arranged on racks ▷

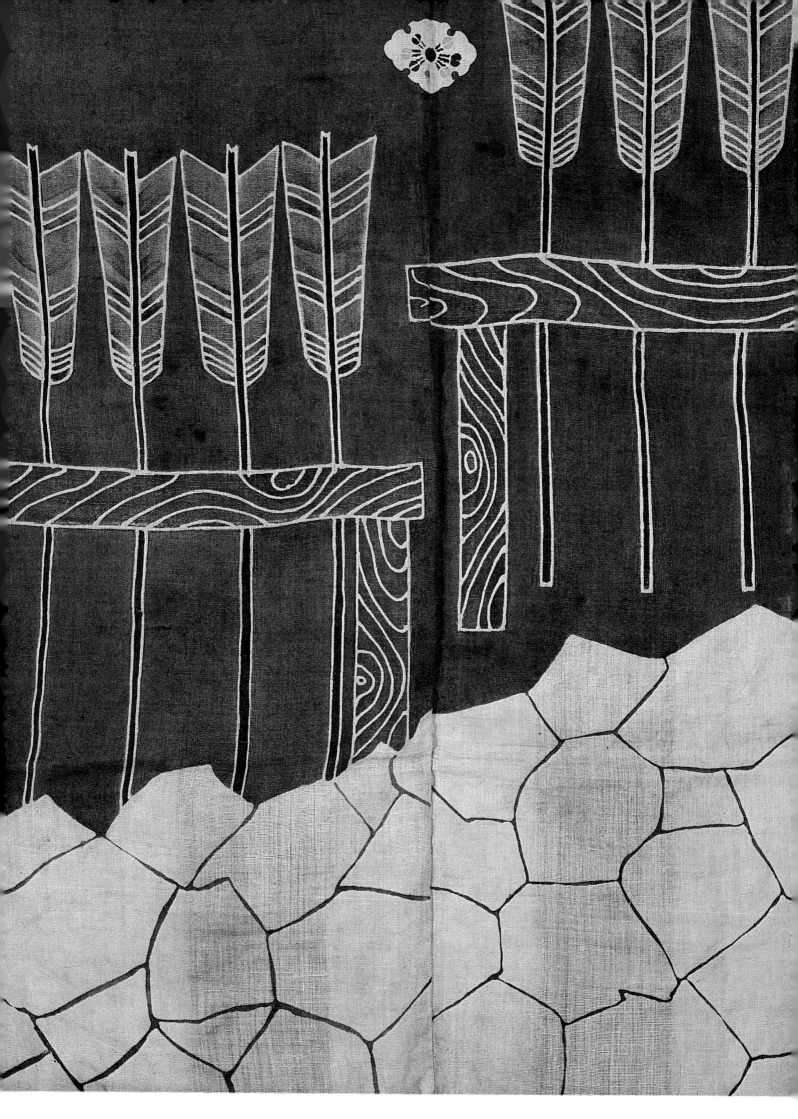

32 (left) Candle shop sign; (right) pipe shop sign

Black-and-white Plates

CHERRY BLOSSOMS

1

1 Sword guard with design of cherry and plum blossoms
2 Cherry sprays against vertical serpentine lines
3 Cherry tree, drying fishnets, and wave crests
4 Cherry blossoms and ornamental ribbons
5 Sword guard with cherry blossom design
6 Tea caddy with drooping cherry tree design
7 Plate with cherry tree design
8 Drooping cherry sprays, fans, and poetry cards
9 Drooping cherry branches and court carriage
10 Cherry trees in oblique bands
11 Drooping cherry branches, wave crests, curtains, fishnets, and clams
12 Cherry branch
13 Cherry blossoms and landscape
14 Drooping cherry branches and fans
15 Cherry sprays against geometric pattern
16 Cherry blossoms and landscapes
17 Cherry blossoms and streams
18 Cherry and plum blossoms, wave crests, bamboo grass, crane, and mandarin orange sprays
19 Drooping cherry branches
20 Drooping cherry branches
21 Cherry sprays and streams
22 Cherry blossoms

2

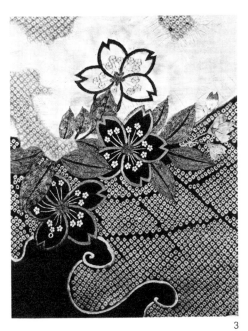

3

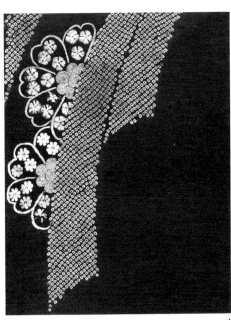

4

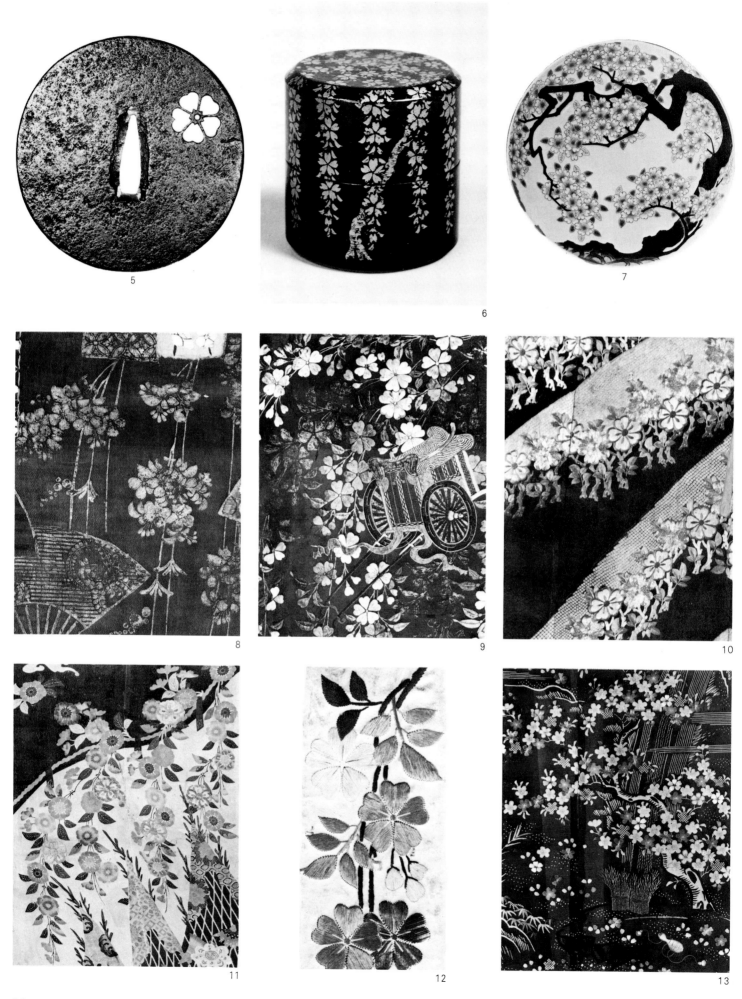

5

6

7

8

9

10

11

12

13

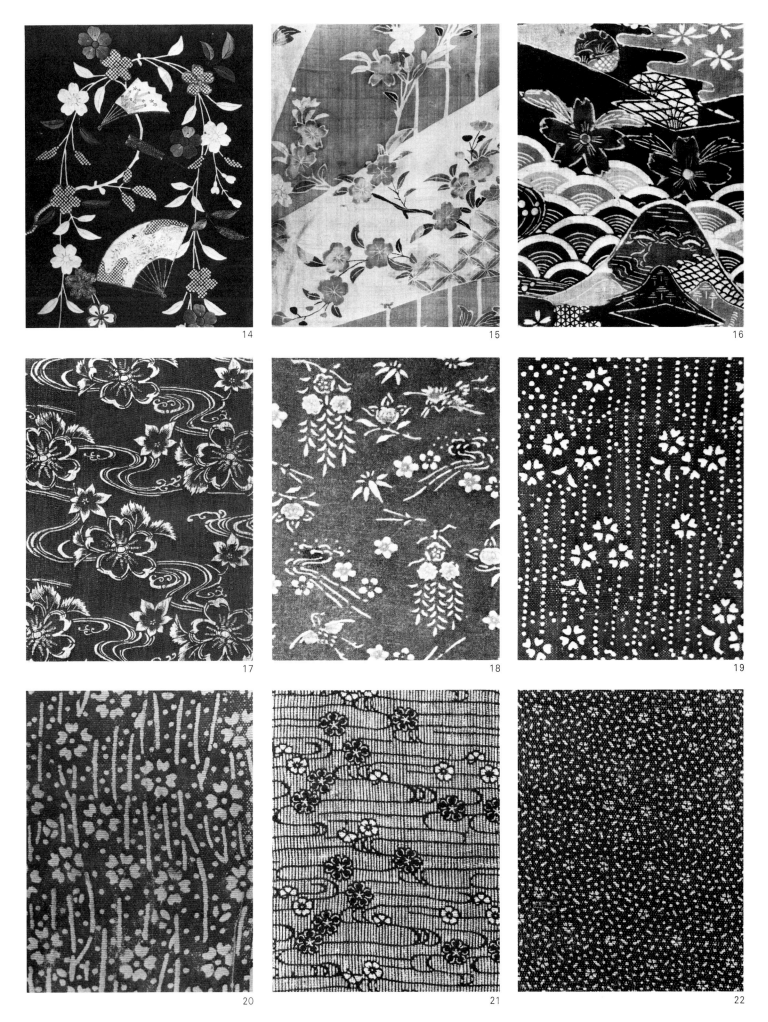

14

15

16

17

18

19

20

21

22

PAULOWNIAS

1

1 Five- and three-leafed paulownia crest
2 Paulownia tree
3 Paulownias against oblique bands
4 Fans with paulownias against pattern of wisterias and irises
5 Paulownia, scrolling vines, and flower-shaped rhombus
6 Paulownias against netting diaper
7 Five- and three-leafed paulownia crest
8 Paulownia crest
9 Sword guard with paulownia design
10 Paulownias
11 Bowl with paulownia design
12 Paulownia spray in a circle and willow tree
13 Paulownia tree and flying phoenix
14 Paulownia and scrolling vines
15 Paulownias and scrolling vines

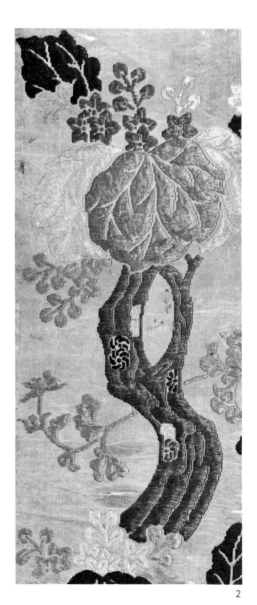

2

3

4

5

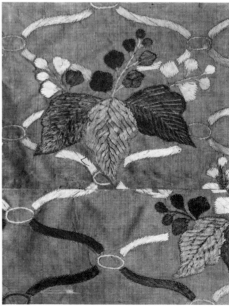

6

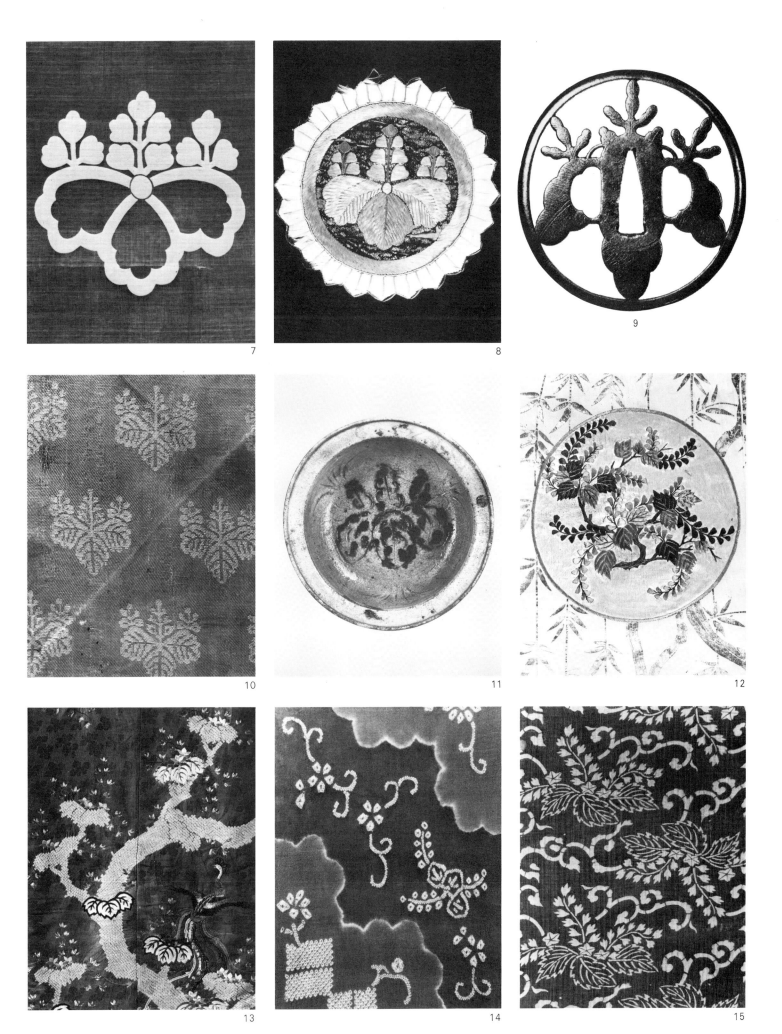

7

8

9

10

11

12

13

14

15

PEONIES

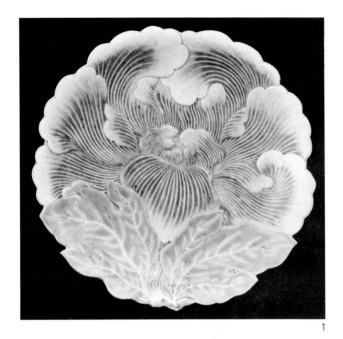

1

1 Plate with peony design
2 Bowl with peony design
3 Peony crest
4 Peony and cart
5 Peony scrolls and hollyhocks
6 Curtain with peony design and hollyhocks
7 Peony branches and sliding screens
8 Peonies against vertical lines and interlocking circles
9 Peony
10 Peony scrolls
11 Peony branches
12 Peonies and chrysanthemums

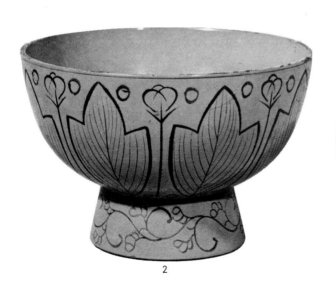

2

3

4

5

6

7

8

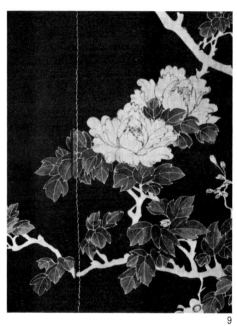

9

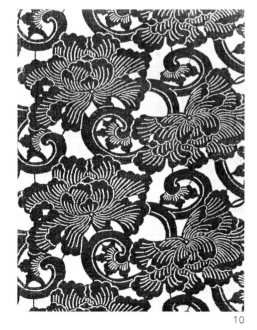

10

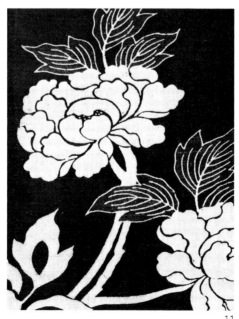

11

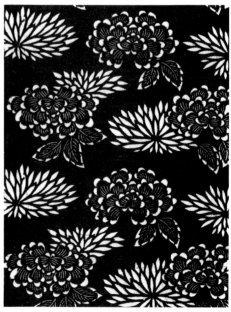

12

CAMELLIAS

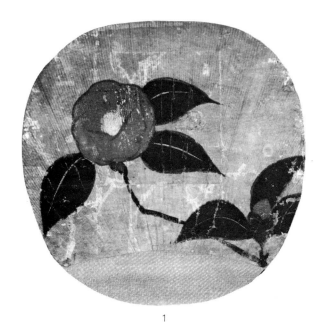

1

1 Round fan paper with camellia branch design
2 Camellia blossoms and wisteria sprays
3 Camellias, chrysanthemums, and poetry cards against overlapping lozenge diaper
4 Camellia branch
5 Camellia trees and wave crests
6 Camellia tree and willow branches
7 Camellia tree and bamboo fence
8 Camellia and plum trees
9 Camellia blossoms, fan papers, and streams
10 Lid of a lacquered box for holding cups with camellia tree design
11 Plate with camellia tree design
12 Plate with camellia branch design
13 Plate with camellia branch design

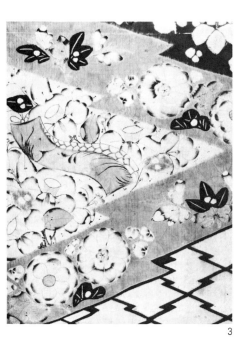

2

3

4

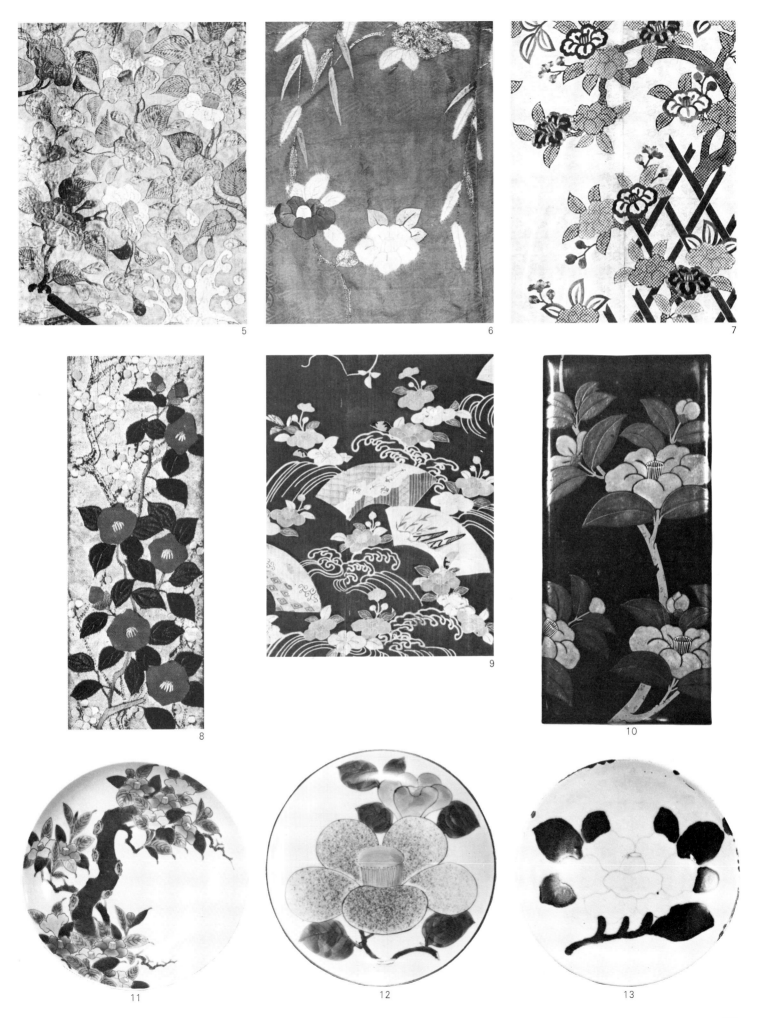

WISTERIAS

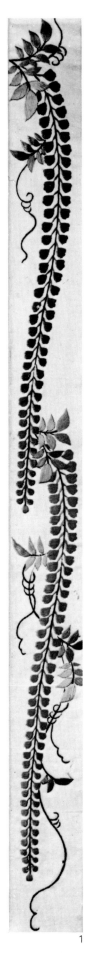

1 Wisteria clusters
2 Wisteria on trellis
3 Mirror back with design of wisteria tree by the sea and two birds
4 Wisteria blossoms curled into the revolving ''commas'' (*tomoe*) shape against a diaper of foliate diamonds within a tortoise-shell lattice
5 Wisteria and camellia blossoms
6 Wisterias and other plants
7 Wisteria and cranes
8 Wisteria sprays
9 Wisteria sprays
10 Wisteria on trellis
11 Noodle sauce cup with wisteria and ball desigr
12 Plate with design of wisteria on trellis and butterflies
13 Wisteria crest, dots, and bands

3

4

76

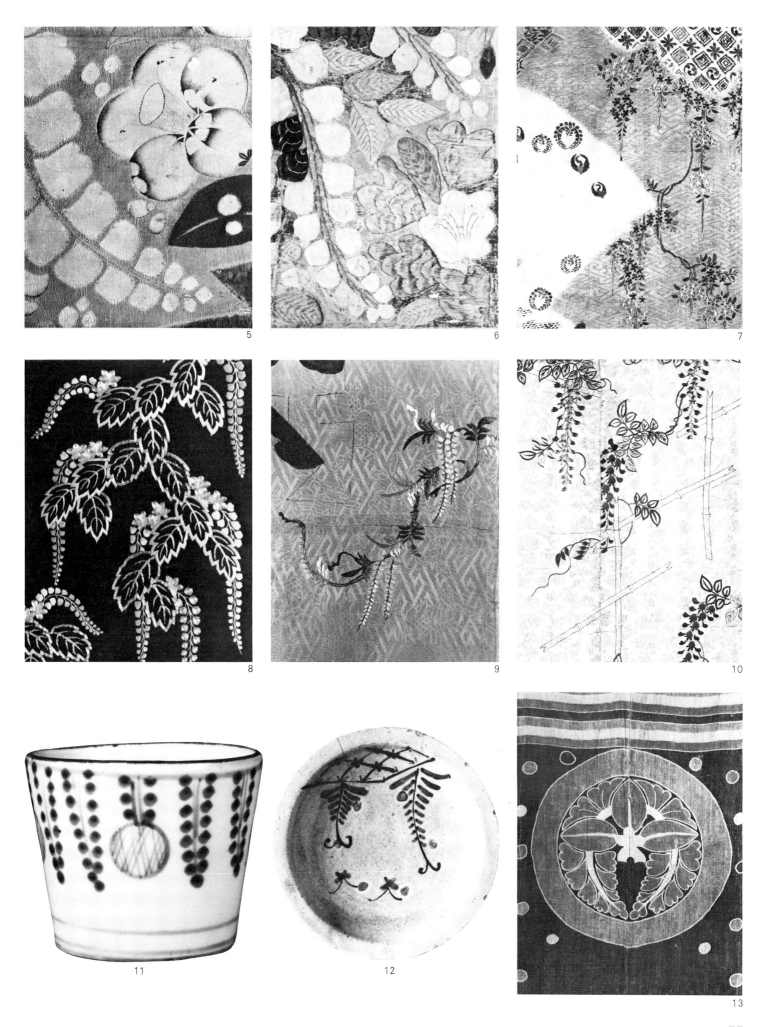

5

6

7

8

9

10

11

12

13

77

WILLOWS

1

1 Tea caddy with drooping willow tree design
2 Drooping willow branches covered with snow
3 Drooping willow branches and balls used in courtly game
4 Tray with design of willow, crescent moon, and herons
5 Plate with willow tree design
6 Willow branches in a circle
7 Willow branches and poetry card
8 Willows and landscapes against overlapping lozenges
9 Willows covered with snow and paulownias against crossing diagonal lines
10 Willow trees and flowers in circles
11 Willow trees
12 Willows and boats laden with flowers
13 Willow trees and round fans
14 Willow branches and balls used in courtly game

2

3

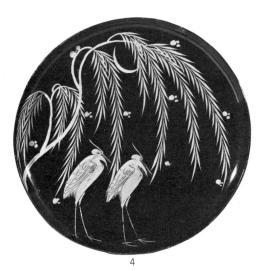

4

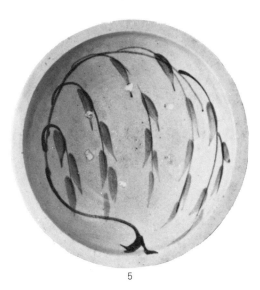

5

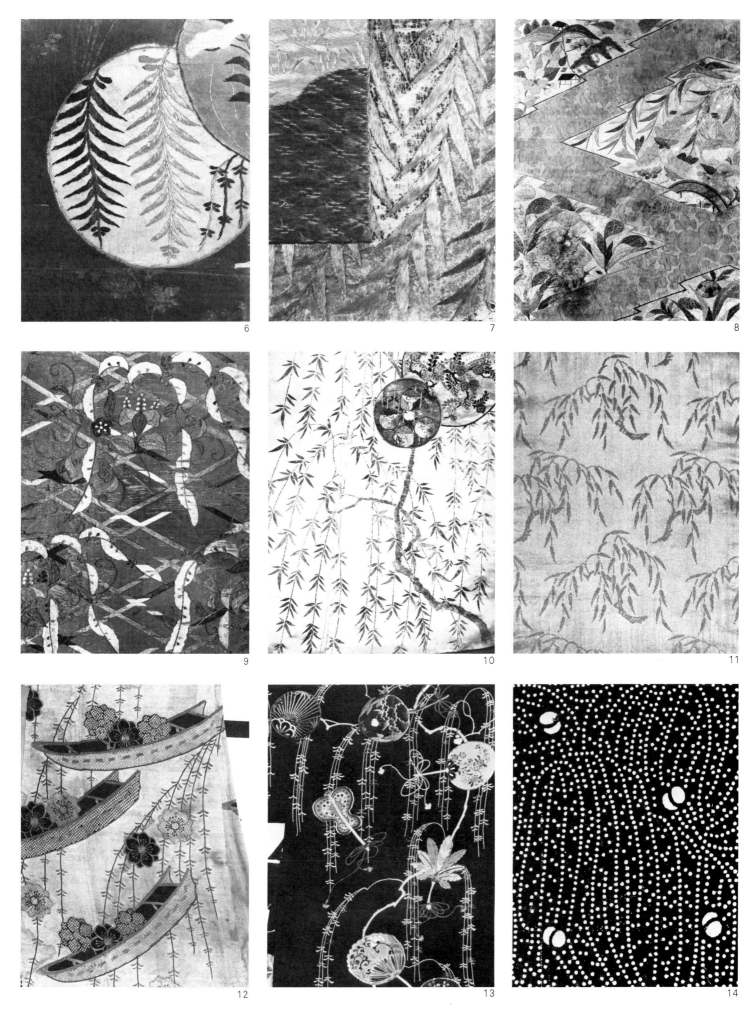

6

7

8

9

10

11

12

13

14

1

1 Nail concealer with narcissus design
2 Square dish with design of horsetails and miscanthuses
3 Small dish with budding branch design
4 Plate with horsetail design
5 Inside of writing box lid with design of bracken sprouts and dandelions on dikes
6 Bracken
7 Plate with design of narcissus, hares, and wave crests
8 Plate with spirea design
9 Orchid roundel
10 Orchid
11 Violets and lateral bands against overlapping lozenges
12 Dandelions
13 Dandelions

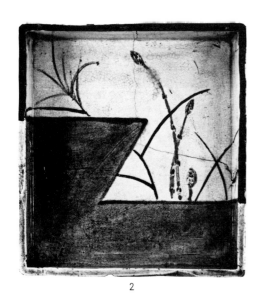

2

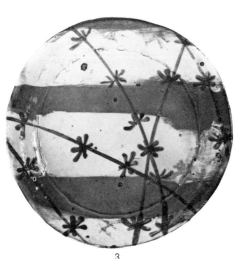

3

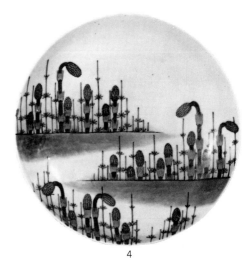

4

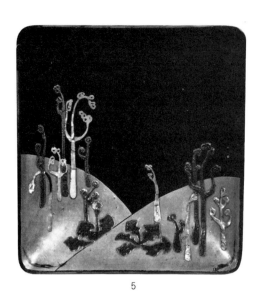

5

6

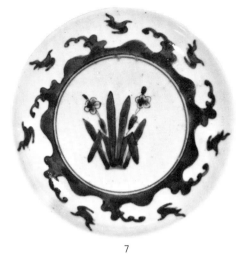

7

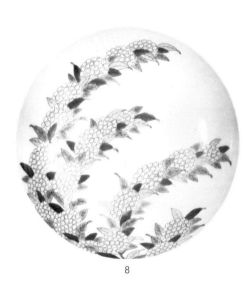

8

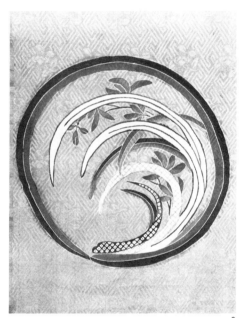

9

10

11

12

13

PLUM BLOSSOMS

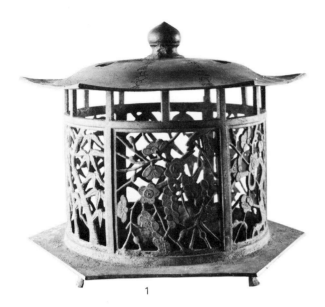

1

1 Hanging lantern with design of plum and bamboo
2 Plum blossoms forming crossing diagonal lines
3 Plum blossom crest
4 Plum blossoms in a circle
5 Tea bowl with design of spear-stemmed plum branches
6 Oil plate with design of Japanese nightingale on plum branch
7 Plum branches
8 Plum branch
9 Plum blossoms against vertical serpentine lines
10 Plum blossoms on water
11 Plum tree
12 Plum blossoms and plum sprays
13 Spear-shaped plum trees and bamboo
14 Plum blossoms
15 Plum sprays
16 Plum branch
17 Plum blossoms in circles
18 Plum blossoms
19 Plum blossoms against broken ice patterns
20 Plum blossoms, pine needles, and overlapping lozenges
21 Plum tree, bamboo, crane, and tortoise
22 Plum tree

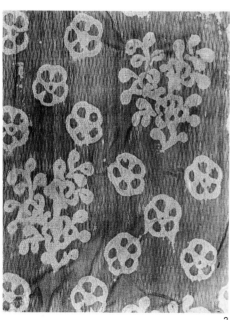

2

3

4

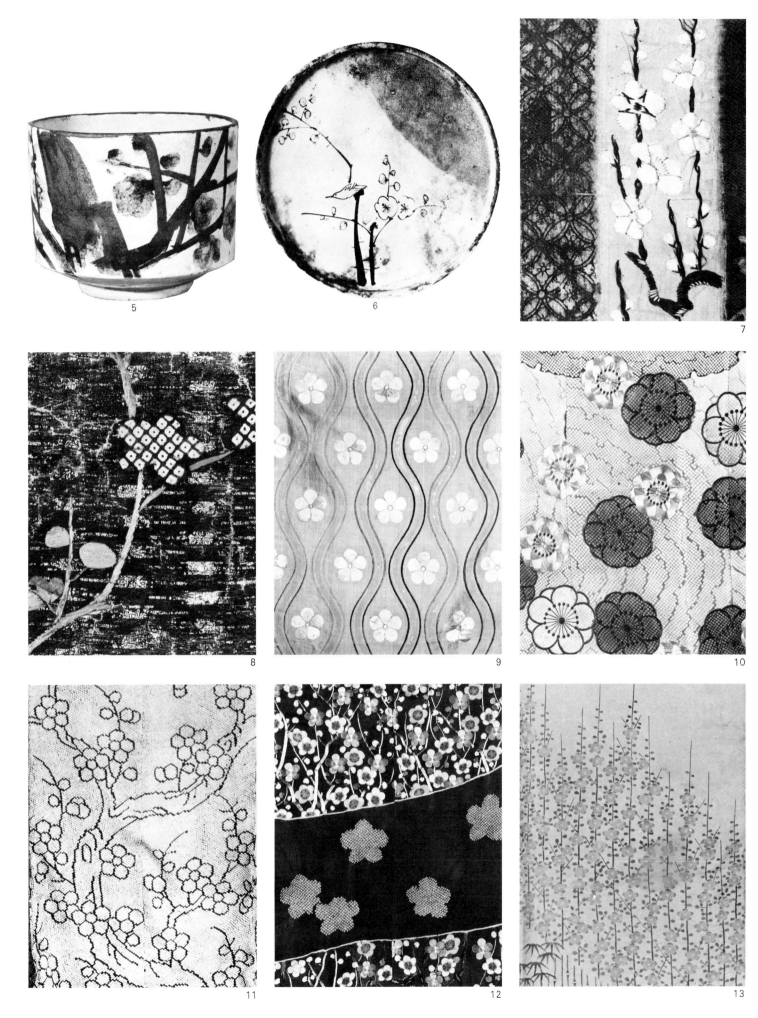

5

6

7

8

9

10

11

12

13

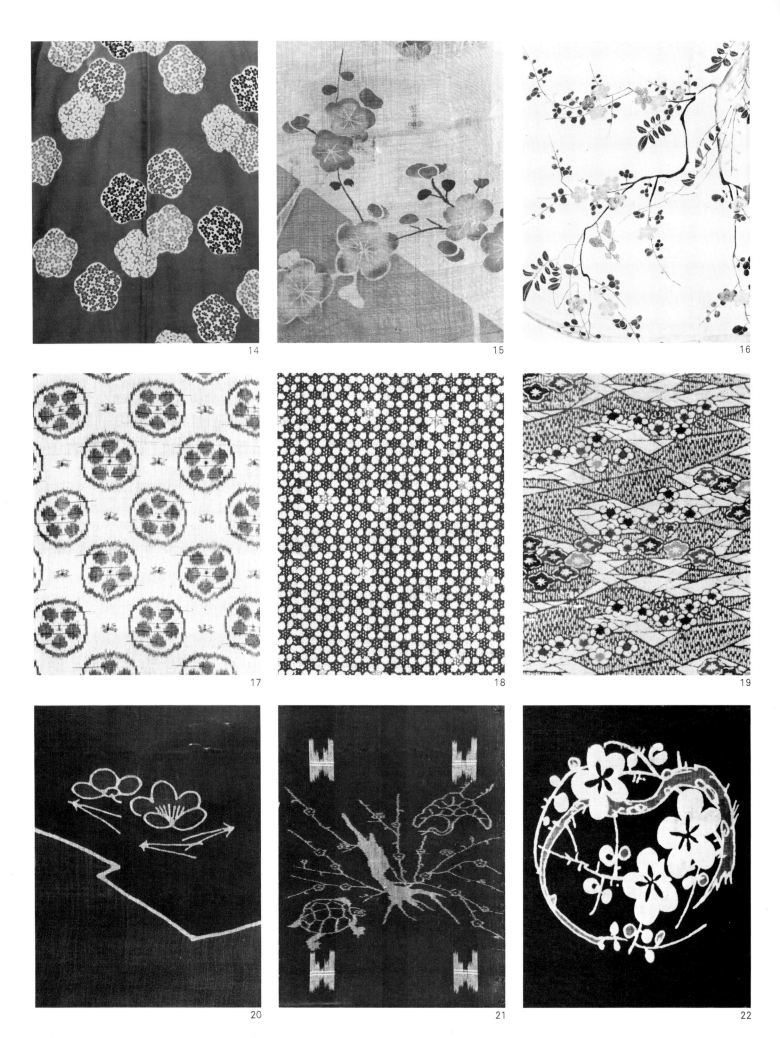

14

15

16

17

18

19

20

21

22

LOTUS FLOWERS, SUMMER GRASSES, AND SEASHELLS

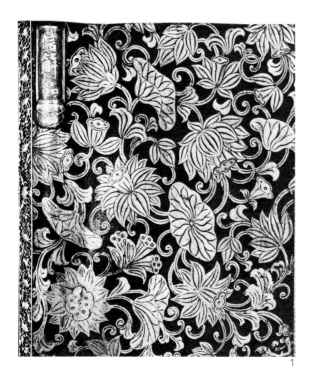

1

1 Sutra cover with design of lotus and scrolling vines
2 Lotus flower
3 Pond with lotus flower
4 Irises, water plantain, and maple leaves against oblique bands
5 Bowl with iris design
6 Sword guard with design of irises and dewdrops on leaves
7 Irises in stream
8 Irises in stream, butterflies, pines, and overlapping lozenges
9 Irises in stream
10 Irises, plum and cherry blossoms, and stream
11 Irises
12 Iris
13 Ivy
14 Ivy against "cypress fence" diaper
15 Ivy and scrolling vines
16 Hollyhocks and plum blossoms against vertical serpentine lines
17 Hollyhock in circle
18 Hollyhocks
19 Hollyhocks and curtain
20 Hollyhocks
21 Candock, Chinese bellflowers, and streams
22 Plate with design of clams, seaweed, and waves
23 Clams decorated with flowers, sea and shore
24 Plate with design of cucumber flower and leaf
25 Lilies
26 Crest with triple oak leaves
27 Paper mulberry leaf
28 Wood-sorrel flower crest
29 Hydrangea sprays and Japanese syllabic letters
30 Kyōgen robe with design of hydrangea flower and leaves with butterflies
31 Thistles and bird

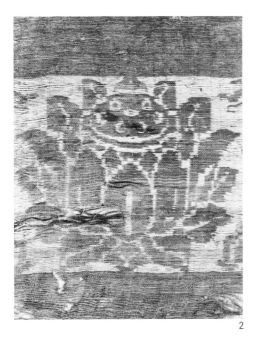

2

3

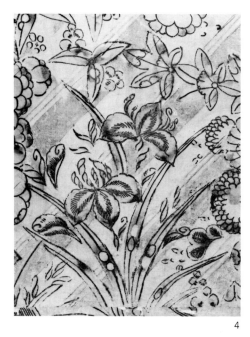

4

5

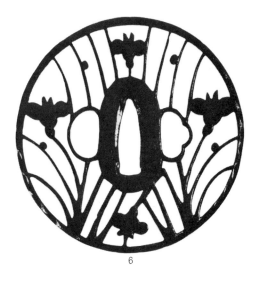

6

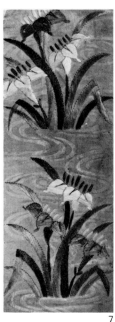

7

8

9

10

11

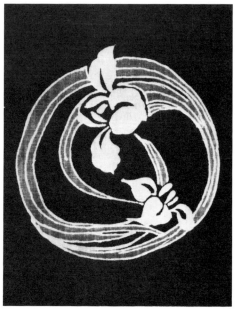

12

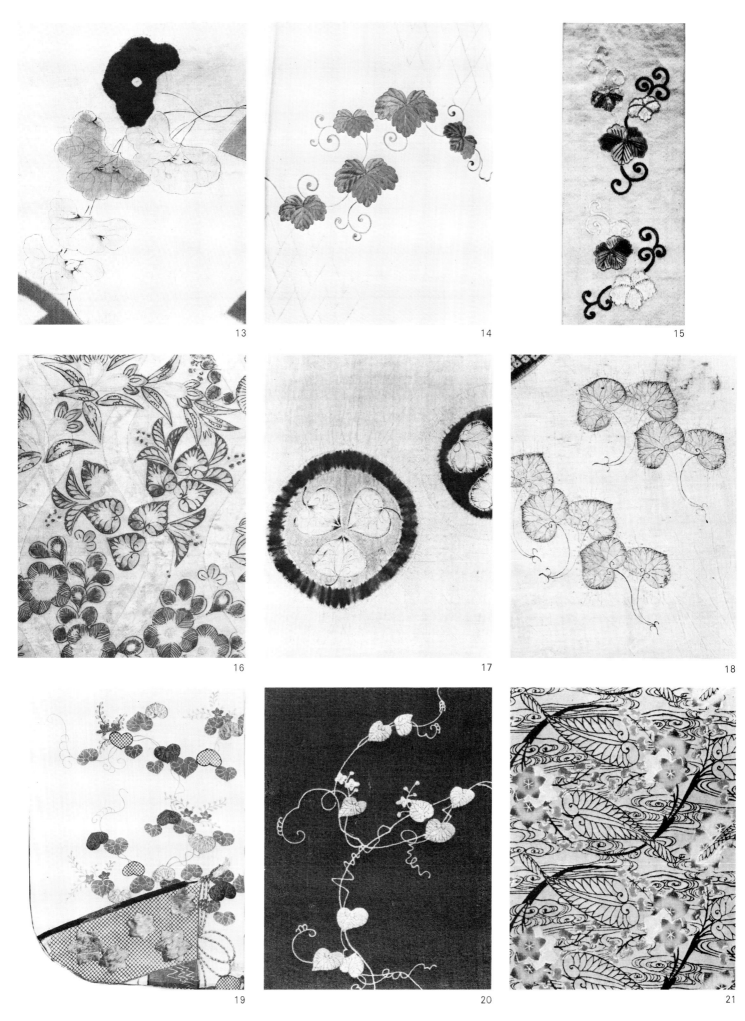

13

14

15

16

17

18

19

20

21

22

23

26

24

25

27

29

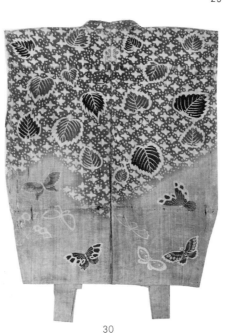

30

31

28

88

MORNING GLORIES AND CLEMATIS FLOWERS

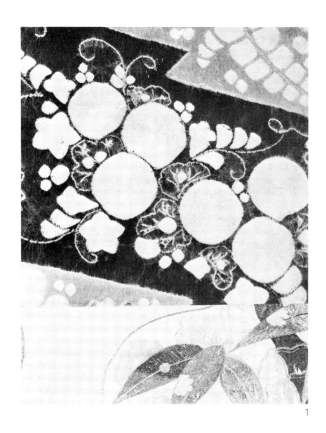

1

1 Morning glories, wisteria, and overlapping lozenges
2 Noodle sauce cup with morning glory design
3 Morning glories and bamboo
4 Morning glories and bamboo fence
5 Morning glories and bamboo
6 Morning glories
7 Clematis
8 Moonflowers
9 Moonflowers
10 Clematis and snow crystal
11 Clematis and stream
12 Clematis
13 Clematis against stripes
14 Clematis and bamboo fence

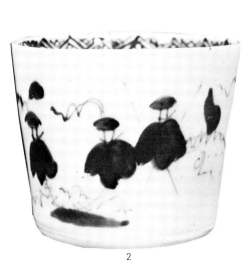

2

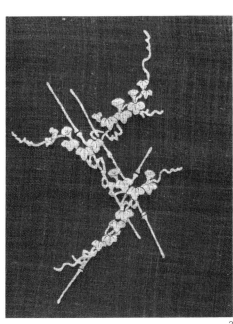

3

4

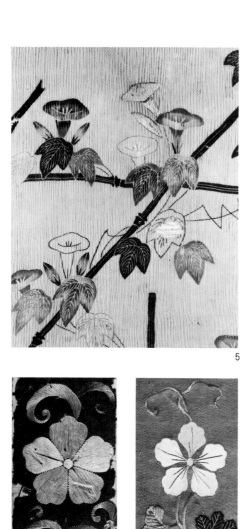

5

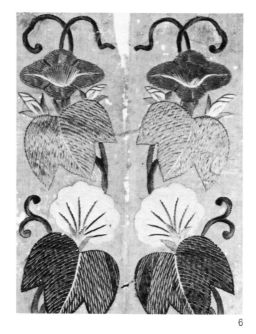

6

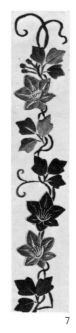

7

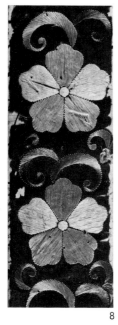

8

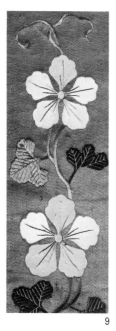

9

10

11

12

13

14

FRUITS, VEGETABLES, AND GRAINS

1

2

1 Mandarin orange crest
2 Noodle sauce cup with mandarin orange design
3 Mandarin orange spray among tortoise-shell hexagons enclos-
 ing imaginary flower motif
4 Mandarin orange sprays against sequences of triangles
5 Mandarin orange crest
6 Chestnut branch
7 Plate with chestnut branch design
8 Kyōgen robe with design of pine cones and needles
9 Clove tree blossoms
10 Bowl with radish design
11 Sword guard with radish design
12 Plate with broad bean design
13 Auspicious plant crest
14 Auspicious plant crest
15 Fruiting peach sprays and trailing haze
16 Gourds, bamboo, and stream
17 Tobacco tray with gourd design
18 Gourds and millstone
19 Gourd vine and a broken bamboo fence
20 Mount Fuji, eagle, egg-plants, and geometric motif
21 Mount Fuji, eagles, and egg-plants
22 Rice plant roundel and scrolling vines
23 Noodle sauce cup with rice sheaf design
24 Rice plants

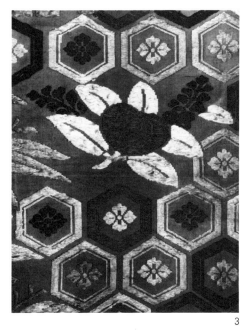

3

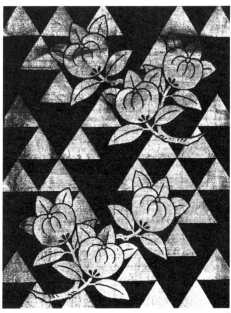

4

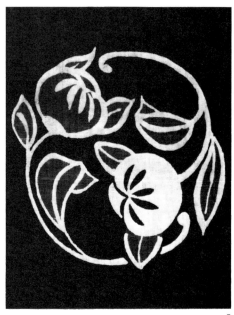

5

6

7

8

9

10

11

12

13

14

15

92

16

17

18

19

20

21

22

23

24

CHRYSANTHEMUMS

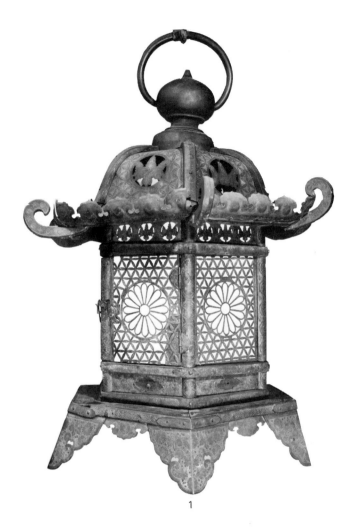

1

1 Hanging lantern with chrysanthemum and paulownia design
2 Rice bowl with chrysanthemum design
3 Chrysanthemums, paulownias, and miscanthus leaves laden with snow
4 Chrysanthemums and wisterias
5 Chrysanthemums and miscanthus leaves with dewdrops
6 Chrysanthemums and scrolling vines
7 Chrysanthemums
8 Chrysanthemums beside streams
9 Chrysanthemums, paulownias, and flower-laden rafts
10 Chrysanthemums and narcissi
11 Chrysanthemums and miscanthuses beside bamboo fence
12 Chrysanthemums against semicircular wave patterns
13 Chrysanthemums and scrolling vines
14 Chrysanthemums
15 Chrysanthemums
16 Chrysanthemums and miscanthuses
17 Chrysanthemums
18 Chrysanthemums in horizontal bands
19 Snow crystals enclosing chrysanthemum petals, arranged in semicircular wave patterns
20 Chrysanthemum sprays against diaper of interlocking squares
21 Chrysanthemums beside bamboo fence
22 Chrysanthemums against overlapping lozenges
23 "Kōrin chrysanthemums" (design said to be based upon a drawing by Ogata Kōrin) and winding stream
24 Chrysanthemums
25 Chrysanthemum
26 Chrysanthemum roundel
27 Chrysanthemums
28 Chrysanthemum sprays against dots
29 Chrysanthemums

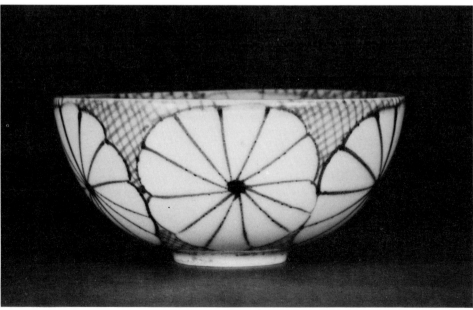

2

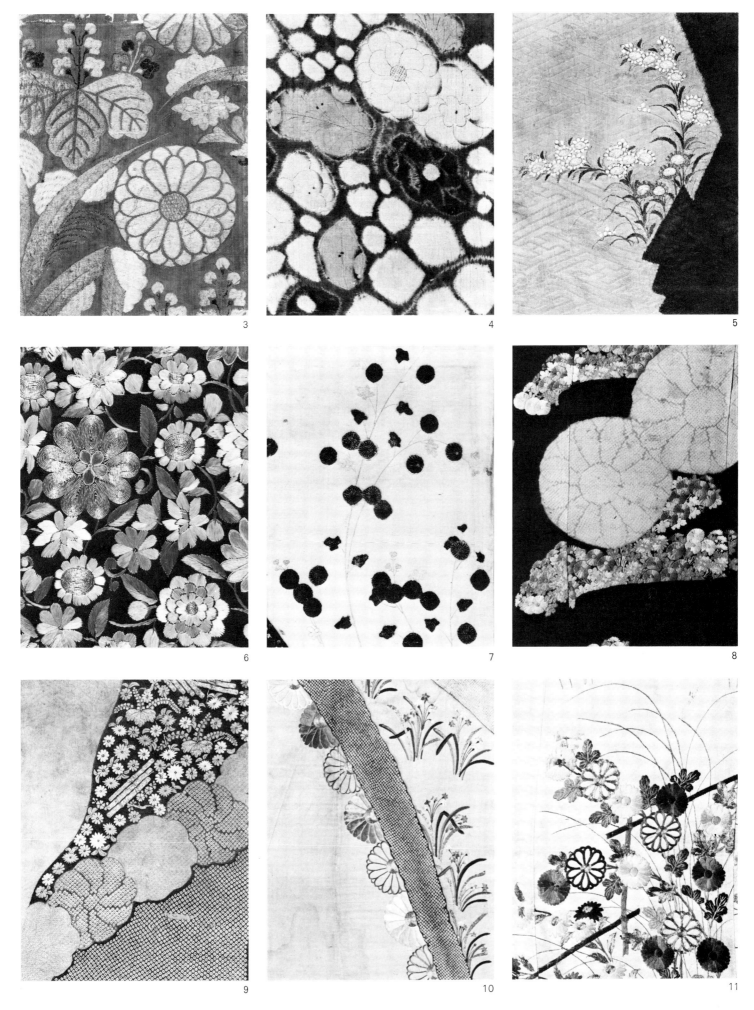

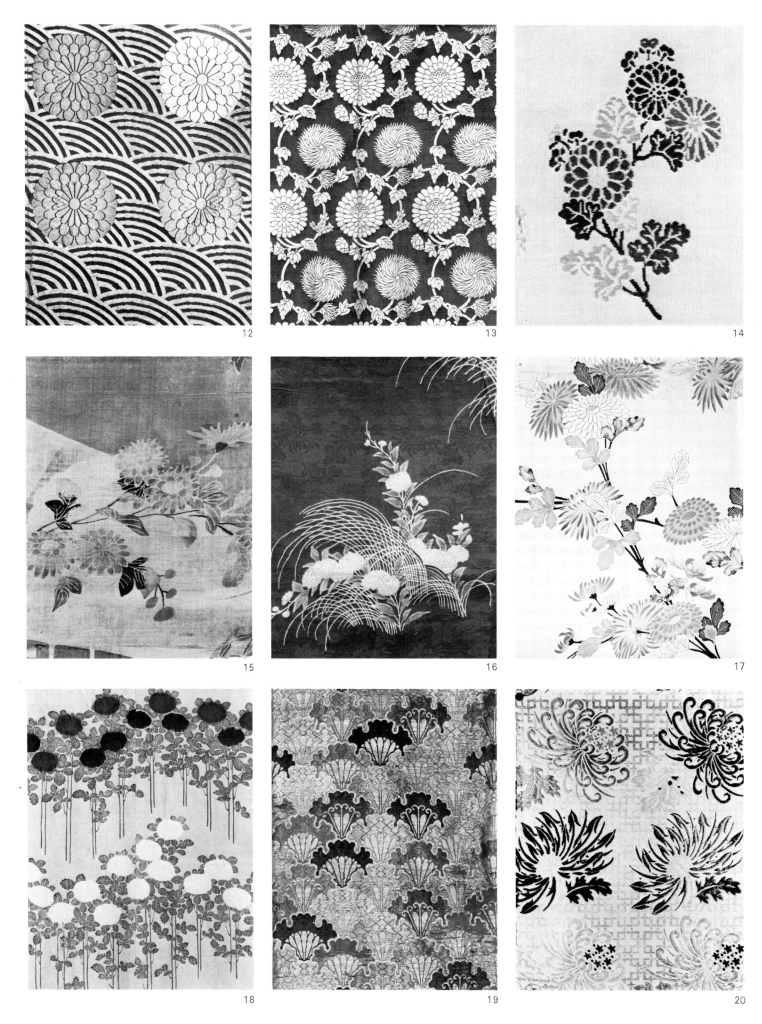

12

13

14

15

16

17

18

19

20

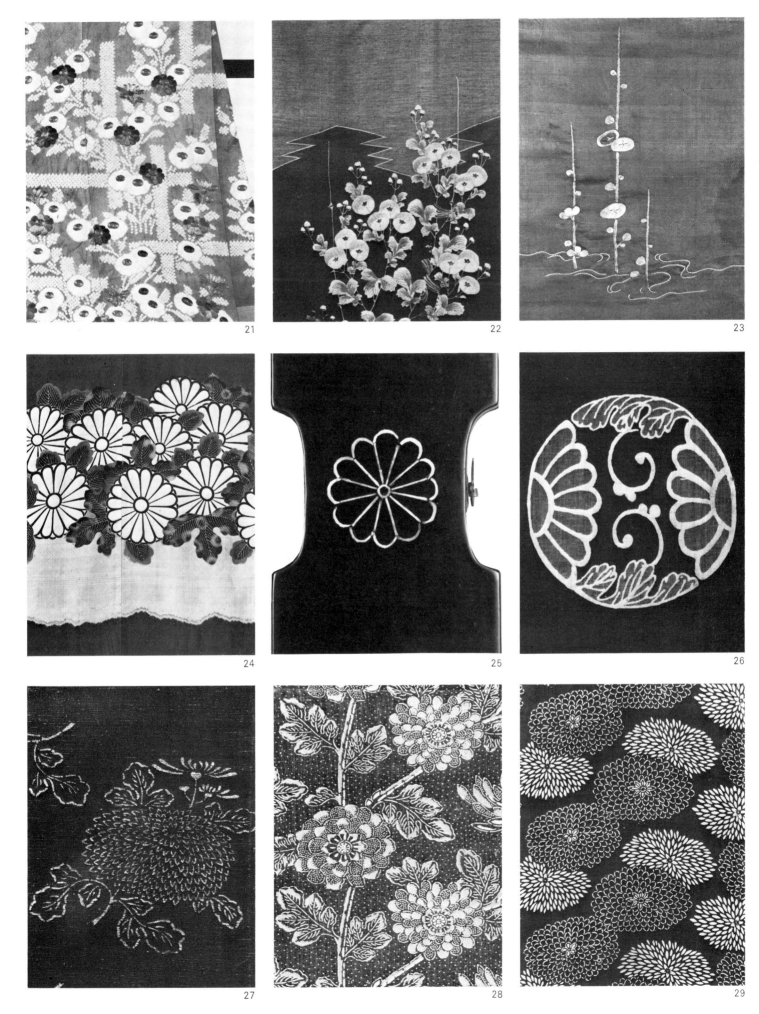

21

22

23

24

25

26

27

28

29

AUTUMN GRASSES

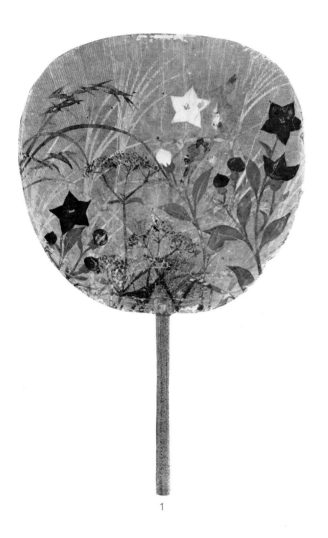

1

1 Round fan with design of Chinese bellflowers, bush clover, and miscanthuses
2 Flowering plant
3 Chinese bellflowers
4 Chinese bellflowers
5 Chinese bellflowers
6 Autumn flowering grasses
7 Chinese bellflowers
8 Chrysanthemums, wild pinks, bush clover, miscanthuses, and trailing clouds
9 Wild pinks
10 Chinese bellflowers beside rocks
11 Begonias against "cypress fence" diaper
12 Wild pinks
13 Wild pinks and pine needles
14 Bush clover and rabbit
15 Bush clover and overlapping lozenges
16 Bush clover
17 Bush clover beside bamboo fence
18 Bush clover and *Patrinia* plant beside stylized stream pattern
19 Bush clover, *Patrinia* plant, and miscanthuses
20 Chrysanthemums, bush clover, miscanthuses, and trailing haze
21 Bush clover
22 Bush clover and geometric patterns
23 Miscanthus
24 Robe with design of miscanthus with dewdrops
25 Underside of habiliment box with miscanthus design
26 Autumn grasses and paulownia crests
27 Miscanthuses and plovers in flight
28 Miscanthuses with dewdrops and cricket
29 Miscanthuses and chrysanthemums
30 Miscanthus, chrysanthemums, and butterflies
31 Autumn grasses and plovers in flight

2

3

4

5

6

7

8

9

10

11

12

13

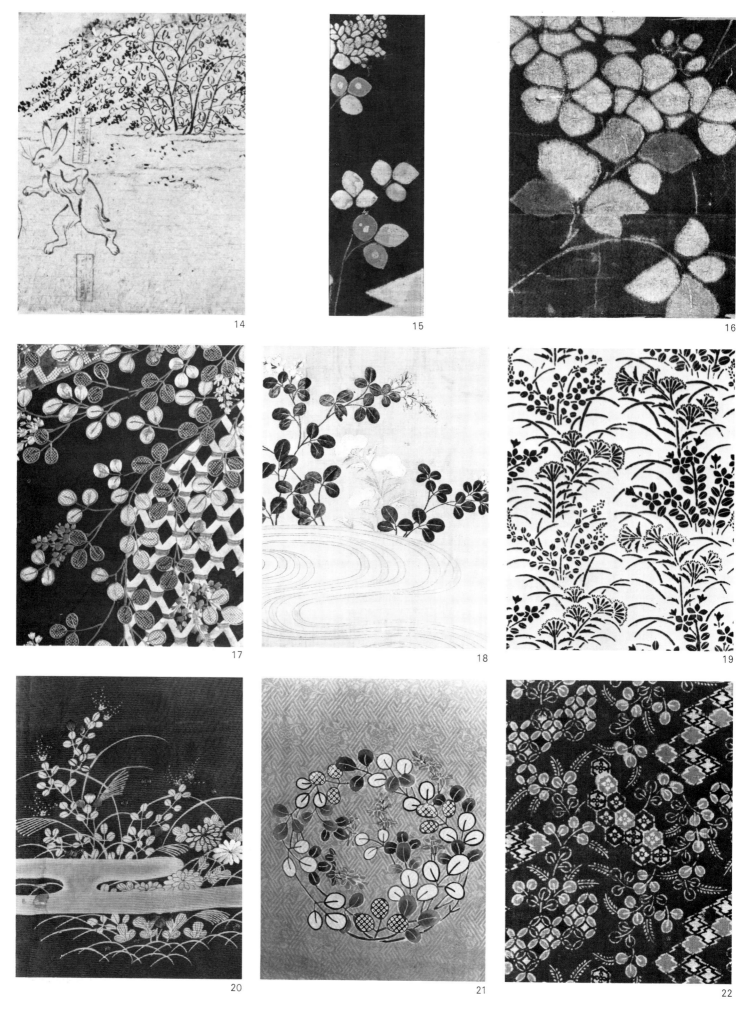

14

15

16

17

18

19

20

21

22

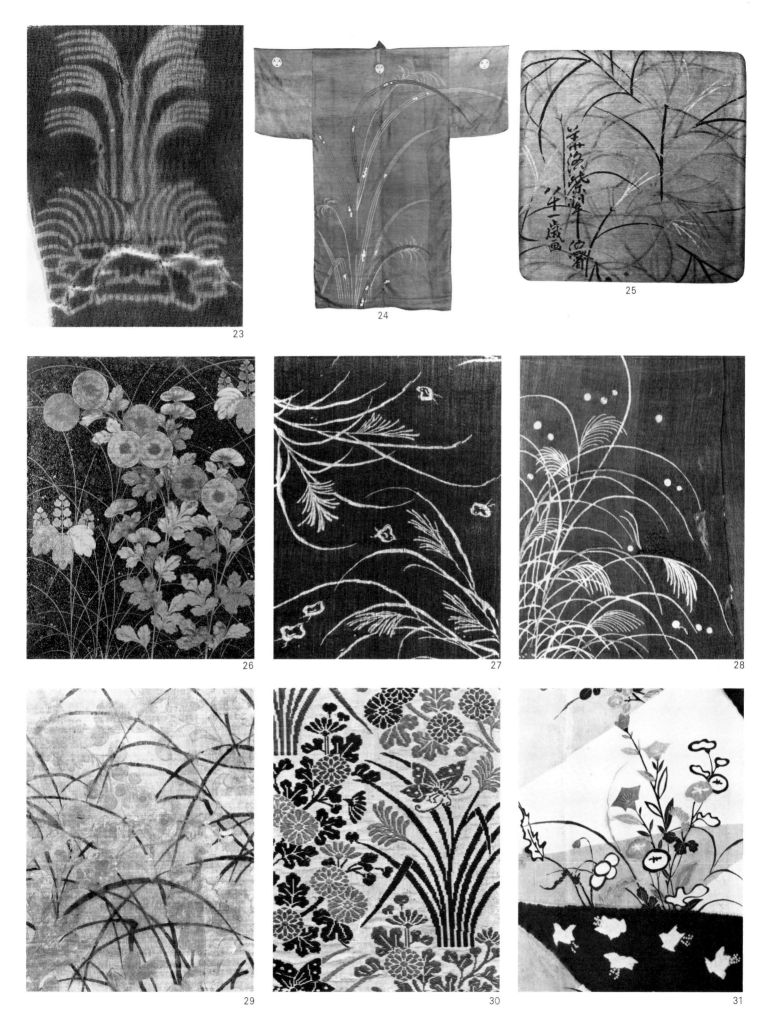

23

24

26

27

28

29

30

31

MAPLE LEAVES AND GINKGO LEAVES

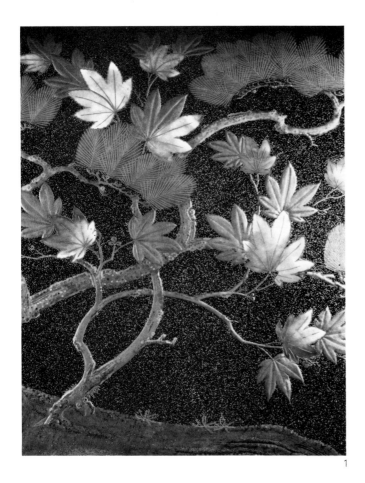

1 Maple and pine trees
2 Tea bowl with maple leaf design
3 Bottle with maple leaf design
4 Small plate with maple leaf design
5 Maple leaves against vertical serpentine lines
6 Maple leaves
7 Maple leaves against stripes
8 Maple trees
9 Maple branch fence and plum sprays
10 Maple leaves
11 Maple leaves and flowers
12 Maple leaves, chrysanthemum spray, and paving stone patterns
13 Ginkgo leaf crest
14 Ginkgo leaf roundel

1

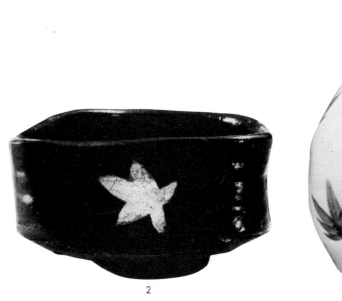

2

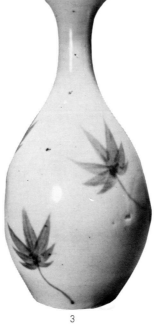

3

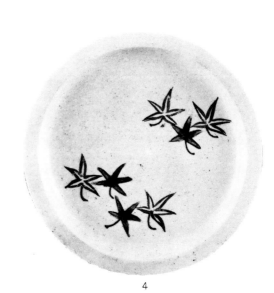

4

5

6

7

8

9

10

11

12

13

14

103

GRAPEVINES

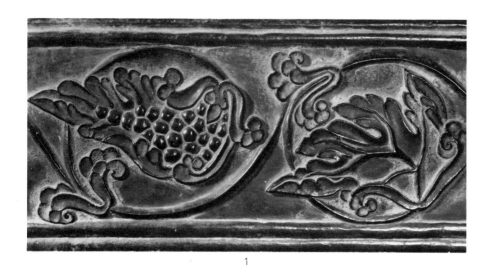

1

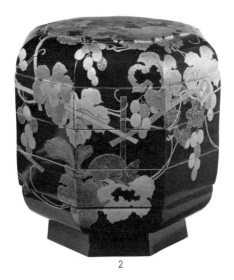

2

1 Grapevine
2 Tiered food box with design of grapevines and squirrels
3 Chest with grapevine design
4 Interior of the lid of cosmetic box with grapevine design
5 Grapevine and poetry card
6 Grapevine
7 Grapevine on bamboo fence
8 Water jar with design of grapevine on trellis
9 Bowl with grapevine design
10 Noodle sauce cup with grapevine design
11 Oil plate with grapevine design
12 Plate with design of grapevine on trellis
13 Plate with design of grapevine and butterfly

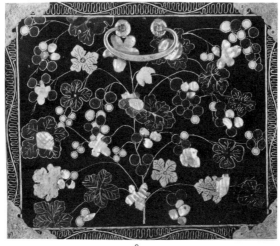

3

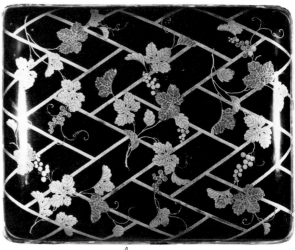

4

5

6

7

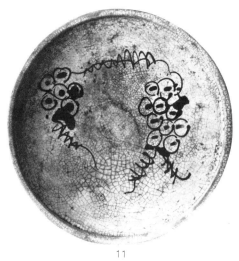

8

9

10

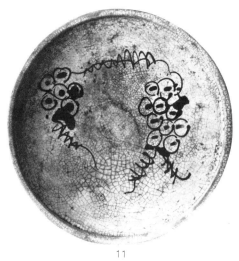

11

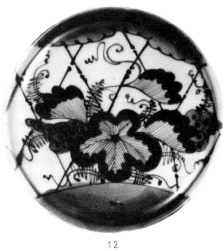

12

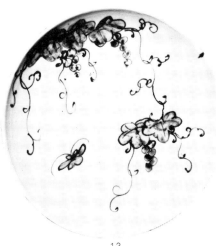

13

105

SCROLLING VINES

1

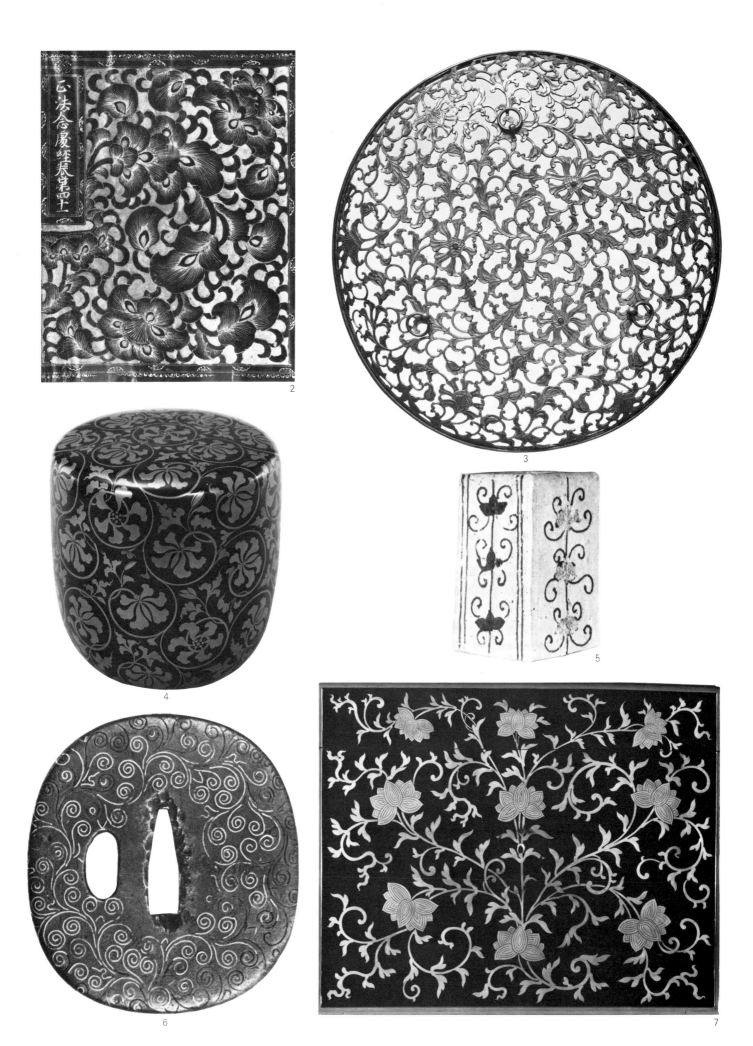

8

9

10

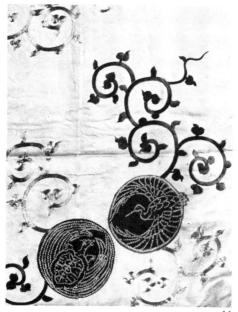

11

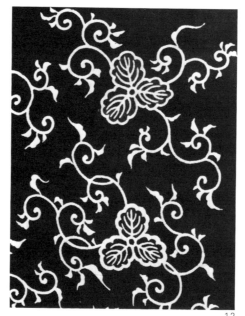

12

13

16

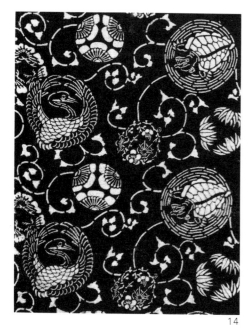

14

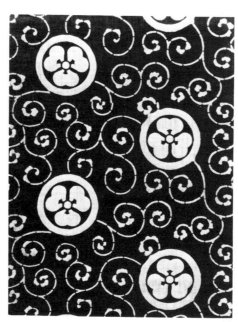

15

17

108

BAMBOO

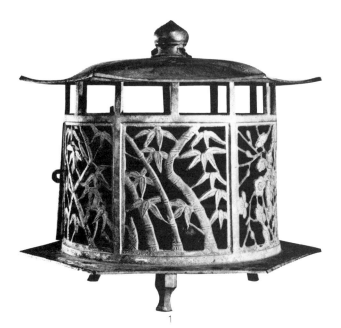

1

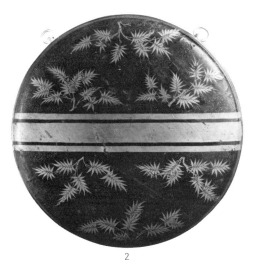

2

1 Hanging lantern with bamboo design
2 Mirror box with design of bamboo grass and stripes
3 Nō songbook cover with design of four bamboo stems
4 Bamboo, paulownias, and birds beside water
5 Large footed bowl with bamboo grass design
6 Jar with bamboo grass design
7 Rectangular dish with bamboo design
8 Bamboo leaves patterned with speckles and with flowers and half-submerged wheels
9 Pine, bamboo, plum, and crane
10 Bamboo and diaper of squares
11 Bamboo, plum sprays, swallows, and moored boat
12 Bamboo and plum branches against overlapping lozenges
13 Bamboo sprays
14 Oblique bamboo stems and thin bamboo stripes
15 Bamboo, lattice windows, broken bamboo fences, and plum sprays
16 Snow-covered bamboo grass and plum blossoms
17 Bamboo grass and tiger
18 Pine, bamboo, and plum combination
19 Bamboo stems and overlaid measuring boxes
20 Bamboo stem, bamboo shoot, hat, and hoe against stripes
21 Rounded bamboo pattern
22 Interlocking squares and octagons, snow-covered bush bamboo, and sparrows
23 Bamboo stripes

3

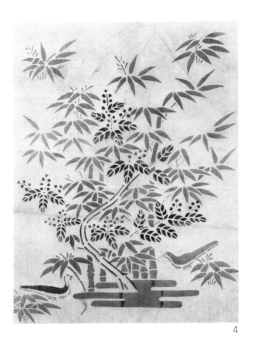

4

5

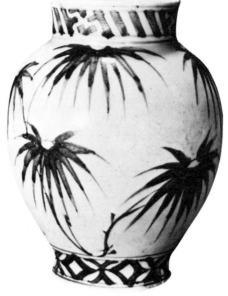

6

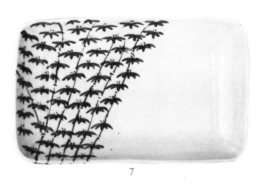

7

8

9

10

11

12

13

14

15

16

17

18

19

20

21

22

23

PINE TREES

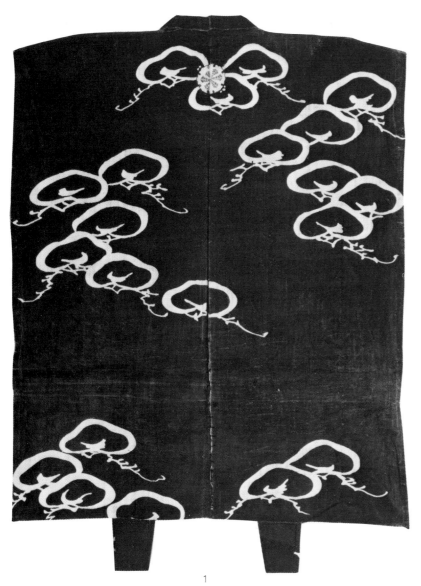

1

1 Kyōgen robe with design of pine trees
2 Crest with pine tree having three branches in a stylized composition
3 Noodle sauce cup with design of pine tree and sky
4 Sword guard with pine tree design
5 Pine trees, lozenges of paired cranes, and tortoise-shell diaper in bands
6 Pine trees with nesting cranes and tortoise
7 Pine tree, cranes, tortoise, and "scattered treasures"
8 Pine tree and cloud roundel
9 Pine trees by the sea and bridge
10 Pine trees by the sea and summer plants
11 Pine trees and bamboo
12 Fan with pine shoots, and drooping cherry blossoms
13 Fan with pine trees beside brushwood fence, and drooping cherry blossoms
14 Pine, bamboo, and plum combination
15 Pine trees and chrysanthemums
16 Pine tree, plum branches, and cranes flying in clouds
17 Pine branches, pine shoots, and plum spray
18 Pine shoots and interlocking "seven jewels" diaper
19 Pine shoots on mountains
20 Uprooted pine shoots and folded-paper cranes
21 Scattered pine needles and overlapping lozenges
22 Pine cones and needles
23 Pine needles and cherry blossoms
24 Broken pine needle and plum blossom
25 Scattered pine needles
26 Old pine trees and sacred Buddhist gems
27 Pines and geometric patterns
28 Pine, bamboo, and plum combinations

2

3

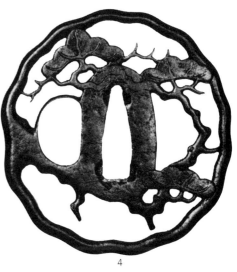

4

5

6

7

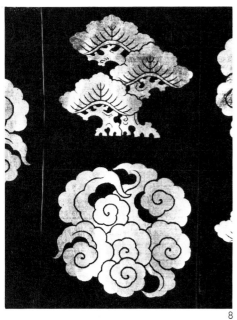

8

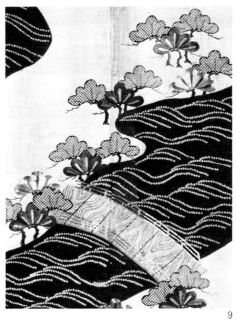

9

10

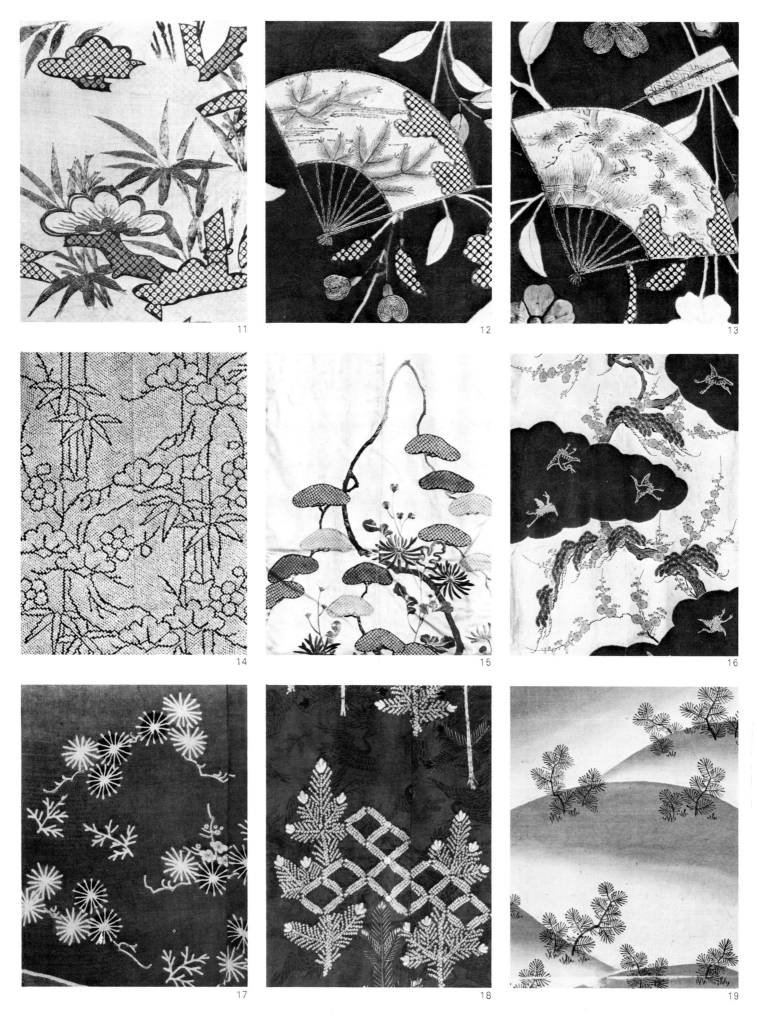

11

12

13

14

15

16

17

18

19

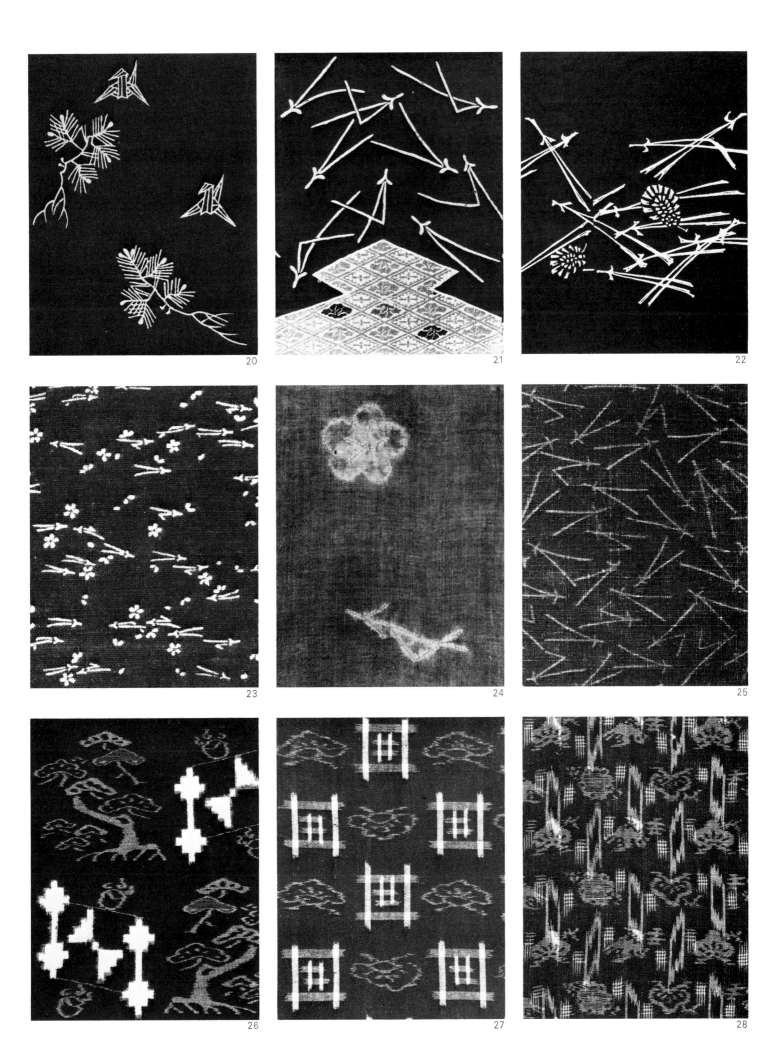

BIRDS AND INSECTS

1 Crane eating fishes
2 Camellias and cranes
3 Sword guard with rounded crane design
4 Crane roundel
5 Cranes and various plants
6 Crane with pine shoot in its mouth
7 Lozenges of paired cranes against tortoise-shell diaper
8 (upper) Crane against bamboo leaves; (lower) crane against pine, bamboo, and plum trees
9 Crane, pine, and plum sprays
10 Crane, the characters meaning "a thousand years," and a geometric pattern
11 Alighting wild geese
12 Geese and Chinese bellflowers
13 Flying geese
14 Two herons
15 Herons and willow branches
16 Birds and drooping cherry branches
17 Swallows and waterfall
18 Flying birds and drooping cherry branches
19 Stylized swallow pattern
20 Sword guard with design of swallows and willow tree
21 Long-tailed bird against netting diaper
22 Birds and thistles
23 Sparrows and drying nets
24 Cock, bundles of rice seedlings, and chrysanthemums
25 Sparrows, drooping cherry blossoms, and incense emblems
26 Sparrow in bamboo roundel
27 Hawk on a pine branch and geometric patterns
28 Sparrow against lattice ground
29 Praying mantis, a cricket, chrysanthemums, and autumn grasses
30 Sword guard with design of crickets and autumn grasses
31 Dragonflies

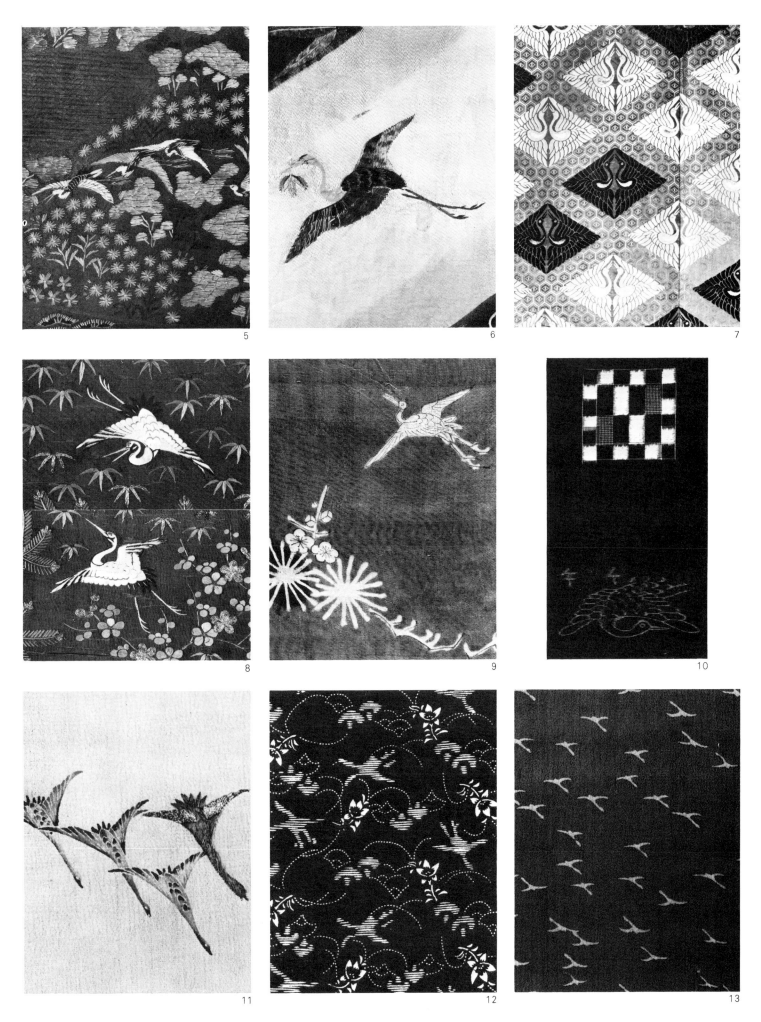

5 6 7

8 9 10

11 12 13

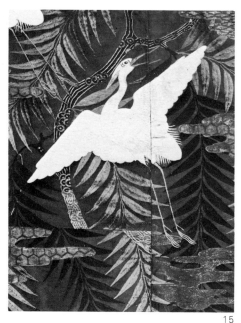

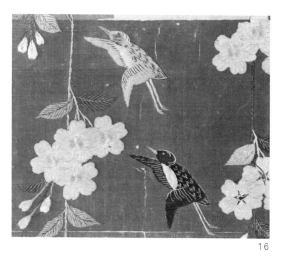

14

15

16

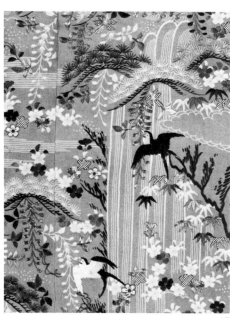

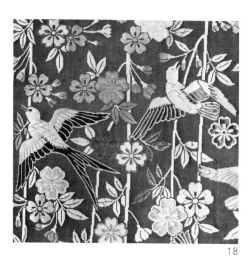

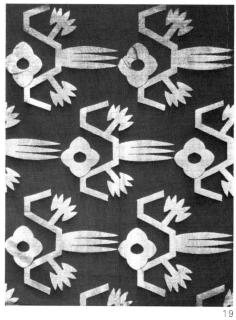

17

18

19

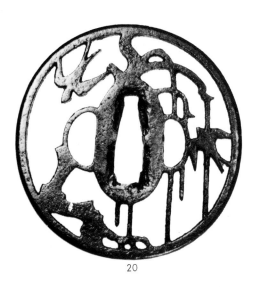

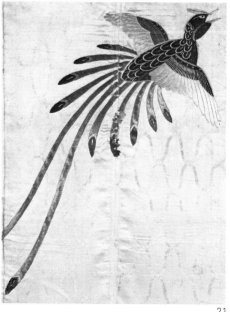

20

21

22

118

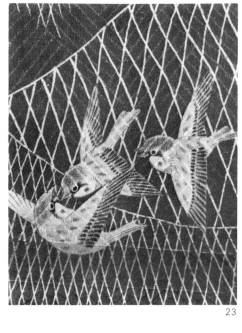

23

24

25

26

27

28

29

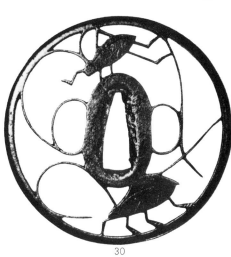

30

31

119

MANDARIN DUCKS AND PLOVERS

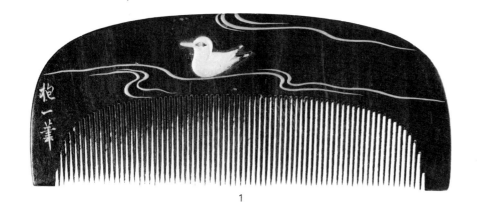

1

1 Comb with mandarin duck in winding stream
2 Mandarin ducks in stream
3 Mandarin ducks in stream
4 Plovers, rocks, and bamboo leaves
5 Plovers
6 Interior of the lid of inkstone box with design of plovers in flight
7 Plovers and streams
8 Plovers in flight
9 Dish with design of plovers in flight and wave
10 Plovers in flight, reeds, and waves
11 Kyōgen robe with design of plovers in flight and wave
12 Sequence of stylized plovers

2

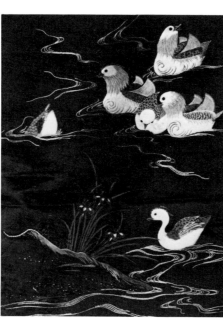

3

4

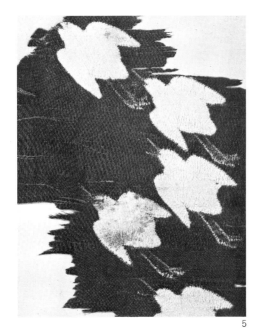

5

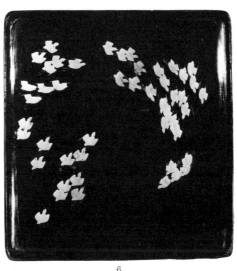

6

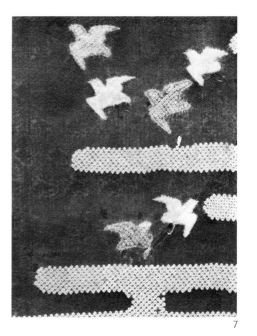

7

8

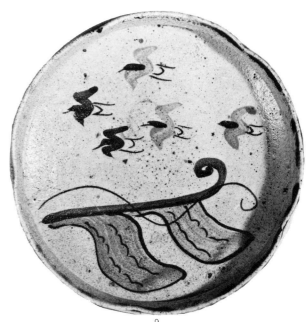

9

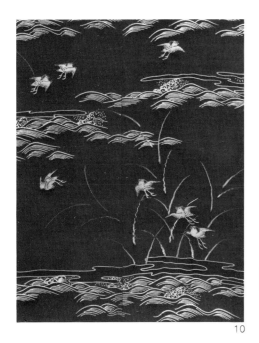

10

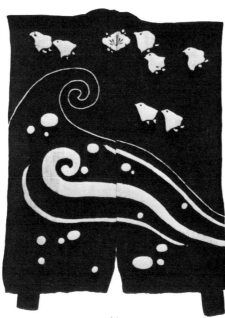

11

12

121

BUTTERFLIES

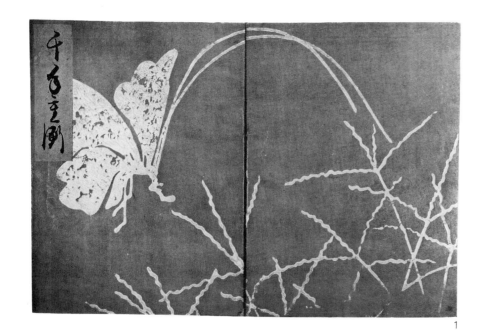

1

1 *Saga-bon* Nō songbook with design of butterfly and grasses
2 Ornament in butterfly shape
3 Swallowtail butterfly
4 Swallowtail butterfly in a circle with plum blossom spray
5 Butterflies and chrysanthemum sprays
6 Butterfly against chrysanthemum sprays
7 Butterflies, Japanese harp, miscanthuses, and bridge struts
8 Foliate dish with butterfly design
9 *Saga-bon* Nō songbook with butterfly design
10 Butterflies, clams, and revolving "commas" (*tomoe*) and lattice pattern in horizontal bands
11 Butterflies
12 Butterflies and interlocking squares and octagons
13 Butterflies

2

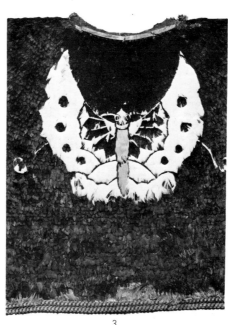

3

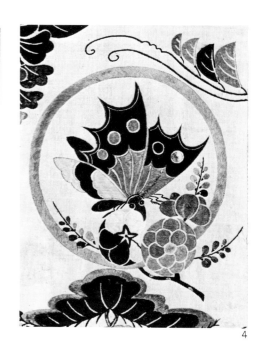

4

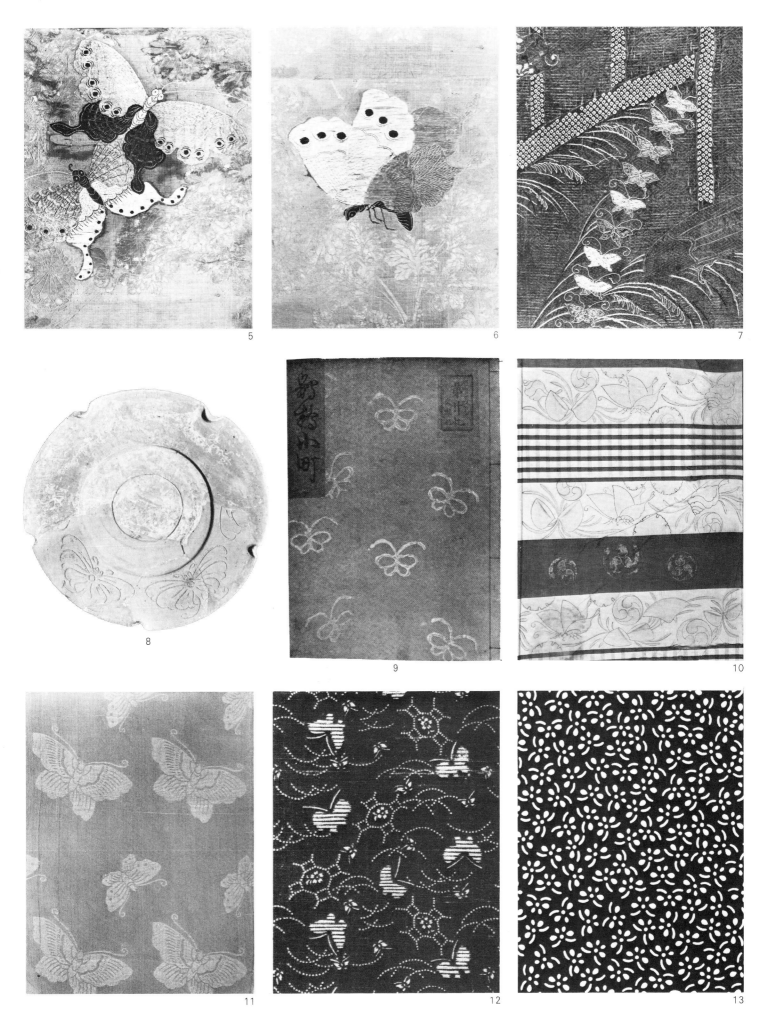

MYTHICAL BEASTS, TORTOISES, AND LIONS

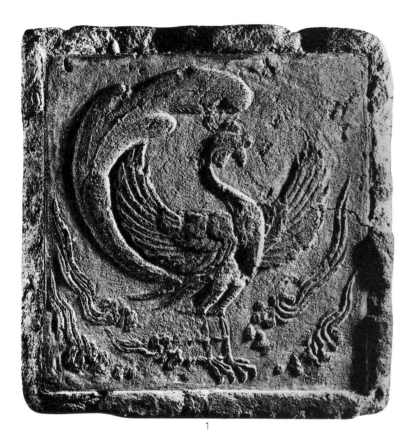

1

1 Ornamental tile with phoenix design
2 Phoenix roof ornament
3 Box with design of phoenixes and honeysuckle
4 Phoenix and floral scrolling vine
5 Nimbus from an image of a bodhisattva with design of phoenix, clouds, and floral scrolling vine
6 Fragment of crown in the shape of phoenix
7 Phoenix
8 Phoenix against hollyhock pattern
9 Crossing diagonal lines enclosing two phoenixes
10 Phoenix and paulownia
11 Phoenix, flowering tree, and clouds in oblique bands
12 Mirror back with design of tortoise, two cranes, and cherry tree on the shore
13 Mirror back with design of two cranes bearing pine branches, tortoise, and fishes in the water
14 Mirror back with tortoise, paulownia sprays, and bamboo
15 Tortoise, pine trees, and bamboo grass in zigzag band
16 Tortoise and two cranes against swastika diaper
17 Roundels of tortoise and crane against scrolling vines
18 Bowl with design of tortoise and crane
19 Plate with design of tortoise and stream
20 Tortoises
21, 22 Chinese lions
23 Mirror back with Chinese lion, peonies, butterflies, and birds
24 Chinese lions against concentric lozenge diaper
25 Votive board with design of Chinese lion and peony
26 Kylin and clouds
27 Sutra box with design of clouds and dragons
28 Dragon roundels
29 Stylized dragons

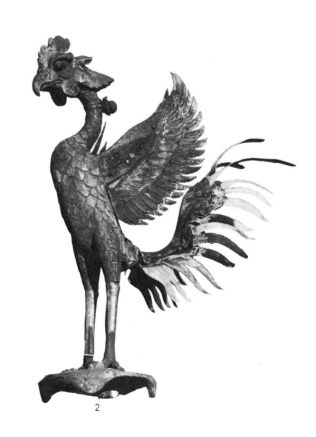

2

124

3

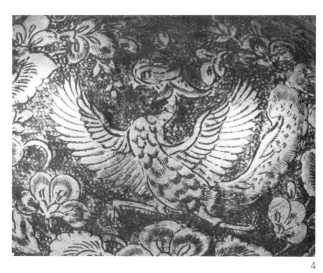

4

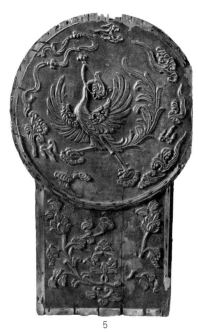

5

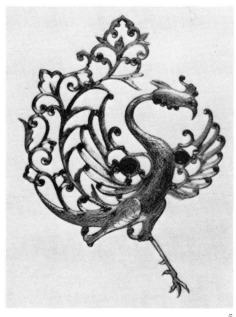

6

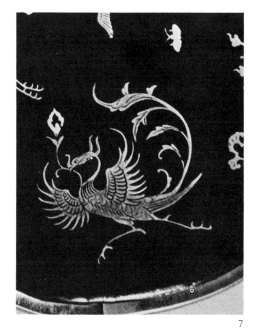

7

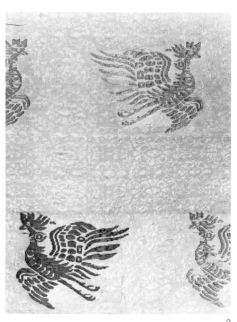

8

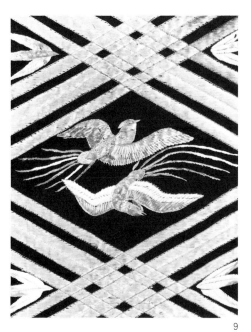

9

10

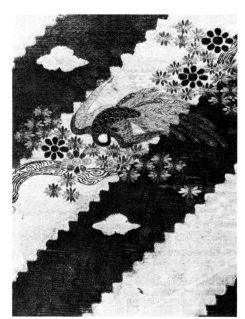

11

125

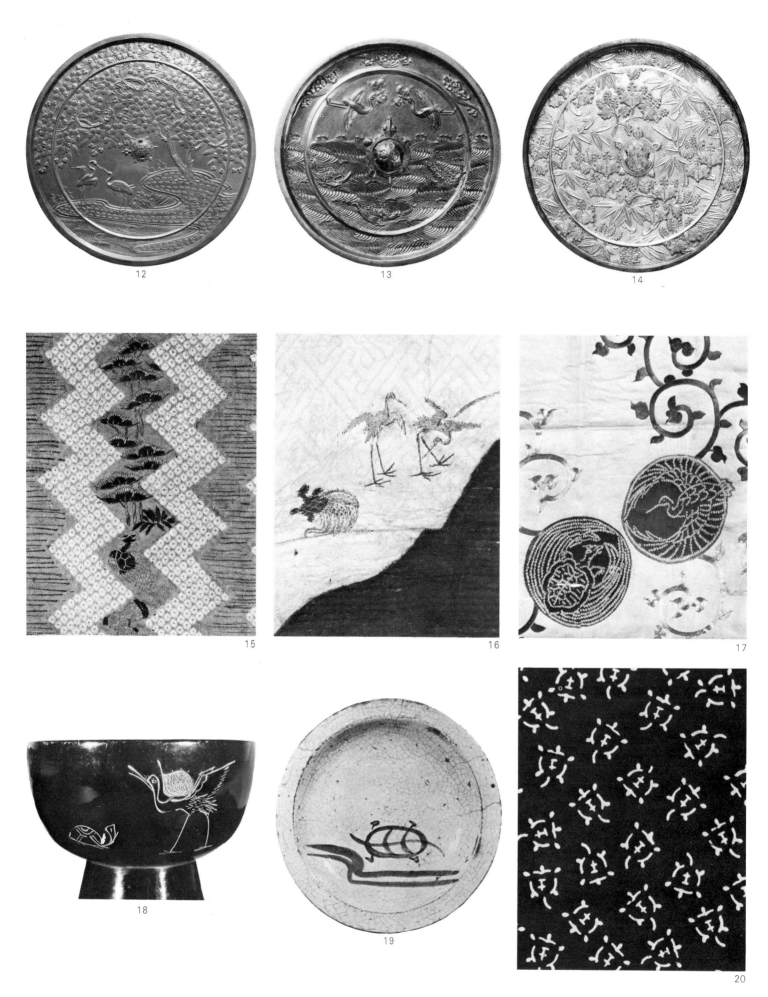

12

13

14

15

16

17

18

19

20

21

22

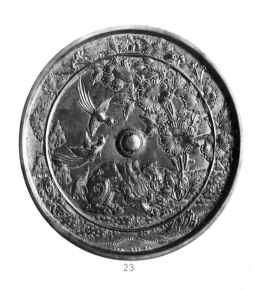

23

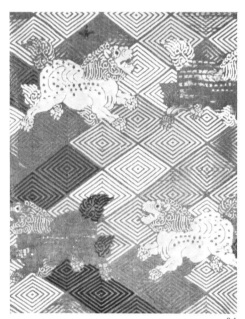

24

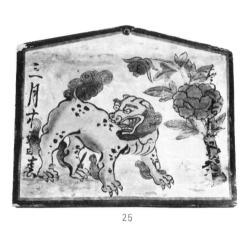

25

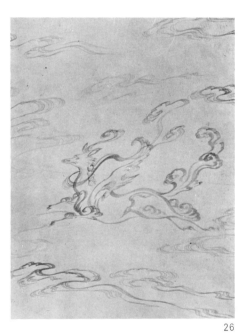

26

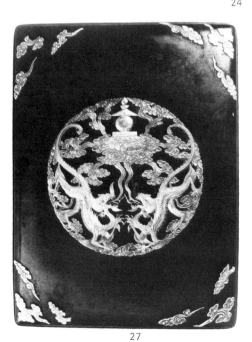

27

28

29

ANIMALS

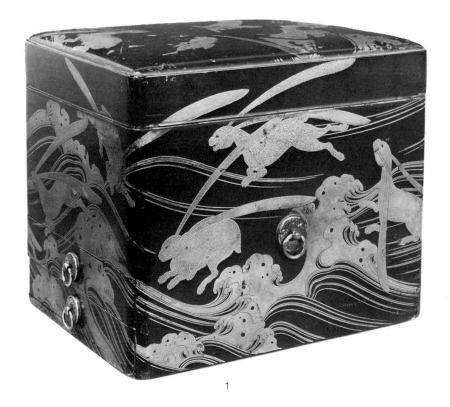

1

1 Cosmetic box with design of hare jumping over waves
2 Hare jumping over waves
3 Hare and waves
4 Hare and miscanthuses
5 Horse and spring grasses
6, 7 Horses
8 Two deer and tree
9 Hanging lantern with design of deer and maple trees
10 Sword guard with design of deer and autumn grasses
11 Deer, insect, chrysanthemums, and maple trees
12 Deer, insects, and trailing clouds
13 Deer and man drawing bow
14 Tiered food box with design of squirrels and grapevines
15 Dogs, dandelions, violets, and spring grasses
16 Wild boar surrounded by dogs and a man drawing a bow
17 Monkey
18 Rice-planting scene
19 Roundels of two tigers
20 Tiger, sparrows, bamboo, and lattice
21 Tiger and bamboo

2

3

4

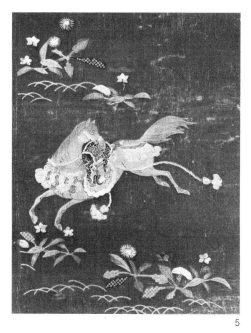

5

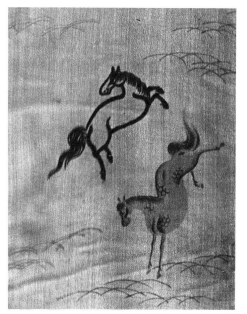

6

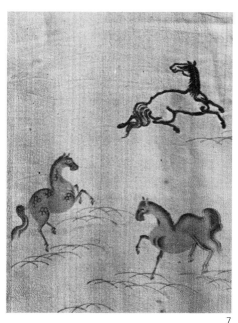

7

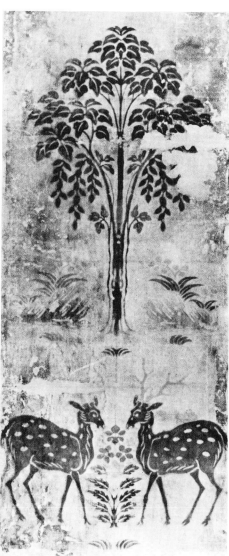

8

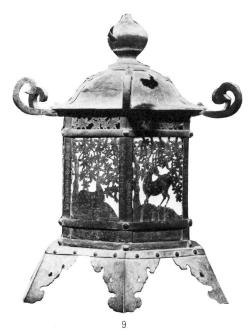

9

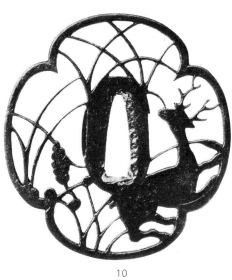

10

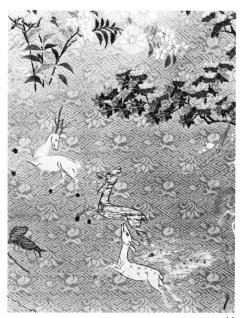

11

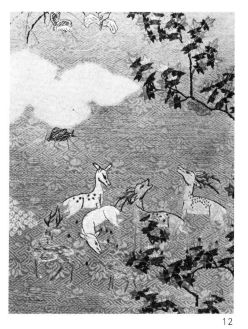

12

13

14

15

16

17

18

19

20

21

HUMAN BEINGS

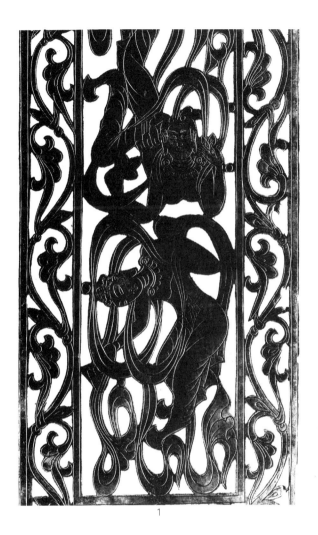

1 Apsaras and scrolling honeysuckle
2 Scene with people running after flying storehouse
3 Scene with people and carriages
4 Musicians in boat
5 Poets
6 Watchmen at festival
7 Dancing girl
8 Rice planting
9 Chinese child holding flowers
10 People dancing on a fishermen's festival day
11 Ch'in Kao astride a carp
12 Otafuku (smiling chubby woman symbolic of happiness) and geometric patterns
13 Sake cup with design of Dutchmen
14 Oil plate with design of man on bridge and seagulls
15 Square bottle with design of beautiful girl looking at a garden
16 Vase with design of Dutchmen
17 Plate with design of old man holding a broom and the inscription "an easy life in retirement: eleven grandchildren"
18 Plate with design of comedian
19 Plate with design of man hunting wild boar
20 Plate with design of woman taking the first bath of the New Year
21 Plate with design of rustic figure, rice field, and fence
22 Oil plate with design of oil seller with sunshade and pole

4

5

6

7

8

9

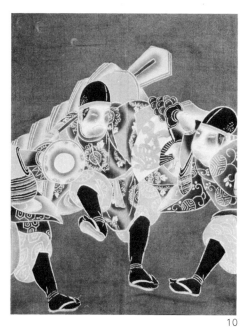

10

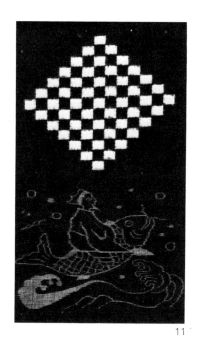

11

12

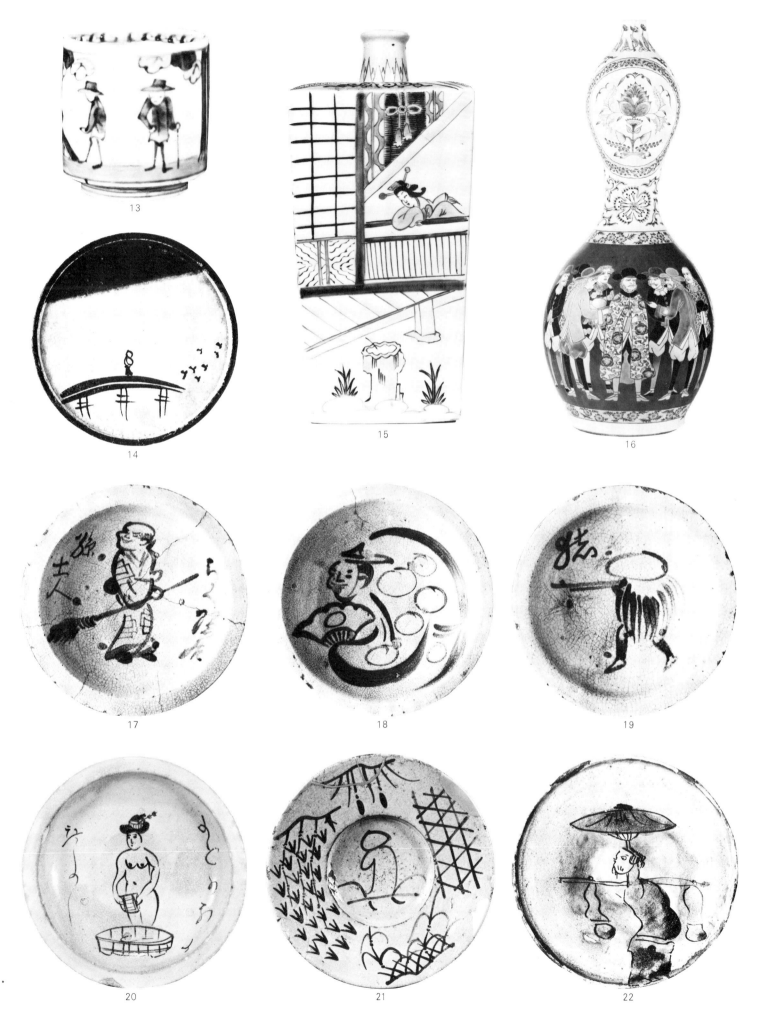

13

14

15

16

17

18

19

20

21

22

LANDSCAPES

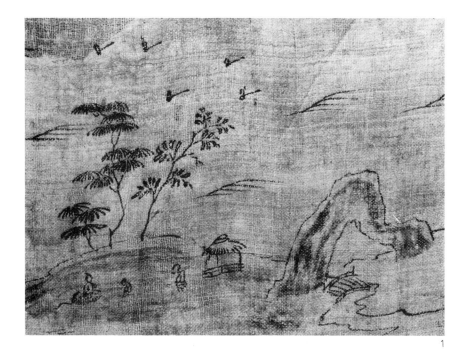

1

2

3

1 Trees and figures beside a hut
2 Quiver with design of rocks, bamboo leaves, plovers, and wild geese, bordered by floral scrolling vines and butterflies
3 Writing box with design of boat among reeds and plovers
4 *Saga-bon* Nō songbook with design of moon and mountains with pine trees
5 *Saga-bon* Nō songbook with design of pebble-filled embankment basket and waves
6 Sword guard with design of country house
7 Sword guard with design of bridge, wild geese, and sailboat on waves
8 Dish with design of two cows, tall buildings, and mountains covered with cherry trees
9 Oil plate with design of sparrows in flight, stacked rice sheaves, and clappers to frighten sparrows away
10 Noodle sauce cup with sailboat design
11 Waterfalls and two ducks among mountains covered with camellia trees
12 Houses with hoist, mountains, pine trees, and cherry blossoms against overlapping lozenges
13 Smoking volcano and flocks of wild geese
14 Mountains, pine tree, miscanthuses, and birds in flight
15 Plum blossoms on overlapping mountains
16 Trailing haze in the shape of overlapping lozenges, mountain, cranes, and cherry and plum blossoms
17 Mountains, pine trees, bridge, and waterfall
18 Eight-plank bridge and winding streams
19 Eight-plank bridge with flowers
20 Eight-plank bridge, rocks, irises, hollyhocks, and various other plants
21 View of the Uji river
22 Eight-plank bridge, irises in stream, and overlapping lozenges
23 A famous scenic spot
24 View of Kiyomizu Temple
25 Waterside scene
26 Flowering plant, waterfall, and cottage
27 Tea hut among bamboo
28 Country houses
29 Wave crests and fishnet
30 Fishnets drying on cherry tree and wave crests
31 Pebble-filled embankment baskets in water and cherry blossom
32 Pebble-filled embankment baskets in water
33 Drying fishnets
34 Drying fishnet and sparrows
35 Cranes, clouds, plants, and seashore
36 Drying fishnets, waves, and plovers in flight
37 Waterside scene
38 Boats and maple sprays
39 Sailboat among reeds and streams
40 Sailboat, wave crests, and plum sprays
41 Pine trees beside water, sailboats, and plovers in flight
42 Sailboats on waves
43 Rocky mountain and moored boats
44 Shinto shrine gate and autumn grasses
45 Castle, pine trees, plum trees, and wild geese
46 Town scene, bridges, sailboats, and zigzag bands

4

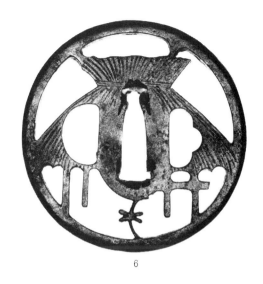

6

5

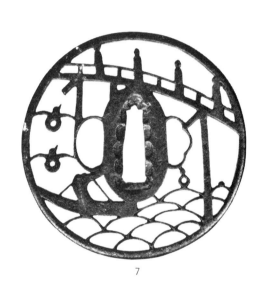

7

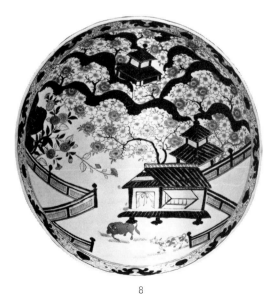

8

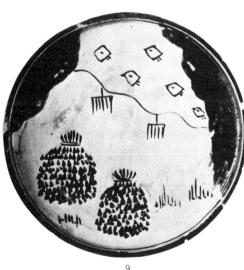

9

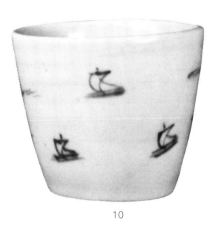

10

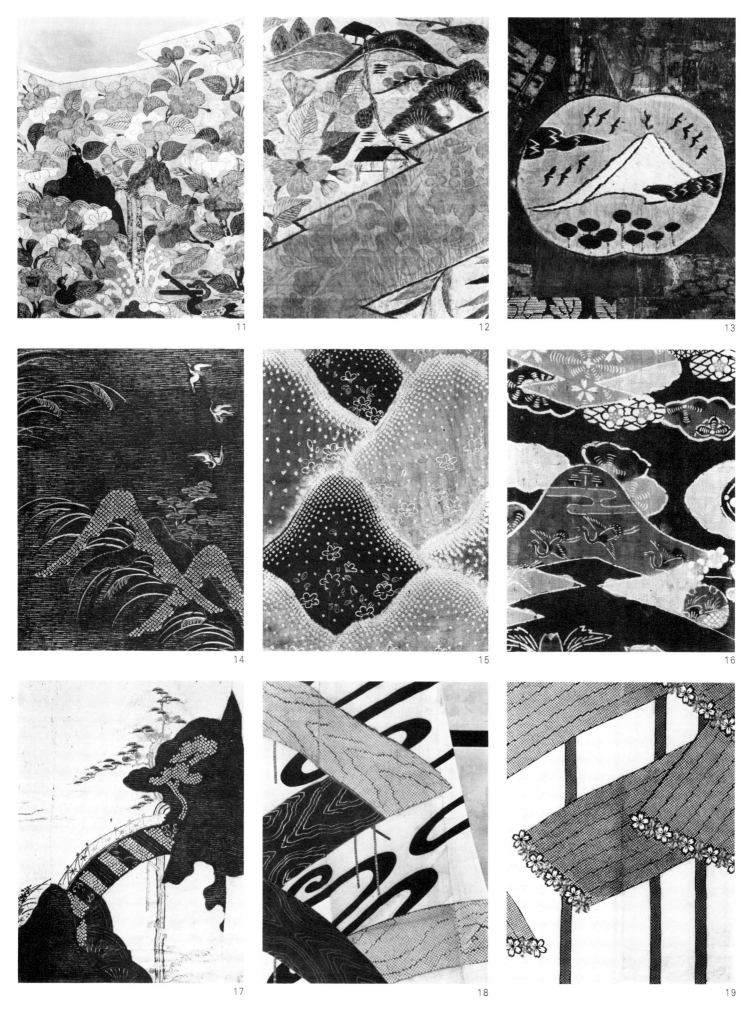

11

12

13

14

15

16

17

18

19

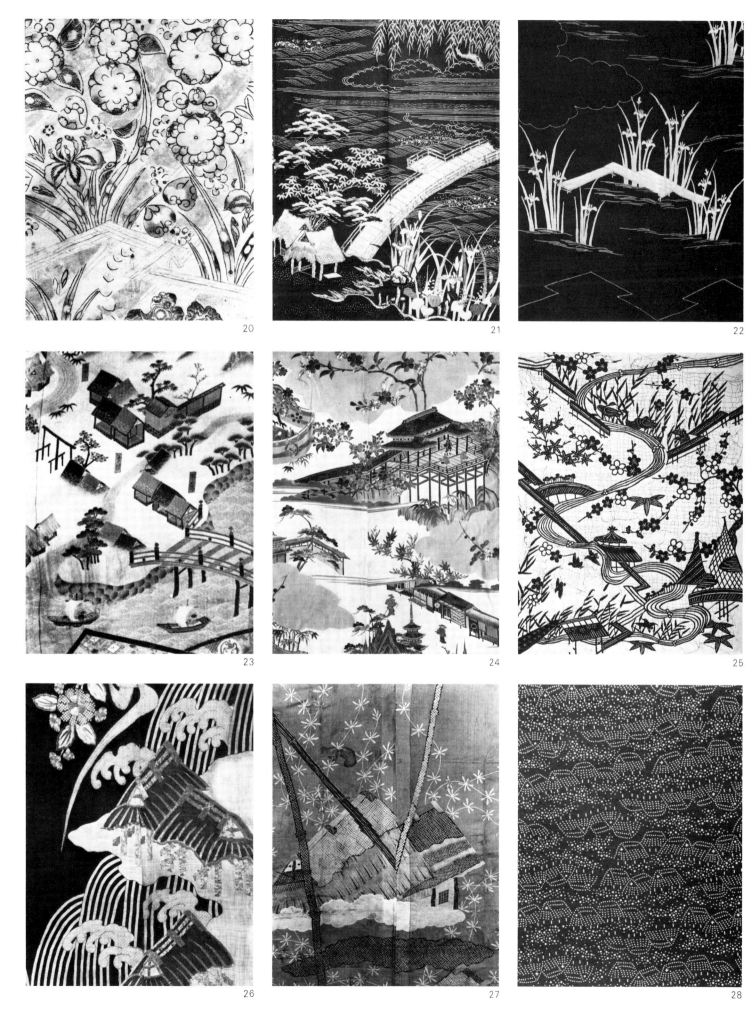

20

21

22

23

24

25

26

27

28

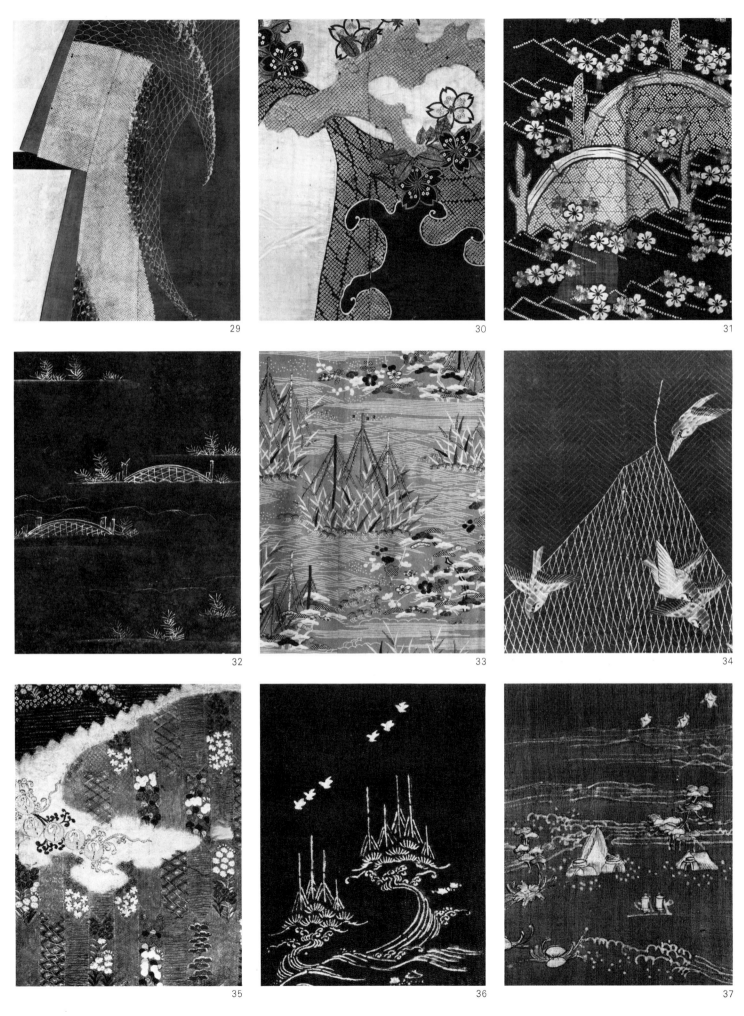

29

30

31

32

33

34

35

36

37

38

39

40

41

42

43

44

45

46

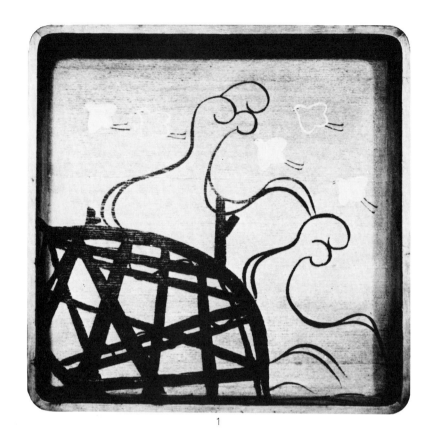

1

1 Interior of habiliment box with design of pebble-filled embankment baskets, wave crests, and plovers in flight
2 Small dish with design of waterplants and waves
3 Waves
4 Wave patterns
5 Waves
6 Waterfall, drops of water, and cherry blossom
7 Wave crests and chrysanthemums
8 Wave crests against bridge supports
9 Waterfalls and floral scrolls
10 Running water and chrysanthemums
11 Stylized stream patterns and bush clover
12 Stylized stream patterns and cherry blossom
13 Stream and orchids
14 Wave crests and bits of foam
15 Wave crests, reeds, and pines
16 Stream and plants
17 Chrysanthemums in semicircular wave pattern
18 Semicircular wave pattern
19 Semicircular waves and sailboats
20 Pine trees by the sea
21 Stream and bush clover
22 Stream, fan, and cherry sprays
23 Foaming waves, rocks, and plovers
24 Waves
25 Streams, half-submerged wheels, reeds, maple leaves, cherry blossoms, and cranes
26 Stream and clematis flowers
27 Winding stream, cherry and plum blossoms, and trailing haze in the shape of overlapping lozenges
28 Rising waves, cherry blossoms, and plovers

2

3

4

5

6

7

9

10

8

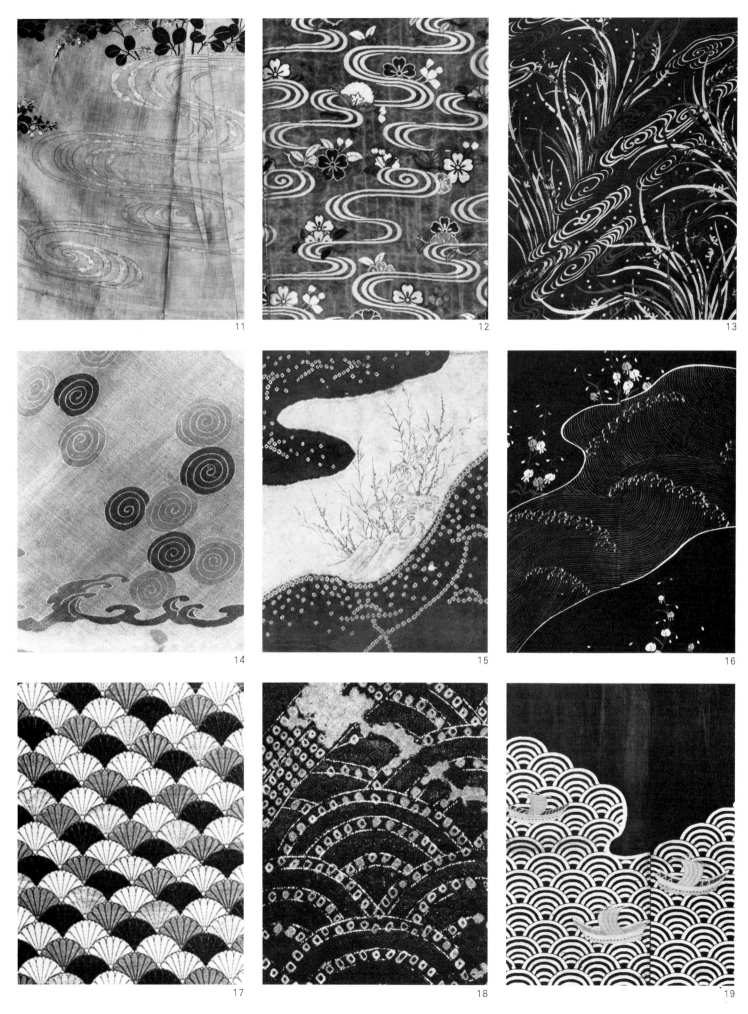

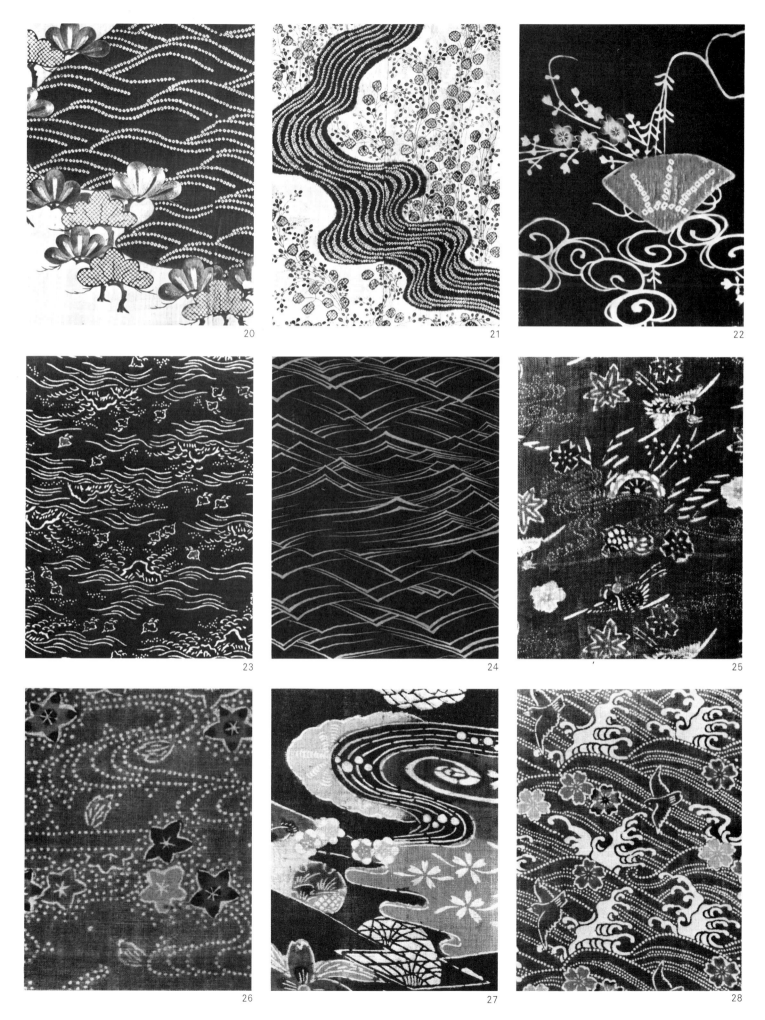

20

21

22

23

24

25

26

27

28

METEOROLOGICAL PHENOMENA

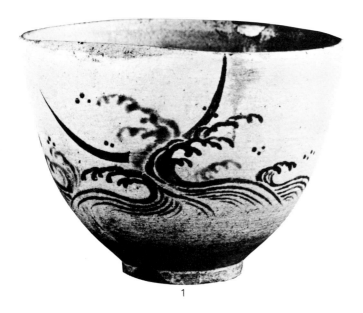

1

1 Tea bowl with design of crescent moon and wave crests
2 Tea bowl with design of moon and miscanthuses
3 Clouds
4 Cloud crest
5 Trailing clouds, pine trees, grapevines, and various other plants
6 Clouds and sandbars with plants
7 Trailing clouds
8 Trailing haze, pines, and crane
9 Dewdrops on miscanthus leaves
10 Dewdrops on lotus leaves
11 Grass with dewdrops
12 Side of sutra box with rain design
13 Rain, umbrellas, and cherry blossoms
14 Snow crystal roundels enclosing flowers
15 Snow crystal, bamboo leaves laden with snow, and bamboo shoots
16 Crest with design of snow on bamboo leaves
17 Kyōgen robe with design of bamboo leaves laden with snow
18 Trailing haze, cranes, and plants
19 Trailing haze and ferns
20 Trailing haze, pine trees, and other plants

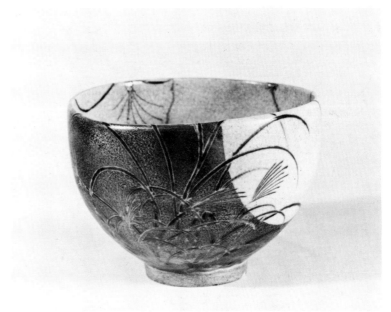

2

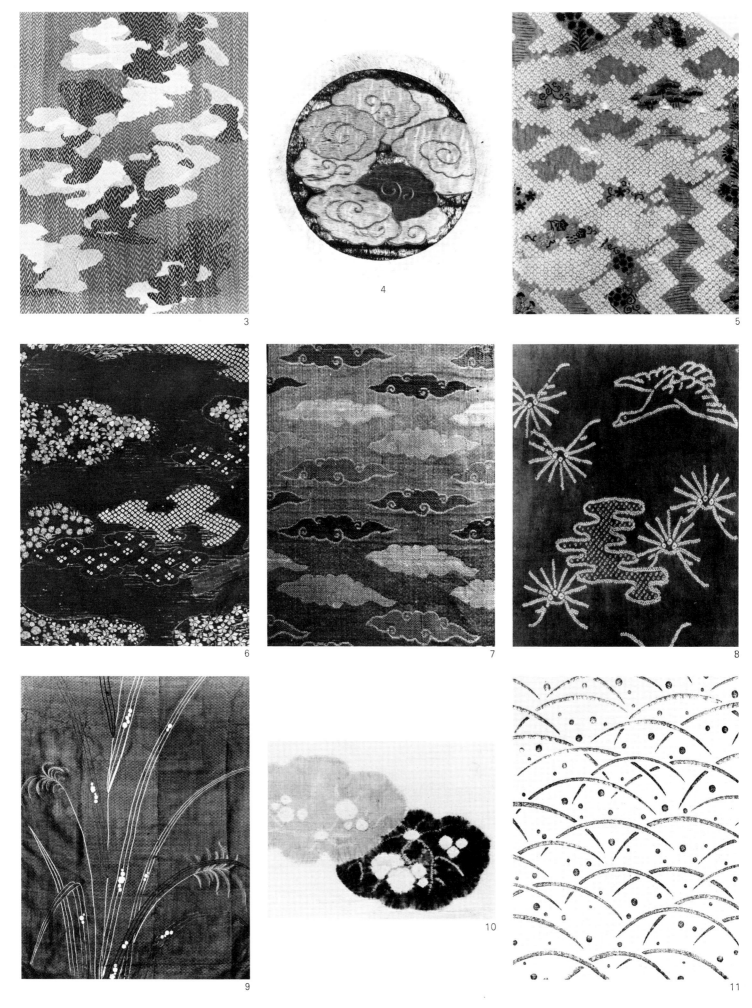

3

4

5

6

7

8

9

10

11

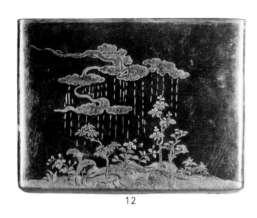

12

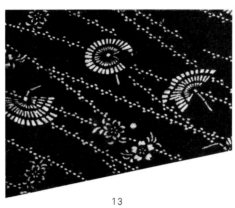

13

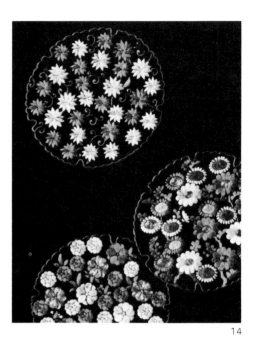

14

15

16

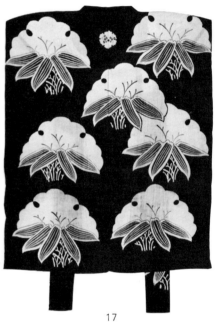

17

18

19

20

FANS

1

1 Cosmetic box with design of circles formed by three cypress fans
2 Open fans and scrolling vines
3 Circle composed of three open fans, with clematises
4 Roundel of three open fans composed of cherry blossoms
5 Scattered open fans
6 Fan papers with bamboo design against overlapping lozenge diaper and concentric lozenges
7 Folding fan, wood sorrel, and autumn grasses
8 Folding fans with design of cherry blossoms and wild pinks
9 Open and closed fans against drooping cherry branches
10 Folding fans and plum sprays
11 Folding fan with design of the sun
12 Fan-shaped dish with design of scattered crests
13 Dish with design of two folding fans
14 Cypress fans and plum tree
15 Cypress fan and cherry sprays
16 Cypress fans and hollyhock scrolls
17 Folding fans against rope pattern
18 Sequences of folding fans
19 Folding fans and "seven jewels" diaper
20 Round fan, cricket, and miscanthuses
21 Round fans, toys, and flowers against stripes
22 Folding and round fans, autumn grasses, and plovers

2

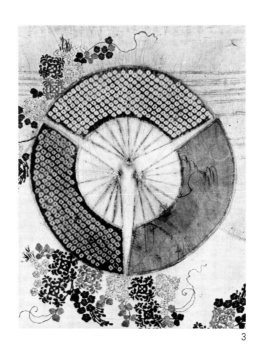

3

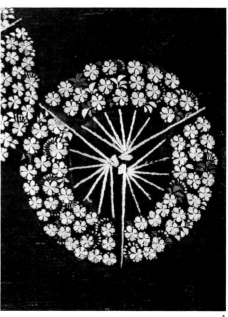

4

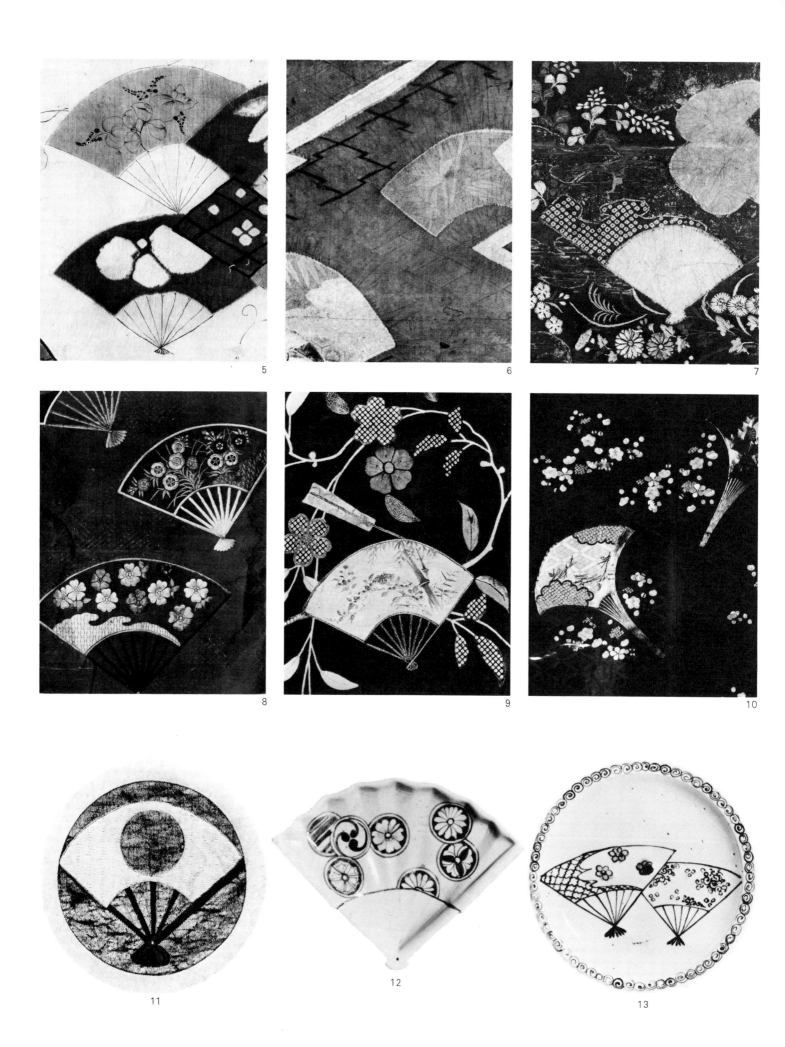

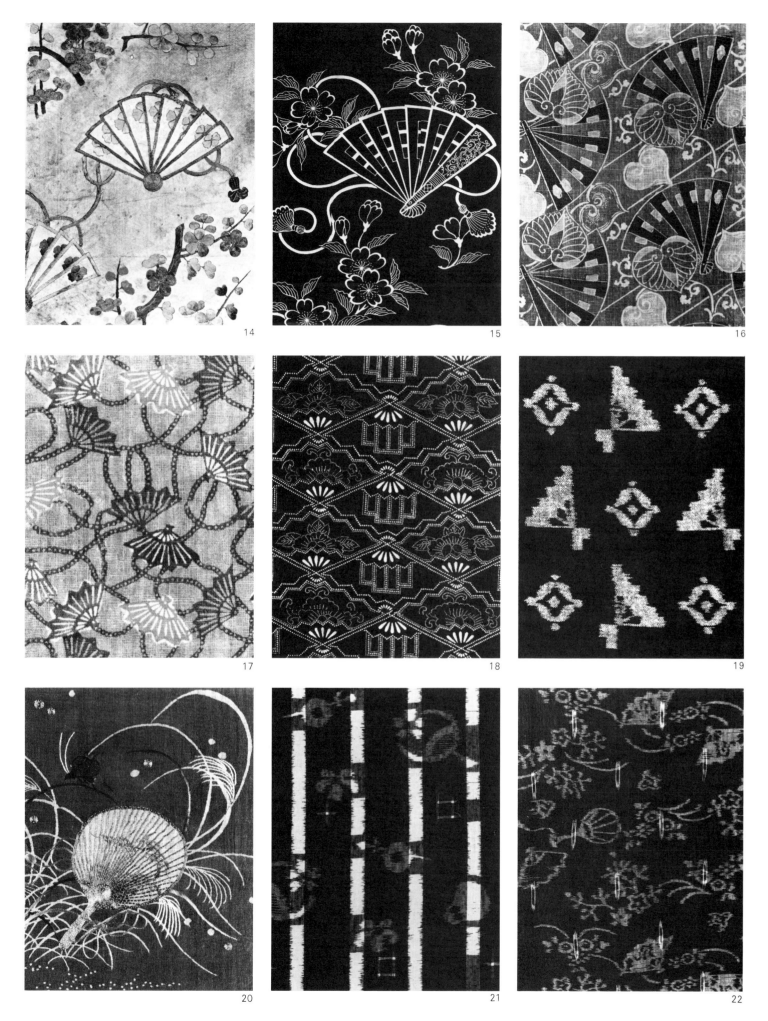

14

15

16

17

18

19

20

21

22

149

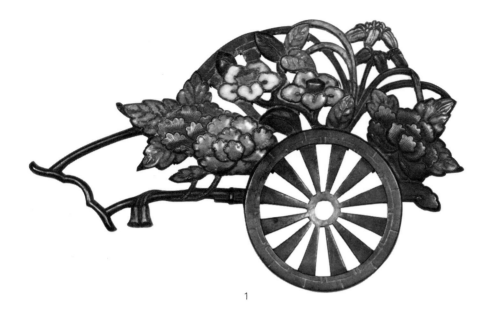

1

1 Nail concealer in the shape of cart filled with flowers
2 Court carriage, fence, wild geese, and haze
3 Court carriages and lilies against vertical serpentine lines
4 Court carriages and drooping cherry branches
5 Carriages
6 Overlapping wheels against checker pattern
7 Waterwheels
8 Half-submerged wheels
9 Half-submerged wheels
10 Cart laden with flowers beside willow tree
11 Court carriages, pine trees, and fence
12 Cart laden with chrysanthemums and irises, butterfly, and autumn grasses
13 Court carriage beside rocks, drying fishnets, pine and plum trees, and bamboo

2

3

4

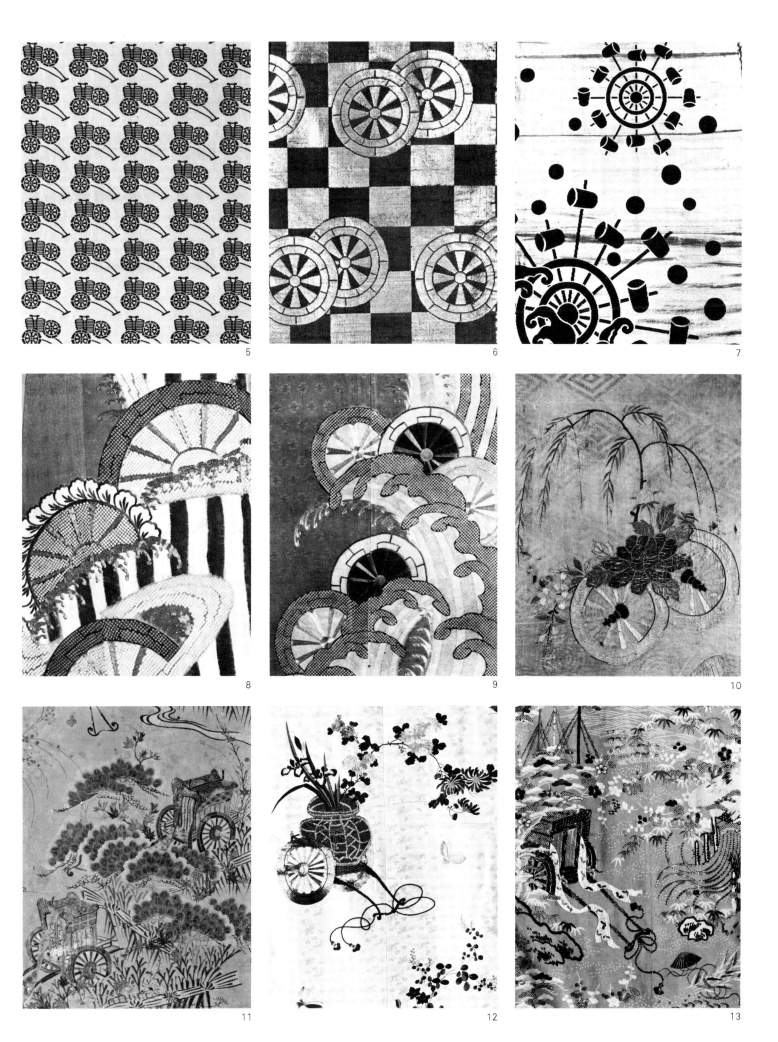

IMPLEMENTS

1

1 Sword guard with design of stone monument and sickles
2 Kyōgen robe with design of pike blade cases
3 Kyōgen robe with sword guard design
4 Spools
5 Tea bowl with design of shower of arrows
6 Arrows and semicircular waves
7 Arrowheads
8 Arrow feathers within stripes
9 Arrow wheels within diaper of interlocking squares and octagons
10 Japanese harp bridges and maple leaves
11 "Scattered treasures"
12 "Scattered treasures" in checker pattern
13 "Scattered treasures" in checker pattern
14 Hat shape with cranes, pine trees, and floral scrolling vines
15 Hats with chrysanthemums and drooping cherry sprays
16 Basket with wild pinks
17 Baskets with cherry blossoms
18 Basket with Chinese bellflowers and bush clover
19 Brushwood bundles and cherry and maple branches
20 Sliding screens, wisteria, and pine needles
21 Mallets and fulling blocks
22 Furniture
23 Utensils for tea ceremony
24 Trivets
25 Tea kettle, pair of tongs, and young pine branches
26 Tea ladle
27 Tea bowls and tea whisk
28 Flower scissors
29 Bag for gold
30 Gourd tied to cherry tree
31 *Kakure-mino* (imaginary coat said to render the wearer invisible) and geometric patterns

2

3

4

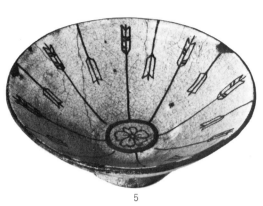

5

6

7

8

9

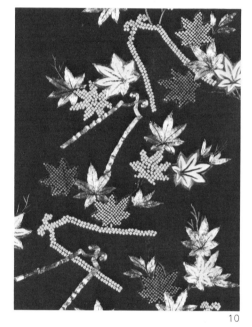

10

11

12

13

14 15 16

17 18 19

20 21 22

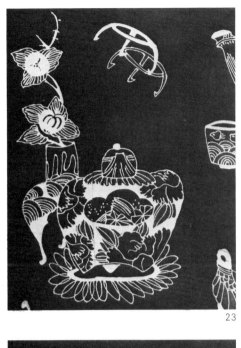

23

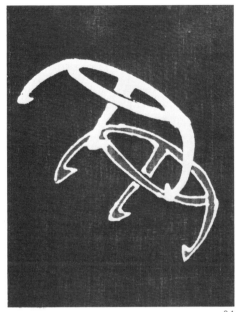

24

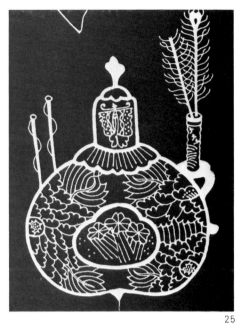

25

26

27

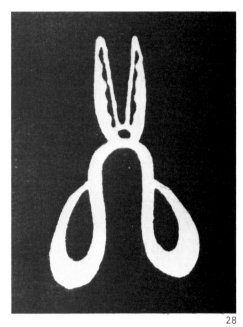

28

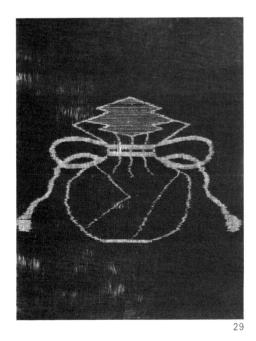

29

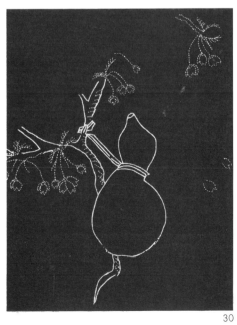

30

31

GAMES AND MUSICAL INSTRUMENTS

1

1 Playing cards
2 Japanese harps and pine tree with pine nuts
3 Oil plate with shamisen, Japanese harp, and books
4 Flutes
5 Japanese chess pieces
6 Japanese chess piece, gourd, and fan
7 Japanese chess pieces and drooping cherry branches
8 Books
9 Flowering tree and poetry cards
10 Poetry cards, sealed letter, and bamboo curtains
11 Comb with design of girls' festival dolls and drooping cherry branches
12 Box to hold shells for shell game, with chrysanthemums
13 Outdoor partitions and drooping cherry branches
14 Curtains, pine tree, overlapping lozenges, and flowers
15 Basket with peonies against lattice pattern
16 Flower basket
17 Insect cage with wisteria, crane, tortoise, and "scattered treasures"
18 Insect cage, cricket, and miscanthuses with dewdrops
19 Insect cage and round fan
20 Sword guard with design of bow, arrows, and wild geese
21 Daruma dolls
22 Balance toys
23 Auspicious ornaments and sacred Buddhist gems
24 Auspicious ornament
25 Auspicious ornaments
26 Battledore and ball
27 Sacred Shinto rope and battledore with cherry blossom design
28 Tops

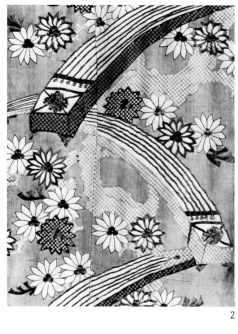

2

3

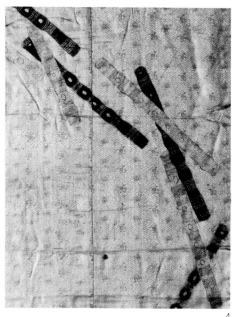

4

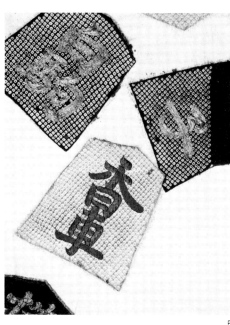

5

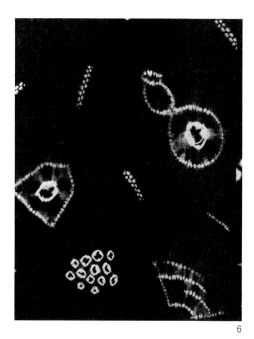

6

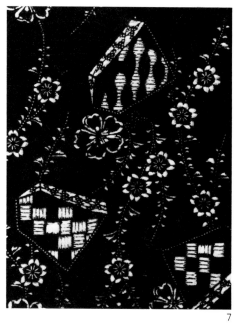

7

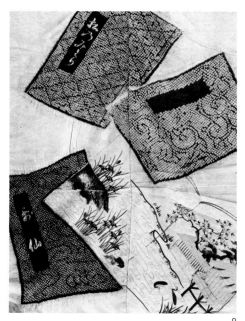

8

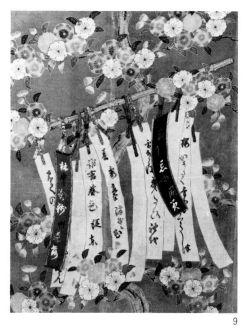

9

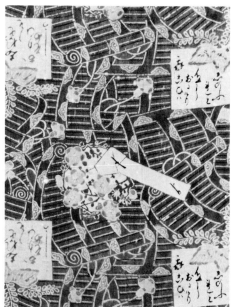

10

11

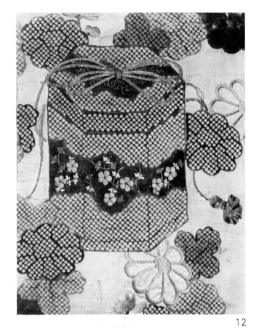

12

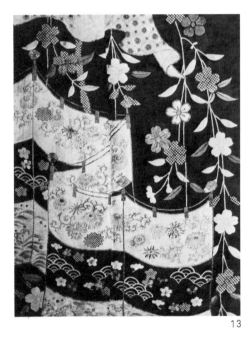

13

14

15

17

18

16

19

158

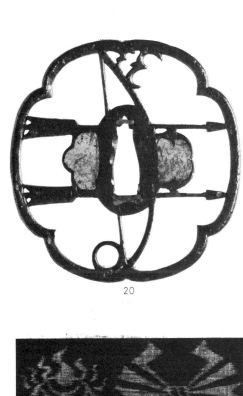

20

21

22

23

24

25

26

27

28

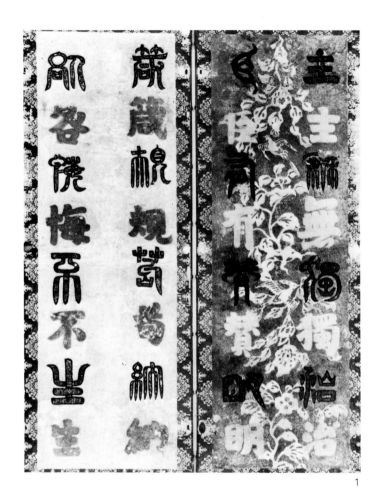

1

1 Characters made of feathers
2 Sword guard with design of five-storied pagoda and the characters for the name of Hachiman Bodhisattva
3 Sword guard with coin design
4 Characters for the numbers from one to ten
5 (left) Characters, bamboo fence, and chrysanthemums
 (right) Characters and bamboo fence
6 Snow crystal roundels enclosing characters and cranes, and bands of paulownia sprays
7 Snow crystal and circle enclosing a character
8 Characters from and volumes of *The Tale of Genji*
9 Sequences of the character for "bird"
10 Characters from the anthology *Japanese and Chinese Poems for Recitation*
11 Disks and parts of disks with horary emblems
12 Drawing of coat with design of the character for "ten thousand"
13 Drawing of coat with design of a syllabic letter
14 Drawing of coat with design of the characters for "fish market" in a roundel and the characters for "fish market" and a fish in a square
15 Pictorial puzzle with small axes, characters for "Japanese harp," and chrysanthemums, symbolizing the hearing of good news
16 Batting shop sign
17 Fan shape with characters for "happiness" and "longevity"
18 Character for "bird"
19 Characters for "rising sun" with mountain, sun, and clouds, and geometric pattern
20 Character for "old" with "old-man" pine tree and geometric pattern
21 Mat with footprint design

2

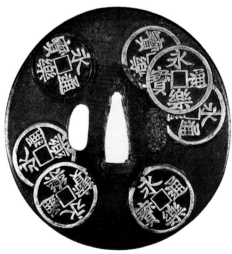

3

4

5

6

7

8

9

10

11

12

13

14

15

16

17

18

19

20

21

CIRCLES

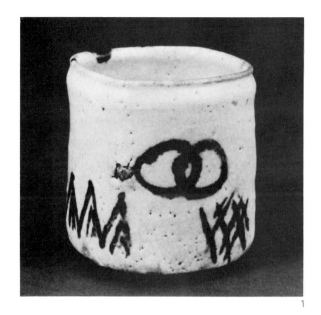

1

1 Pot with design of two interlocked circles
2 Street lantern with design of two interlocked circles
3 Shop lantern with design of two interlocked circles
4 Shop curtain with design of two interlocked circles
5 "Seven jewels" diaper
6 Noodle sauce cup with "seven jewels" diaper
7 Various crests
8 Paulownia in a circle
9 Revolving "commas" (*tomoe*)
10 Triple triangles in a circle
11 Spirals and flower motif
12 Spots
13 Overlapped "seven jewels" diaper

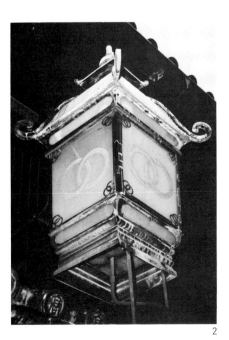

2

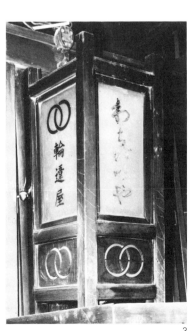

3

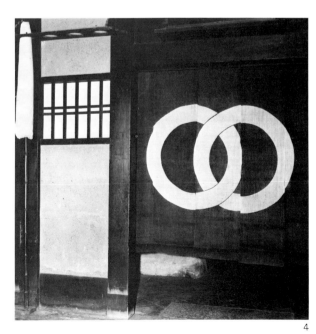

4

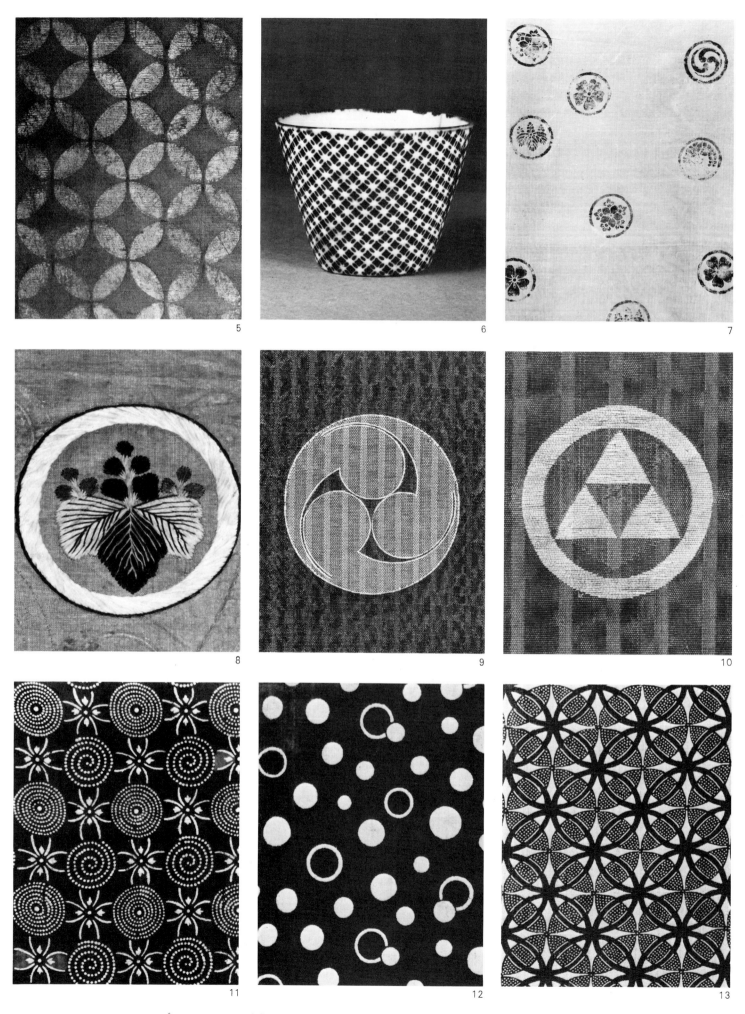

GEOMETRIC PATTERNS

1

1 Crest of four squares
2 Connected squares
3 Concentric squares and diagonally connected squares
4 Square dish with design of sequences of rectangles and circles
5 Crossing diagonal bands with floral scrolls, enclosing lozenges of paulownia and bamboo motifs
6 Diaper of lozenges enclosing paired cranes
7 Crossing diagonal lines enclosing paulownia, bamboo, and paired phoenix motifs
8 Crossing diagonal lines
9 Concentric lozenges and paulownia
10 Lozenge diaper
11 Crossing diagonal lines with leaf motif around lozenged chrysanthemums
12 Concentric lozenge diaper
13 Crossing diagonal lines enclosing imaginary flowers
14 Fish scale diaper
15 Fish scale diaper
16 Stylized irises
17 Ainu garment with geometric patterns
18 Irregular swastika diaper
19 Swastika diaper
20 Swastika diaper
21 Diaper of hemp leaves
22 Curved arrangements of small "sharkskin" dots
23 Floral lozenge diaper
24 Lobed medallions enclosing floral lozenges
25 "Seven jewels" diaper with flowers at intersections, enclosing four oak leaves
26 Imaginary flowers with scrolling vines against overlapping lozenge diaper
27 Overlapping lozenge diaper
28 Three-storied lozenges in a circle
29 Diaper of overlapped vertical and horizontal lozenges
30 Medallions of pine, bamboo, and plum combinations against trailing haze in an overlapping lozenge pattern
31 Floral lozenges between "mountain paths"
32 Noodle sauce cup with lozenge-and-dot design
33 Noodle sauce cup with geometric pattern
34 Noodle sauce cup with design of lozenge diaper enclosing flower motifs, with circles at intersection
35 Horizontal bands of geometric patterns
36 Cherry blossoms and paulownia with tortoise-shell diaper
37 Sequences of hexagons
38 Noodle sauce cup with design of sequences of arrow feathers
39 Oblique serpentine lines
40 "Tottering" stripes

2

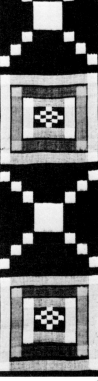

3

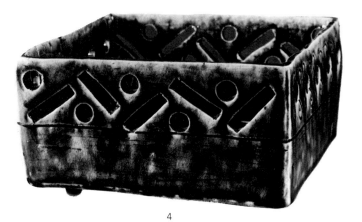

4

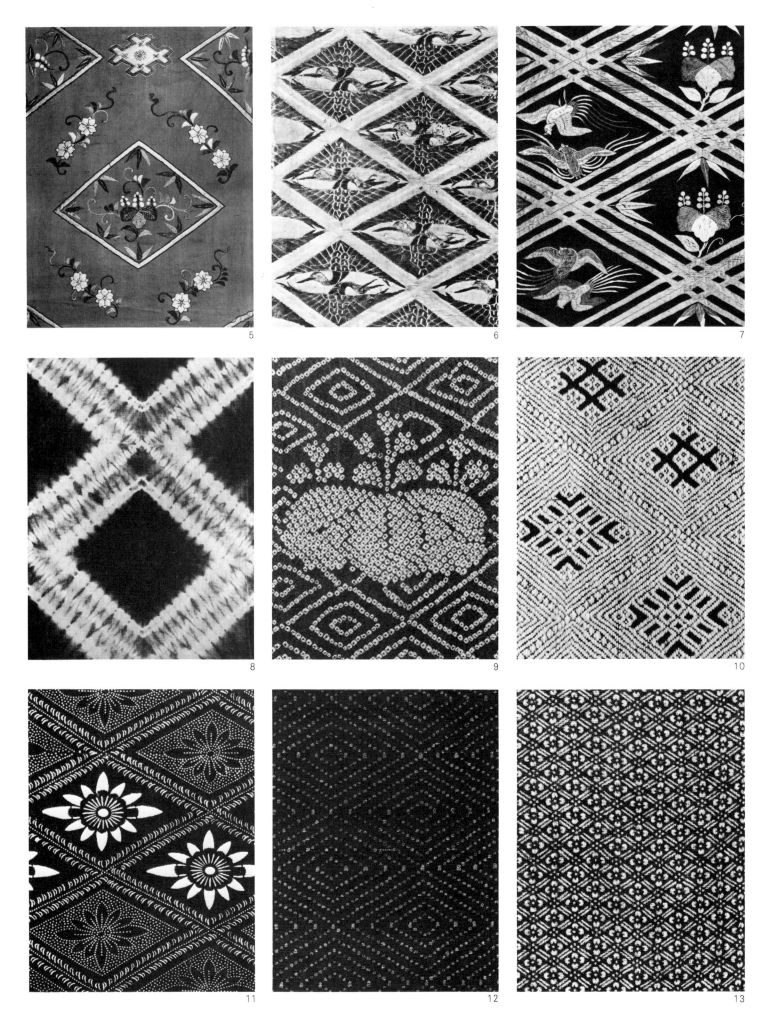

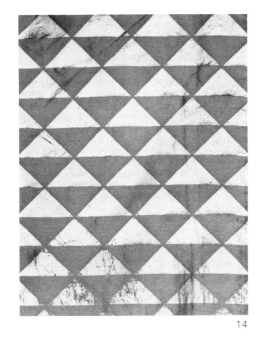

14

15

16

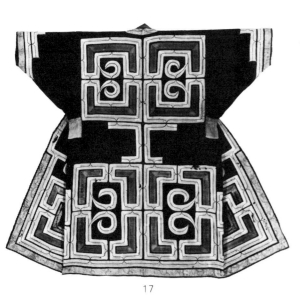

17

18

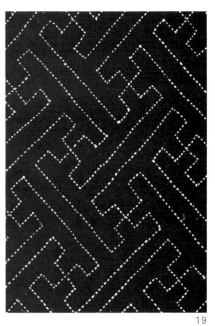

19

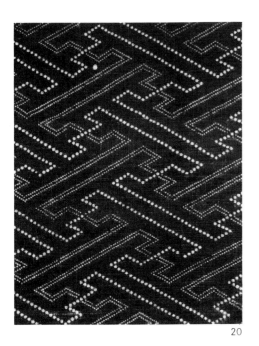

20

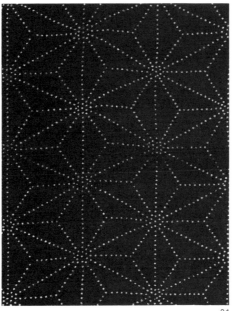

21

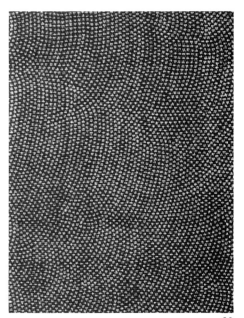

22

167

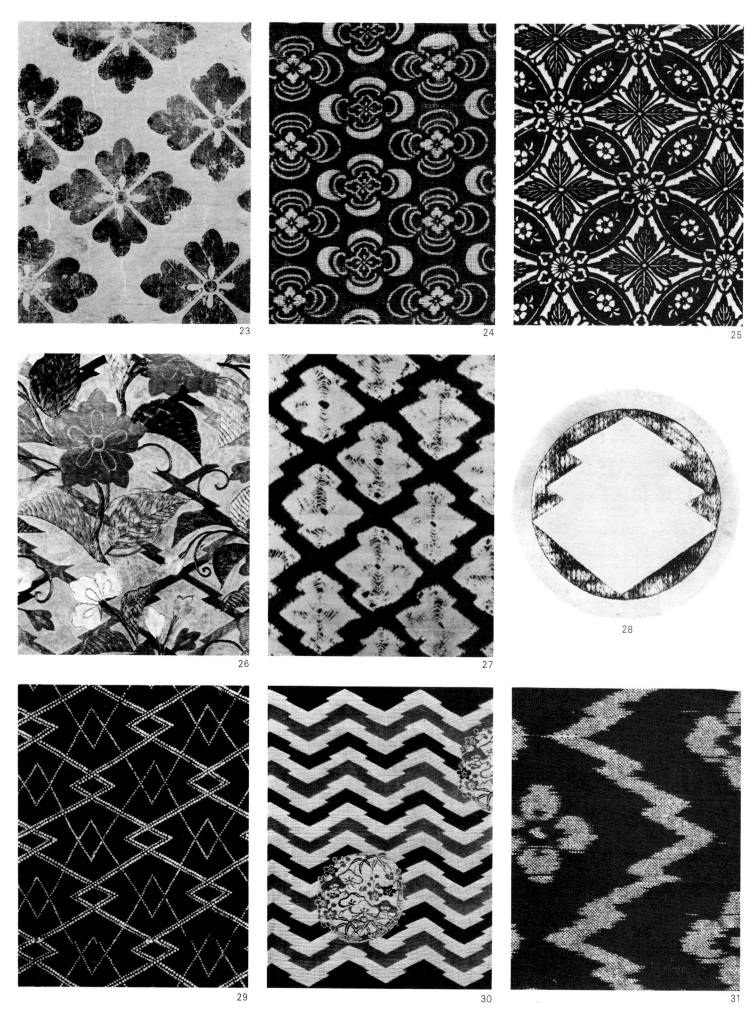

23

24

25

26

27

28

29

30

31

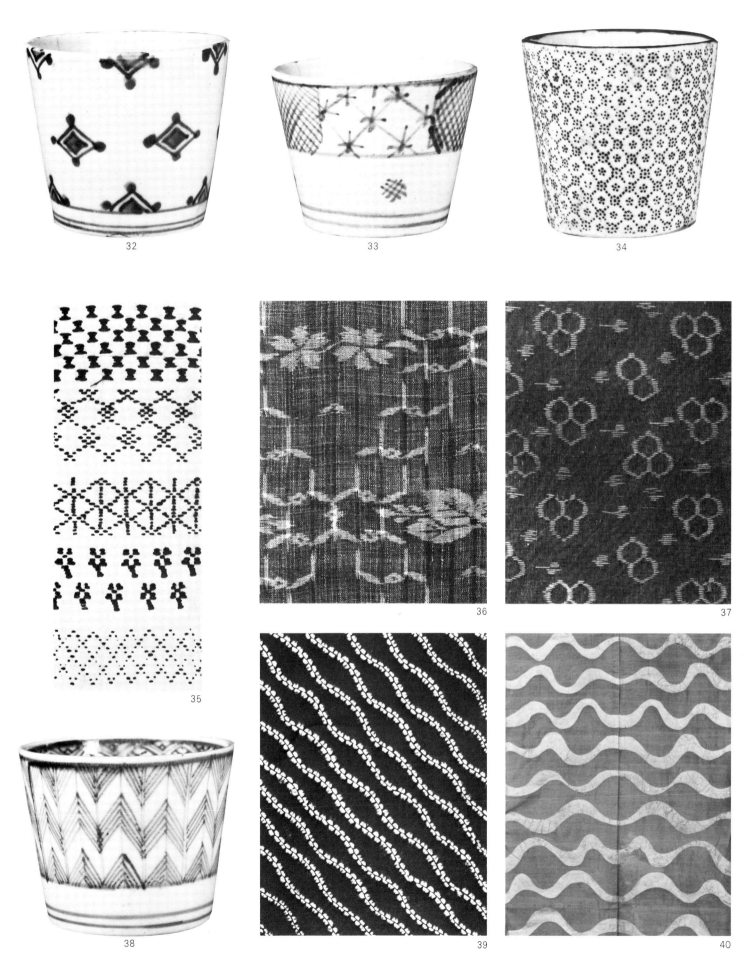

32

33

34

35

36

37

38

39

40

STRIPES AND LATTICES

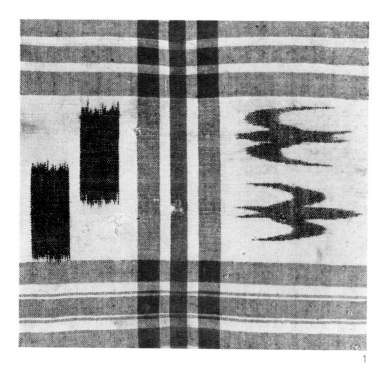

1 Lattice and stylized birds
2 Stepped lattice and birds
3 Stripes, plants, and insects
4 Stripes and crenellated bands
5 Stylized birds and interlocked squares against lattice
6 Stripes
7 Stripes
8 Stripes
9 Stripes
10 Graduating shaded stripes
11 Stripes
12 Stripes
13 Diaper of interlocked concentric squares
14 Checkered pattern
15 Lattice pattern
16 Flower vase with design of broken lattices with scrolling vines
17 Lattice pattern
18 Lattice pattern
19 Noodle sauce cup with lattice design
20 Lattice pattern
21 Lattice pattern
22 Lattice pattern
23 Lattice pattern

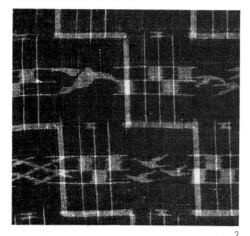

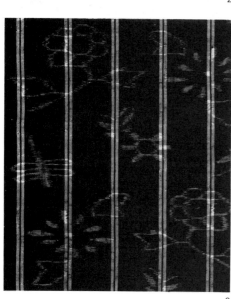

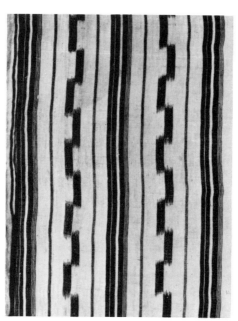

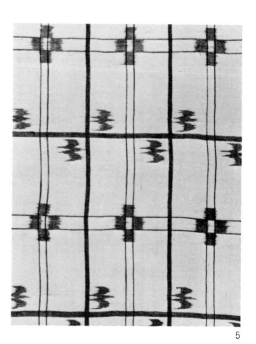

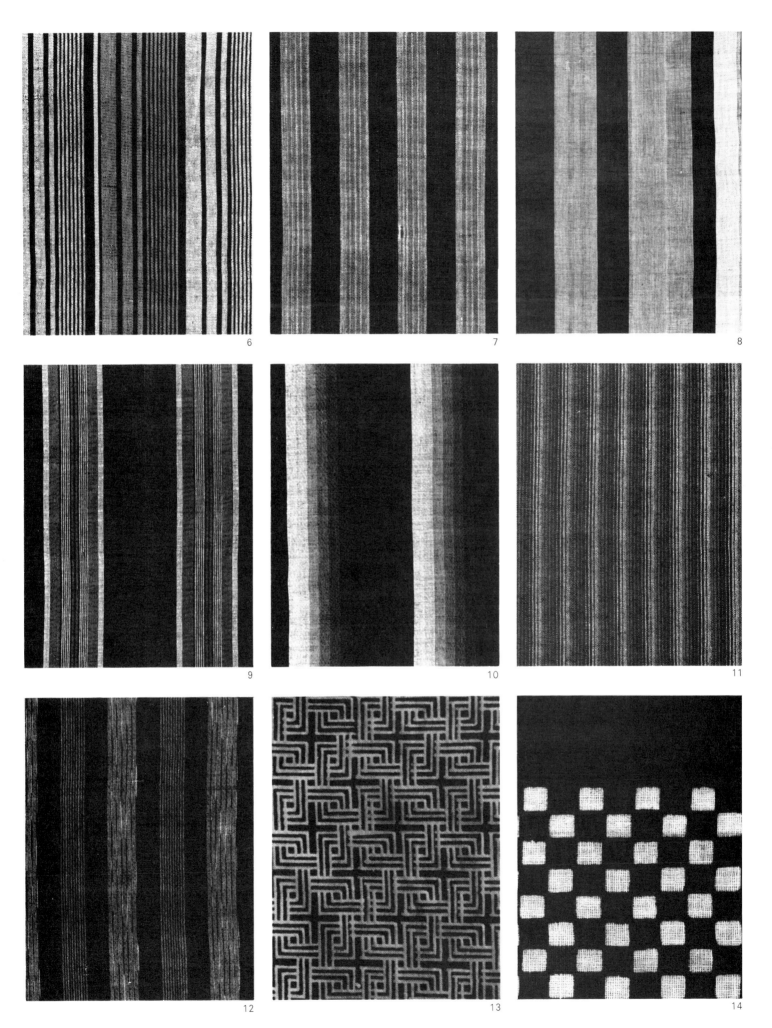

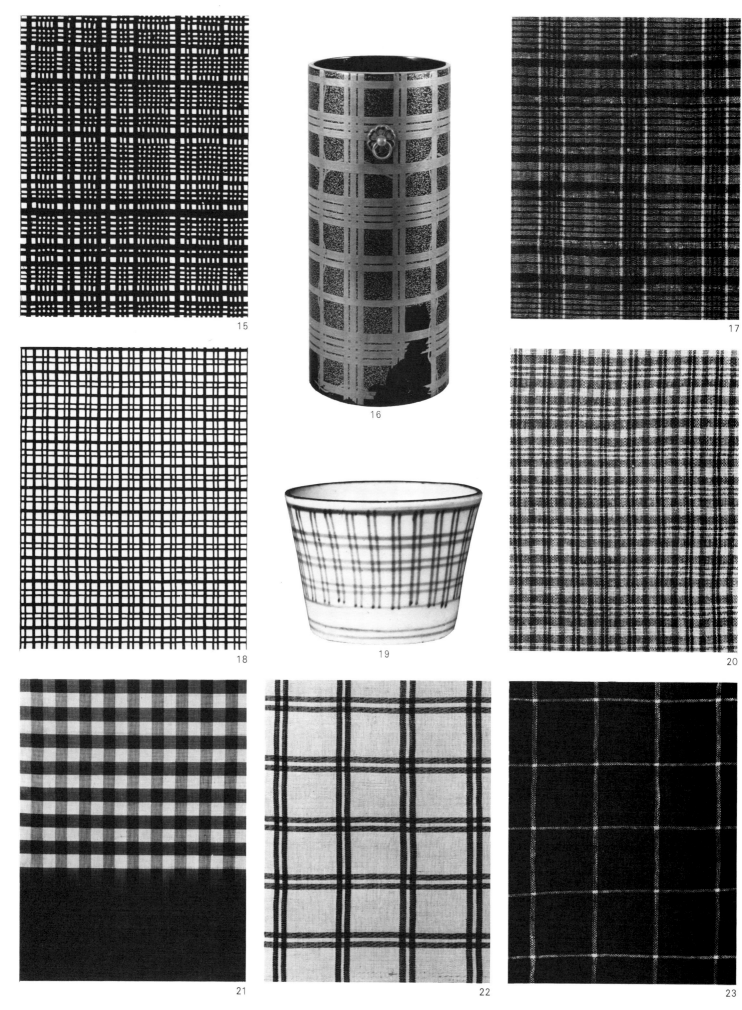

15

16

17

18

19

20

21

22

23

Family Crests

CHERRY BLOSSOMS

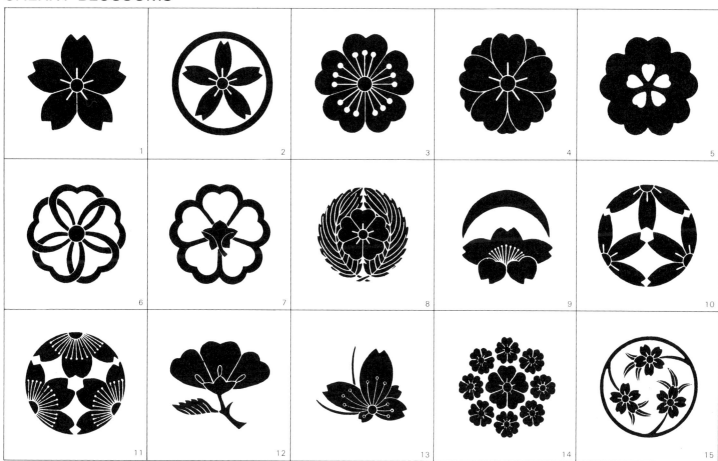

PAULOWNIAS

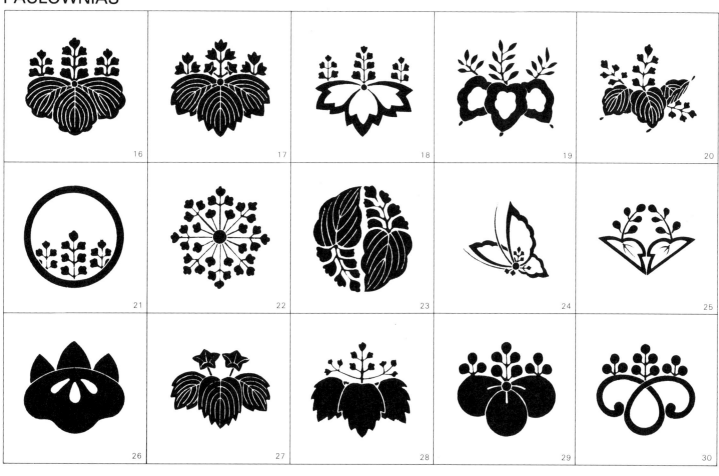

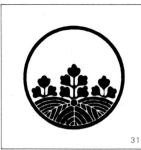 31
 32
 33
 34
 35

PEONIES

 36
 37
 38
 39
 40

 41
 42
 43
 44
 45

CAMELLIAS

 46
 47

WISTERIAS

 48
 49
 50
 51
 52

 53
 54
 55
 56
 57

WILLOW

SPRING GRASSES

Hollies 69-73, yellow roses 74-78, brackens 79-83, violets 84-86, orchids 87-88

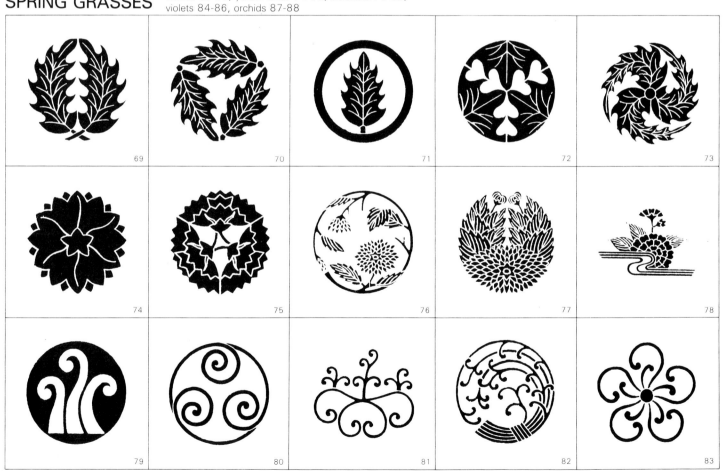

84 85 86 87 88

PLUM BLOSSOMS

89 90 91 92 93

94 95 96 97 98

99 100 101 102 103

LOTUS FLOWERS, SUMMER GRASSES, AND SEASHELLS

Lotus flowers 104-5, reeds 106, water plantains 107-8, ivies 109-13, hollyhocks 114-18, irises 119-22, seashells 123

104 105 106 107 108

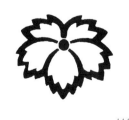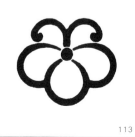

109 110 111 112 113

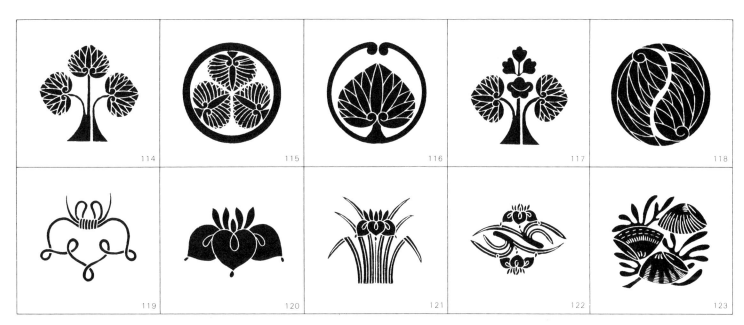

MORNING GLORIES AND CLEMATIS FLOWERS
Morning glories 124-25, clematis flowers 126-28

FRUITS, VEGETABLES, AND GRAINS
Peach 129, mandarin oranges 130-33, gourds 134-36, turnip 137, radishes 138, rice plants 139-43

CHRYSANTHEMUMS

AUTUMN GRASSES
Chinese bellflowers 159-68, bush clover 169,
wild pink 170, gentians 171-73

MAPLE LEAVES AND GINKGO LEAVES Maple leaves 174-82, ginkgo leaves 183

 174
 175
 176
 177
 178

 179
 180
 181
 182
183

GRAPEVINES

 184
 185
 186
 187
 188

SCROLLING VINES

 189
 190
 191
 192
 193

BAMBOO

 194
 195
 196
 197
 198

 199
 200
 201
 202
203

181

PINE TREES
Old trees 204-10, branch-and-needle clusters 211-12,
cone and needles 213-18

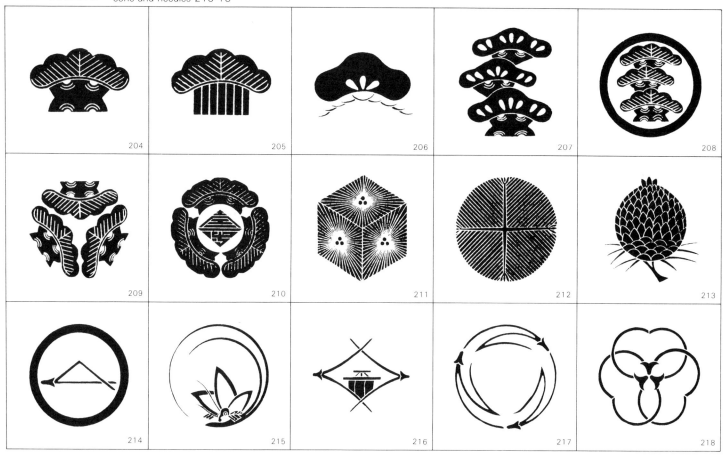

BIRDS AND INSECTS
Cranes 219-26, geese 227-33, sparrows 234-35,
dove 236, hawk 237, centipede 238

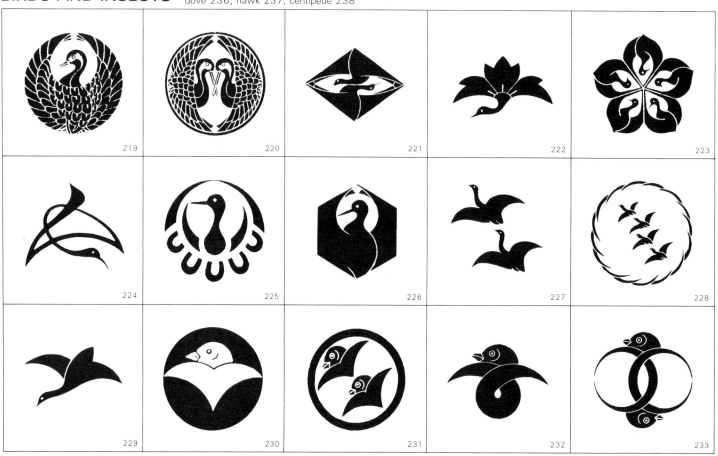

234 · 235 · 236 · 237 · 238

MANDARIN DUCKS AND PLOVERS Mandarin ducks 239-40, plovers 241-48

239 · 240 · 241 · 242 · 243

244 · 245 · 246 · 247 · 248

BUTTERFLIES

249 · 250 · 251 · 252 · 253

254 · 255 · 256 · 257 · 258

259 · 260 · 261 · 262 · 263

183

MYTHICAL BEASTS, TORTOISES, AND LIONS
Dragons 264-67, phoenixes 268-70, tortoises 271-72, Chinese lions 273

ANIMALS
Antlers 274, horns 275, monkeys 276-77, horses 278-80, hares 281-83

WATER

294

295

296

297

298

METEOROLOGICAL PHENOMENA Moons 299-302, stars 303, clouds 304-5, haze 306-7, snow 308

299

300

301

302

303

304

305

306

307

308

FANS Folding fans 309-18, cypress fan 319, round fans 320-21, feather fan 322, military fan 323

309

310

311

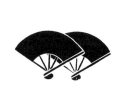

312

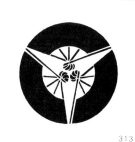

313

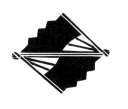

314

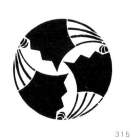

315

316

317

318

319

320

321

322

323

WHEELS Wheel 324, waterwheels 325-26, wind wheels 327-28

IMPLEMENTS

Shinto gate 329, amulet 330, Shinto pendant 331, arrows 332, helmet crests 333, battle helmet 334-35, axes 336, pliers 337, scissors 338, sickles 339, nail extractor 340, keys 341-42, coins 343, weight 344, pestles 345, measuring boxes 346-47, spool 348, headgear 349, military hat 350, umbrellas 351, urn 352, feather dusters 353

186

GAMES AND MUSICAL INSTRUMENTS

Battledore 354, shuttlecock 355, balls 356-57, sealed letter 358, tops 359, chess pieces 360, bow and target 361, balance toys 362, shamisen bridge 363, drums 364-66, Japanese harp bridges 367, plectrums for Japanese harp 368, fire bell 369, gong 370, bells 371, auspicious ornament 372-73

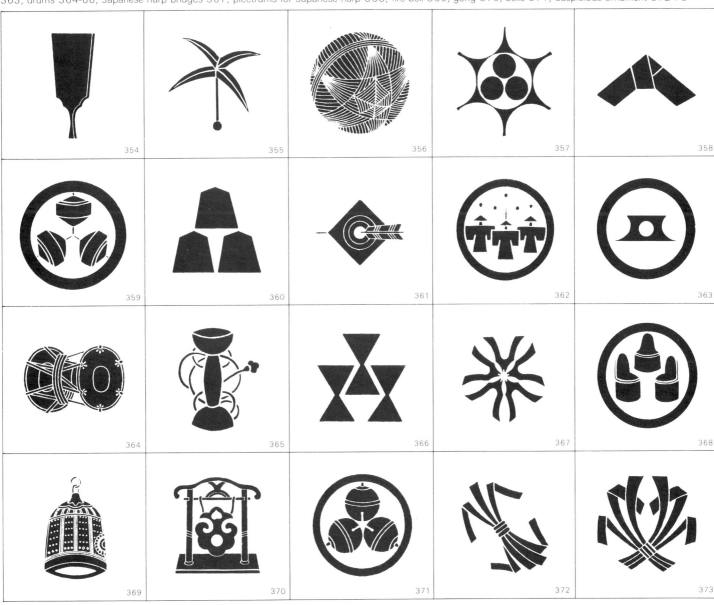

CHARACTERS

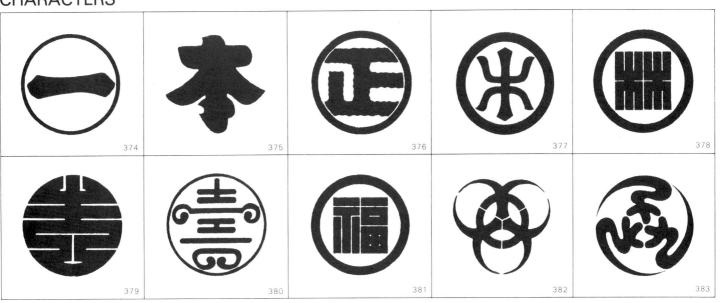

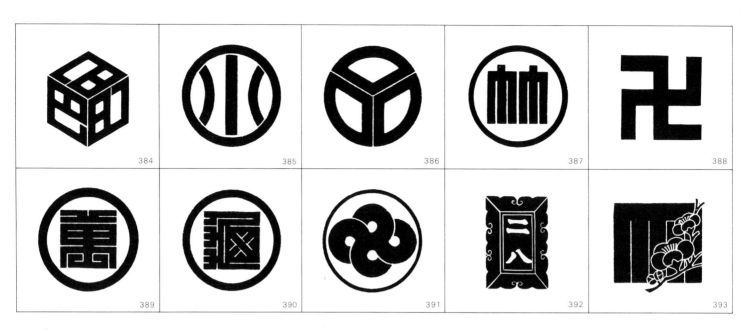

CIRCLES
Circles 394-95, cross 396, revolving "commas" (*tomoe*) 397-98, "seven jewels" 399-401, stars 402-3, interlocked circles 404-8

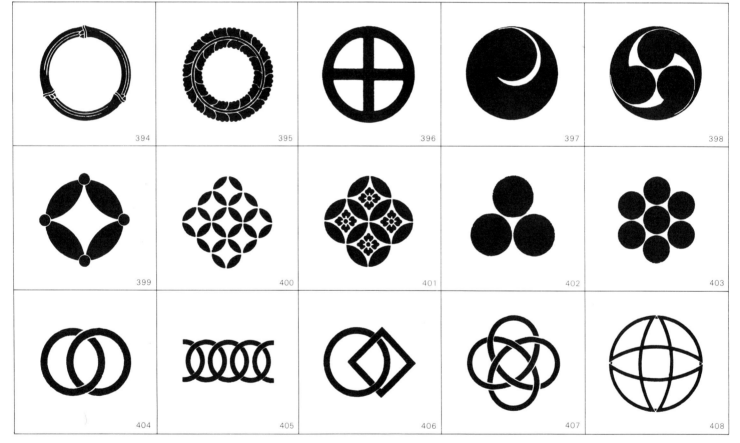

GEOMETRIC PATTERNS
Triangle sequences 409-13, measuring boxes 414-15, meshes 416-17, paving stones 418-20, enclosures 421-23, lozenges 424-35, netting 436, hemp leaves 437, tortoise-shell patterns 438-43

Notes to the Plates

Note: The names of objects shown in detail only are given in parentheses.

COLOR PLATES (pp. 33–64)

1 Peacock and lilies (Buddhist banner). Embroidery on plaited-weave silk. Nara Period. Shōsō-in Repository, Nara.

2 Flowering cherry trees, willow tree, and three girls playing musical instruments (*Tale of Nezame* handscroll). Gold and silver leaf with color on paper. Heian Period. Yamato Bunkakan, Nara.

3 Half-submerged wheels (cosmetic box). Lacquer and gold on wood with mother-of-pearl inlay. Heian Period. Tokyo National Museum.

4 Page from poetry anthology with design of boat among reeds and geese on wind-swept shore (*Anthology of the Thirty-six Poets*). Paper collage flecked with gold and silver. Heian Period. Nishi Hongan-ji, Kyoto.

5 Gong, hand drum, canopy, and Buddhist banner (*Taira Family Dedicatory Sutras*). Gold and silver leaf with color on paper. Heian Period. Itsukushima Shrine, Hiroshima Prefecture.

6 Lid of writing box with design of cormorant on rock and groups of plovers. Lacquer and gold on wood with mother-of-pearl inlay. Heian Period.

7 Flowering cherry tree, crane, and tortoise (mirror back). Bronze. Kamakura Period. Saidai-ji, Kyoto.

8 Yellow and white peonies (garment worn under armor). Brocade. Nambokuchō Period. Tokyo National Museum.

9 Cosmetic box with design of chrysanthemums and scrolling vines. Lacquer and gold on wood with mother-of-pearl inlay. Muromachi Period. Kumano Hayatama Shrine, Wakayama Prefecture.

10 Camellias (monk's portable cabinet). Wood carving and colored lacquer painting. Muromachi Period. Chūson-ji, Iwate Prefecture.

11 Paulownias, bamboo, and phoenix against hollyhock pattern (overgarment). Double-weave silk. Muromachi Period. Atsuta Shrine, Aichi Prefecture.

12 Rectangular dish with design of moon, mountain temple, and boats on waves. Oribe ware. Momoyama Period.

13 Willow branches laden with snow (short coat). Embroidery on silk. Momoyama Period. Fujii Museum, Kyoto.

14 Pottery fragments with design of (top) autumn grasses and deer; (bottom) mountain temple, hare, and moon. Shino ware. Momoyama Period. Gifu Prefecture Pottery Exhibition Hall.

15 Sun and moon (Buddhist banner). Tie-dyeing on silk. Momoyama Period. Nezu Art Museum, Tokyo.

16 Maple tree (one of a pair of folding screens). Color on gold-leafed paper. Attributed to Kanō Sanraku. Momoyama Period. Nezu Art Museum, Tokyo.

17 Sutra box with design of floral scrolling vines. Lacquer on wood with mother-of-pearl inlay. Attributed to Hon'ami Kōetsu. Edo Period. Hompō-ji, Kyoto.

18 Bamboo and calligraphy (poetry card). Color on gold- and silver-leafed paper. Painting by Tawaraya Sōtatsu and calligraphy by Hon'ami Kōetsu. Edo Period. Museum für Ostasiatische Kunst, Berlin.

19 Fan with design of young bracken, violets, and horsetails. Color on gold-leafed paper. By Ogata Kōrin. Edo Period.

20 Small dishes with design of grapevines and stripes. Oribe ware. Momoyama Period.

21 Butterflies (short coat). Tie-dyeing on silk. Momoyama Period.

22 Tea bowl with design of moonflowers and poem. Pottery. By Ogata Kenzan. Edo Period. Yamato Bunkakan, Nara.

23 Tea storage jar with design of wisteria sprays. Pottery. By Nonomura Ninsei. Early Edo Period. Kyūsei Atami Art Museum, Shizuoka Prefecture.

24 Two women and flowers (large plate). Imari porcelain. Edo Period.

25 Red plum sprays (one of a pair of folding screens). Color on gold-leafed paper. By Ogata Kōrin. Edo Period. Kyūsei Atami Art Museum, Shizuoka Prefecture.

26 Nō robe with design of waves in alternating colors. Silver-leaf imprint on silk. Edo Period.

27 Moon, Chinese bellflowers, and miscanthuses (Kyōgen robe). Dyework over freehand painted resist on hemp. Late Edo Period.

28 Nō headbands with designs of pine trees: (a) Chinese pine. Embroidery on silk. Mid-Edo Period. Uomachi Nōgakkai Society, Aichi Prefecture. (b) Snow-laden pine. Embroidery on silk. Mid-Edo Period. Uomachi Nōgakkai Society, Aichi Prefecture. (c) Old pine. Embroidery on silk. Mid-Edo Period. Shinonome Shrine, Ehime Prefecture. (d) Young pine and mist. Embroidery on silk. Mid-Edo Period. Tokyo National Museum.

29 Water landscape (summer robe). Resist dyeing and embroidery on hemp. Edo Period. Tokyo National Museum.

30 Kyōgen robe with design of fruiting loquat sprays and sequences of triangles. Dyework over freehand painted resist on hemp. Late Edo Period. Itsukushima Shrine, Hiroshima Prefecture.

31 Stone wall and arrows arranged on racks (Kyōgen robe). Dyework over freehand painted resist on hemp. Mid-Edo Period.

32 (left) Candle shop sign. Color on carved wood. Late Edo–Meiji Period. Kyoto Folkcraft Museum. (right) Pipe shop sign. Color on carved wood. Late Edo–Meiji Period. Kyoto Folkcraft Museum.

BLACK-AND-WHITE PLATES

CHERRY BLOSSOMS (pp. 67–69)

1 Sword guard with design of cherry and plum blossoms. Iron openwork. Edo Period.

2 Cherry sprays against vertical serpentine lines (Nō robe). Embroidery and gold-leaf imprint on silk. Edo Period.

3 Cherry tree, drying fishnets, and wave crests (robe). Tie-dyeing and embroidery on silk. Early Edo Period.

4 Cherry blossoms and ornamental ribbons (robe). Tie-dyeing and embroidery on silk. Early Edo Period.

5 Sword guard with cherry blossom design. Iron openwork. Muromachi Period.

6 Tea caddy with drooping cherry tree design. Lacquer and gold on wood. Edo Period. Yamato Bunkakan, Nara.

7 Plate with cherry tree design. Nabeshima porcelain. Edo Period. Tokyo National Museum.

8 Drooping cherry sprays, fans, and poetry cards (Nō robe). Embroidery and gold-leaf imprint on silk. Momoyama Period.

9 Drooping cherry branches and court carriage (Nō robe). Embroidery and gold- and silver-leaf imprint on silk. Early Edo Period.

10 Cherry trees in oblique bands (robe). Tie-dyeing and embroidery on silk. Early Edo Period. Tokyo National Museum.

11 Drooping cherry branches, wave crests, curtains, fishnets, and clams (robe). Dyeing on silk. Edo Period. Tokyo National Museum.

12 Cherry branch (Nō headband). Embroidery and gold-leaf imprint on silk. Edo Period.

13 Cherry blossoms and landscape (robe). Dyeing and embroidery on silk. Edo Period. Tokyo National Museum.

14 Drooping cherry branches and fans (robe). Dyeing and embroidery on silk. Edo Period. Tokyo National Museum.

15 Cherry sprays against geometric pattern (robe). Dyeing on silk. Edo Period.

16 Cherry blossoms and landscapes (kimono). Dyework over stenciled resist on hemp. 19th century.

17 Cherry blossoms and streams (fragment). Dyework over stenciled resist on hemp. Edo Period.

18 Cherry and plum blossoms, wave crests, bamboo grass, crane, and mandarin orange sprays (kimono). Dyework over stenciled resist on cotton. 19th century.

19 Drooping cherry branches (fragment). Dyework over stenciled resist on hemp. Late Edo Period.

20 Drooping cherry branches (fragment). Fine dyework over stenciled resist on hemp. Late Edo Period.

21 Cherry sprays and streams (fragment). Fine dyework over stenciled resist on cotton. Meiji Period.

22 Cherry blossoms (man's sleeveless coat). Fine dyework over stenciled resist on hemp. Edo Period.

PAULOWNIAS (pp. 70–71)

1 Five- and three-leafed paulownia crest (coat worn over armor). Inlay work and embroidery on wool. Edo Period. Maeda Ikutoku-kai Foundation, Tokyo.

2 Paulownia tree (Nō robe). Twill-weave silk with brocaded designs. Momoyama Period.

3 Paulownias against oblique bands (Nō robe). Painting and gold- and silver-leaf imprint on silk. Momoyama Period.

4 Fans with paulownias against pattern of wisterias and irises (Nō robe). Embroidery and gold- and silver-leaf imprint on silk. Momoyama Period.

5 Paulownia, scrolling vines, and flower-shaped rhombus (Nō robe). Twill-weave silk with brocaded designs. Momoyama Period.

6 Paulownias against netting diaper (Nō robe). Embroidery and gold-leaf imprint on silk. Momoyama Period.

7 Five- and three-leafed paulownia crest (shop awning). Dyework over stenciled resist on cotton. Edo Period.

8 Paulownia crest (Nō robe). Embroidery and gold-leaf imprint on silk. Early Edo Period.

9 Sword guard with paulownia design. Iron openwork. Edo Period.

10 Paulownias (fragment). Twill-patterned weave silk. Momoyama Period.

11 Bowl with paulownia design. Yellow Seto ware. Momoyama Period. Tokyo National Museum.

12 Paulownia spray in a circle and willow tree (Nō robe). Embroidery and gold- and silver-imprint on silk. Edo Period.

13 Paulownia tree and flying phoenix (gown). Embroidery and tie-dyeing on silk. Edo Period. Tokyo National Museum.

14 Paulownia and scrolling vines (fragment). Tie-dyeing on silk. Meiji Period.

15 Paulownias and scrolling vines (fragment). Dyework over stenciled resist on cotton. Late Edo Period.

PEONIES (pp. 72–73)

1 Plate with peony design. Kakiemon porcelain. Edo Period.

2 Bowl with peony design. Lacquered wood. Edo Period.

3 Peony crest (Nō robe). Embroidery and gold-leaf imprint on silk. Early Edo Period.

4 Peony and cart (Nō robe). Embroidery and gold-leaf imprint on silk. Early Edo Period.

5 Peony scrolls and hollyhocks (summer robe). Embroidery and dyeing on hemp. Edo Period.

6 Curtain with peony design and hollyhocks (summer robe). Embroidery and dyeing on hemp. Edo Period.

7 Peony branches and sliding screens (summer robe). Dyeing and embroidery on hemp. Edo Period. Tokyo National Museum.

8 Peonies against vertical lines and interlocking circles (robe). Dyeing on silk. Edo Period.

9 Peony (curtain). Dyework over freehand painted resist on cotton. Late Edo Period.

10 Peony scrolls (fragment). Dyework over stenciled resist on cotton. Late Edo Period.

11 Peony branches (fragment). Dyework over freehand painted resist on cotton. Late Edo Period.

12 Peonies and chrysanthemums (fragment). Dyework over stenciled resist on cotton. Late Edo Period.

CAMELLIAS (pp. 74–75)

1 Round fan paper with camellia branch design. Painting attributed to Ogata Kōrin. Edo Period.

2 Camellia blossoms and wisteria sprays (fragment). Hand-drawn detailing and tie-dyeing on silk. Momoyama Period. Zuisen-ji Kyoto.

3 Camellias, chrysanthemums, and poetry cards against overlapping lozenge diaper (fragment). Hand-drawn detailing and tie-dyeing on silk. Momoyama Period.

4 Camellia branch (fragment). Hand-drawn detailing and tie-dyeing on silk. Momoyama Period.

5 Camellia trees and wave crests (Nō robe). Embroidery and gold-leaf imprint on silk. Momoyama Period.

6 Camellia tree and willow branches (robe). Tie-dyeing and embroidery on silk. Edo Period.

7 Camellia tree and bamboo fence (robe). Dyeing and embroidery on silk. Edo Period. Tokyo National Museum.

8 Camellia and plum trees (Nō sash). Embroidery and gold-leaf imprint on silk. Design said to be based on drawing by Ogata Kōrin. Edo Period.

9 Camellia blossoms, fan papers, and streams (robe). Dyeing and embroidery on silk. Edo Period.

10 Lid of a lacquered box for holding cups with camellia tree design. Gold and painting on lacquered wood. Momoyama Period. Dairyū-in, Kyoto.

11 Plate with camellia tree design. Nabeshima porcelain. Edo Period.

12 Plate with camellia branch design. Imari porcelain. Edo Period.

13 Plate with camellia branch design. Ko-Imari porcelain. Edo Period.

WISTERIAS (pp. 76–77)

1 Wisteria clusters (Nō headband). Embroidery on silk. Edo Period. Eisei Bunko Foundation, Tokyo.

2 Wisteria on trellis (Nō headband).

191

Embroidery on silk. Edo Period. Eisei Bunko Foundation, Tokyo.

3 Mirror back with design of wisteria tree by the sea and two birds. Bronze. Kamakura Period.

4 Wisteria blossoms curled into the revolving "commas" (tomoe) shape against a diaper of foliate diamonds within a tortoise-shell lattice (Nō robe). Edo Period. Tokyo National Museum.

5 Wisteria and camellia blossoms (robe). Hand-drawn detailing and tie-dyeing on silk. Momoyama Period. Zuisen-ji, Kyoto.

6 Wisterias and other plants (fragment of a Nō robe). Embroidery and gold- and silver-leaf imprint on silk. Momoyama Period.

7 Wisteria and cranes (robe). Dyeing and embroidery on silk. Early Edo Period.

8 Wisteria sprays (robe). Embroidery on silk. Edo Period. Tokyo National Museum.

9 Wisteria sprays (robe). Embroidery on silk. Early Edo Period.

10 Wisteria on trellis (robe). Dyeing and embroidery on silk. Edo Period. Tokyo National Museum.

11 Noodle sauce cup with wisteria and ball design. Imari porcelain. Edo Period.

12 Plate with design of wisteria on trellis and butterflies. Seto ware. Edo Period.

13 Wisteria crest, dots, and bands (saddle-cloth). Dyework over freehand painted resist on hemp. Late Edo Period.

WILLOWS (pp. 78–79)

1 Tea caddy with drooping willow tree design. Lacquer and gold on wood. Edo Period.

2 Drooping willow branches covered with snow (Nō headband). Embroidery on silk. Mid-Edo Period. Shinonome Shrine, Ehime Prefecture.

3 Drooping willow branches and balls used in courtly game (Nō sash). Embroidery and gold-leaf imprint on silk. Edo Period. Shinonome Shrine, Ehime Prefecture.

4 Tray with design of willow, crescent moon, and herons. Lacquered wood. Edo Period. Tokyo National Museum.

5 Plate with willow tree design. Seto ware. Edo Period.

6 Willow branches in a circle (Nō robe). Embroidery and gold-leaf imprint on silk. Momoyama Period.

7 Willow branches and poetry card (fragment of a Nō robe). Embroidery and gold-leaf imprint on silk. Momoyama Period.

8 Willows and landscapes against overlapping lozenges (Nō robe). Embroidery, gold-leaf imprint, and painting on silk. Momoyama Period.

9 Willows covered with snow and paulownias against crossing diagonal lines (fragment of a Nō robe). Embroidery on silk. Momoyama Period.

10 Willow trees and flowers in circles (Nō robe). Embroidery and silver-leaf imprint on silk. Edo Period.

11 Willow trees (Nō robe). Brocade on twill-weave silk. Late Edo Period.

Itsukushima Shrine, Hiroshima Prefecture.

12 Willows and boats laden with flowers (robe). Tie-dyeing and embroidery on silk. Edo Period. Tokyo National Museum.

13 Willow trees and round fans (robe). Dyeing on silk. Edo Period. Tokyo National Museum.

14 Willow branches and balls used in courtly game (fragment). Dyework over stenciled resist on hemp. Edo Period.

SPRING GRASSES (pp. 80–81)

1 Nail concealer with narcissus design. Iron inlaid with gold. Attributed to Kachō. Early Edo Period. Katsura Palace, Kyoto.

2 Square dish with design of horsetails and miscanthuses. Pottery. By Ogata Kenzan. Edo Period.

3 Small dish with budding branch design. Pottery. By Ogata Kenzan. Edo Period. Nezu Art Museum, Tokyo.

4 Plate with horsetail design. Nabeshima porcelain. Edo Period. Arita Ceramic Museum, Saga Prefecture.

5 Inside of writing box lid with design of bracken sprouts and dandelions on dikes. Lacquer and gold on wood with lead and abalone shell inlay. Attributed to Hon'ami Kōetsu. Edo Period. Kyūsei Atami Art Museum, Shizuoka.

6 Bracken (hooded outer garment). Dyework over freehand painted resist on hemp. Edo Period.

7 Plate with design of narcissus, hares, and wave crests. Imari porcelain. Edo Period.

8 Plate with spirea design. Nabeshima porcelain. Edo Period.

9 Orchid roundel (robe). Dyeing on silk. Edo Period.

10 Orchid (robe). Embroidery and tie-dyeing on silk. Edo Period. Tokyo National Museum.

11 Violets and lateral bands against overlapping lozenges (fragment). Hand-drawn detailing, tie-dyeing, embroidery, and gold-leaf imprint on silk. Momoyama Period.

12 Dandelions (Nō sash). Embroidery and silver-leaf imprint on silk. Edo Period.

13 Dandelions (Nō robe). Silver-leaf imprint on silk. Edo Period.

PLUM BLOSSOMS (pp. 82–84)

1 Hanging lantern with design of plum and bamboo. Bronze openwork. Muromachi Period. Tokyo National Museum.

2 Plum blossoms forming crossing diagonal lines (fragment). Wax-resist dyeing on silk. Nara Period. Shōsō-in Repository, Nara.

3 Plum blossom crest (Nō robe). Embroidery and gold-leaf imprint on silk. Early Edo Period.

4 Plum blossoms in a circle (Nō robe).

Embroidery and gold-leaf imprint on silk. Momoyama Period.

5 Tea bowl with design of spear-stemmed plum branches. Pottery. By Ogata Kenzan. Edo Period. Umezawa Memorial Gallery, Tokyo.

6 Oil plate with design of Japanese nightingale on plum branch. Seto ware. Edo Period.

7 Plum branches (Nō robe). Embroidery and gold-leaf imprint on silk. Momoyama Period.

8 Plum branch (Nō robe). Tie-dyeing, embroidery, and gold-leaf imprint on silk. Edo Period.

9 Plum blossoms against vertical serpentine lines (Nō robe). Embroidery and gold-leaf imprint on silk. Edo Period.

10 Plum blossoms on water (robe). Tie-dyeing and embroidery on silk. Edo Period. Tokyo National Museum.

11 Plum tree (robe). Tie-dyeing on silk. Edo Period. Tokyo National Museum.

12 Plum blossoms and plum sprays (robe). Embroidery and tie-dyeing on silk. Edo Period. Tokyo National Museum.

13 Spear-shaped plum trees and bamboo (robe). Dyeing and embroidery on silk. Mid-Edo Period.

14 Plum blossoms (robe). Dyeing on silk. Late Edo Period.

15 Plum sprays (robe). Dyeing on silk. Edo Period.

16 Plum branch (summer robe). Embroidery and dyeing on hemp. Edo Period.

17 Plum blossoms in circles (fragment). Tie-dyed plain-weave cotton, double ikat type. Meiji Period.

18 Plum blossoms (kimono). Dyework over stenciled resist on cotton. 19th century.

19 Plum blossoms against broken ice patterns (kimono). Dyework over stenciled resist on cotton. 19th century.

20 Plum blossoms, pine needles, and overlapping lozenges (hooded outer garment). Dyework over freehand painted resist on silk. Edo Period.

21 Plum tree, bamboo, crane, and tortoise (fragment). Tie-dyed plain-weave cotton, double ikat type. Late Edo Period.

22 Plum tree (wrapping cloth). Dyework over freehand painted resist on cotton. Edo Period.

LOTUS FLOWERS, SUMMER GRASSES, AND SEASHELLS (pp. 85–88)

1 Sutra cover with design of lotus and scrolling vines (cover of the Shinge-bon scroll of the Taira Family Dedicatory Sutras). Gold on dyed paper. Heian Period. Itsukushima Shrine, Hiroshima Prefecture.

2 Lotus flower (fragment). Polychrome silk weave. Nambokuchō Period.

3 Pond with lotus flower (two-fold screen). Painting and gold-leafed paper. Attributed to Tawaraya Sōtatsu. Momoyama Period.

4 Irises, water plantain, and maple leaves

against oblique bands (Nō robe). Painting and gold- and silver-leaf imprint on silk. Momoyama Period.

5 Bowl with iris design. Yellow Seto ware. Momoyama Period.

6 Sword guard with design of irises and dewdrops on leaves. Iron openwork. Muromachi Period.

7 Irises in stream (Nō sash). Embroidery and gold-leaf imprint on silk. Edo Period.

8 Irises in stream, butterflies, pines, and overlapping lozenges (hooded outer garment). Dyework over freehand painted resist on silk. Edo Period.

9 Irises in stream (robe). Dyeing and embroidery on silk. Edo Period. Tokyo National Museum.

10 Irises, plum and cherry blossoms, and a stream (kimono). Dyework over stenciled resist on cotton. 19th century.

11 Irises (fragment). Dyework over stenciled resist on cotton. Meiji Period.

12 Iris (wrapping cloth). Dyework over freehand painted resist on cotton. Edo Period.

13 Ivy (fragment). Hand-drawn detailing and tie-dyeing on silk. Momoyama Period.

14 Ivy against "cypress fence" diaper (child's Nō robe). Embroidery and gold-leaf imprint on silk. Edo Period.

15 Ivy and scrolling vines (Nō sash). Embroidery on silk. Edo Period.

16 Hollyhocks and plum blossoms against vertical serpentine lines (Nō robe). Painting and gold- and silver-leaf imprint on silk. Momoyama Period.

17 Hollyhock in circle (fragment). Hand-drawn detailing and tie-dyeing on silk. Momoyama Period.

18 Hollyhocks (fragment). Hand-drawn detailing and tie-dyeing on silk. Momoyama Period.

19 Hollyhocks and curtain (summer robe). Embroidery and dyeing on hemp. Edo Period.

20 Hollyhocks (summer robe). Dyework over freehand painted resist on hemp. Edo Period.

21 Candock, Chinese bellflowers, and streams (kimono). Dyework over stenciled resist on cotton. 19th century.

22 Plate with design of clams, seaweed, and waves. Imari porcelain. Edo Period.

23 Clams decorated with flowers, sea and shore (Nō robe). Embroidery, tie-dyeing, and gold-leaf imprint on silk. Early Edo Period.

24 Plate with design of cucumber flower and leaf. Oribe ware. Momoyama Period.

25 Lilies (robe). Dyeing on silk. Late Edo Period.

26 Crest with triple oak leaves (Nō robe). Embroidery and gold-leaf imprint on silk. Early Edo Period.

27 Paper mulberry leaf (fragment). Dyework over stenciled resist on cotton. Edo Period.

28 Wood-sorrel flower crest (robe worn under sleeveless coat). Seersucker-type silk weave. Edo Period.

29 Hydrangea sprays and Japanese syllabic letters (summer robe). Dyeing and embroidery on hemp. Edo Period.

30 Kyōgen robe with design of hydrangea flower and leaves with butterflies. Dyework over freehand painted resist on hemp. Late Edo Period.

31 Thistles and bird (robe). Dyeing and embroidery on silk. Late Edo Period.

MORNING GLORIES AND CLEMATIS FLOWERS (pp. 89–90)

1 Morning glories, wisteria, and overlapping lozenges (fragment). Hand-drawn detailing and tie-dyeing on silk. Momoyama Period. Zuisen-ji, Kyoto.

2 Noodle sauce cup with morning glory design. Imari porcelain. Edo Period.

3 Morning glories and bamboo (hooded outer garment). Painting and dyework over stenciled resist on hemp. Edo Period.

4 Morning glories and bamboo fence (robe). Dyeing on silk. Edo Period. Tokyo National Museum.

5 Morning glories and bamboo (robe). Dyeing and embroidery on silk. Edo Period.

6 Morning glories (Nō sash). Embroidery and gold-leaf imprint on silk. Edo Period.

7 Clematis (Nō headband). Embroidery on silk. Edo Period.

8 Moonflowers (Nō sash). Embroidery on silk. Edo Period.

9 Moonflowers (Nō sash). Embroidery on satin-weave silk. Edo Period.

10 Clematis and snow crystal (robe). Embroidery and gold-leaf imprint on silk. Edo Period.

11 Clematis and stream (robe). Dyeing on silk. Edo Period.

12 Clematis (fragment). Dyework over stenciled resist on cotton. Edo Period.

13 Clematis against stripes (stencil). Paper. Edo–Meiji Period.

14 Clematis and bamboo fence (stencil). Paper. Edo–Meiji Period.

FRUITS, VEGETABLES, AND GRAINS (pp. 91–93)

1 Mandarin orange crest (Nō robe). Embroidery and gold-leaf imprint on silk. Early Edo Period.

2 Noodle sauce cup with mandarin orange design. Imari porcelain. Edo Period.

3 Mandarin orange spray among tortoise-shell hexagons enclosing imaginary flower motif (Nō robe). Twill-weave silk with brocaded designs. Edo Period.

4 Mandarin orange sprays against sequences of triangles (Nō robe). Gold brocading on silk. Late Edo Period.

5 Mandarin orange crest (wrapping cloth). Dyework over freehand painted resist on cotton. Edo Period.

6 Chestnut branch (fragment). Hand-drawn detailing and tie-dyeing on silk. Momoyama Period.

7 Plate with chestnut branch design. Lacquered wood. Edo Period.

8 Kyōgen robe with design of pine cones and needles. Dyework over freehand painted resist on hemp. Late Edo Period.

9 Clove tree blossoms (short coat). Hand-drawn detailing and tie-dyeing on silk. Momoyama Period. Seisui-ji, Shimane Prefecture.

10 Bowl with radish design. Yellow Seto ware. Momoyama Period.

11 Sword guard with radish design. Iron openwork. Edo Period.

12 Plate with broad bean design. Lacquer and gold on wood. Edo Period.

13 Auspicious plant crest (wrapping cloth). Dyework over freehand painted resist on cotton. Edo Period.

14 Auspicious plant crest (wrapping cloth). Dyework over freehand painted resist on cotton. Edo Period.

15 Fruiting peach sprays and trailing haze (Nō robe). Gold brocading on silk. Late Edo Period.

16 Gourds, bamboo, and stream (fragment). Dyework over stenciled resist on cotton. Edo Period.

17 Tobacco tray with gourd design. Kyoto ware. Edo Period.

18 Gourds and millstone (under-kimono garment). Dyeing on silk. Meiji Period.

19 Gourd vine and a broken bamboo fence (Kyōgen robe). Dyework over freehand painted resist on hemp. Late Edo Period.

20 Mount Fuji, eagle, egg-plants, and geometric motif (fragment). Tie-dyed plain-weave cotton, double ikat type. Meiji Period.

21 Mount Fuji, eagles, and egg-plants (fragment). Tie-dyed plain-weave cotton, double ikat type. Meiji Period.

22 Rice plant roundel and scrolling vines (chest). Lacquer and gold on wood. Early Edo Period.

23 Noodle sauce cup with rice sheaf design. Imari porcelain. Edo Period.

24 Rice plants (stencil). Paper. Meiji Period.

CHRYSANTHEMUMS (pp. 94–97)

1 Hanging lantern with chrysanthemum and paulownia design. Iron openwork. Momoyama Period.

2 Rice bowl with chrysanthemum design. Imari porcelain. Edo Period.

3 Chrysanthemums, paulownias, and miscanthus leaves laden with snow (Nō robe). Embroidery and gold-leaf imprint on silk. Momoyama Period.

4 Chrysanthemums and wisterias (fragment). Hand-drawn detailing and tie-dyeing on silk. Momoyama Period.

5 Chrysanthemums and miscanthus leaves with dewdrops (robe). Embroidery on silk. Early Edo Period.

6 Chrysanthemums and scrolling vines (robe fragment). Embroidery on silk. Edo Period.

7 Chrysanthemums (Nō robe). Gold-leaf imprint and embroidery. Early Edo Period.

8 Chrysanthemums beside streams (robe). Tie-dyeing and embroidery on silk. Edo Period. Tokyo National Museum.

9 Chrysanthemums, paulownias, and

flower-laden rafts (robe). Tie-dyeing and embroidery on silk. Early Edo Period.

10 Chrysanthemums and narcissi (robe). Tie-dyeing and embroidery on silk. Edo Period. Tokyo National Museum.

11 Chrysanthemums and miscanthuses beside bamboo fence (robe). Embroidery on silk. Edo Period. Tokyo National Museum.

12 Chrysanthemums against semicircular wave patterns (Nō robe). Twill-weave silk with brocaded designs. Edo Period.

13 Chrysanthemums and scrolling vines (Nō robe). Brocade. Edo Period.

14 Chrysanthemums (Nō robe). Twill-weave silk with brocaded designs. Late Edo Period.

15 Chrysanthemums (robe). Dyeing on silk. Edo Period.

16 Chrysanthemums and miscanthuses (robe). Dyeing and painting on silk. Edo Period.

17 Chrysanthemums (robe). Dyeing on silk. Late Edo Period. Tokyo National Museum.

18 Chrysanthemums in horizontal bands (robe). Dyework over stenciled resist on silk. Edo Period. Tokyo National Museum.

19 Snow crystals enclosing chrysanthemum petals, arranged in semicircular wave patterns (Nō robe). Twill-weave silk with brocaded designs. Mid-Edo Period.

20 Chrysanthemum sprays against diaper of interlocking squares (Nō robe). Twill-weave silk with brocaded designs. Late Edo Period.

21 Chrysanthemums beside bamboo fence (robe). Tie-dyeing and embroidery on silk. Edo Period. Tokyo National Museum.

22 Chrysanthemums against overlapping lozenges (robe). Dyeing on silk. Edo Period. Tokyo National Museum.

23 "Kōrin chrysanthemums" (design said to be based upon a drawing by Ogata Kōrin) and winding stream (robe). Embroidery on silk. Edo Period.

24 Chrysanthemums (robe). Dyeing on silk. Meiji Period. Tokyo National Museum.

25 Chrysanthemum (box). Lacquer on wood with mother-of-pearl inlay. Edo Period.

26 Chrysanthemums (wrapping cloth). Dyework over freehand painted resist on cotton. Edo Period.

27 Chrysanthemums (fragment). Dyework over stenciled resist on cotton. Late Edo Period.

28 Chrysanthemum sprays against dots (fragment). Dyework over stenciled resist on cotton. Late Edo Period.

29 Chrysanthemums (fragment). Dyework over stenciled resist on cotton. Late Edo Period.

AUTUMN GRASSES (pp. 98–101)

1 Round fan with design of Chinese bell-flowers, bush clover, and miscanthuses. Color on gold paper. Painted by Ogata Kōrin. Edo Period.

2 Flowering plant (fragment). Wax-resist dyeing on silk. Nara Period. Tokyo National Museum.

3 Chinese bellflowers (fragment). Tie-dyeing on silk. Momoyama Period.

4 Chinese bellflowers (fragment). Tie-dyeing on silk. Momoyama Period.

5 Chinese bellflowers (Nō robe). Gold and silver-leaf imprint on silk. Edo Period.

6 Autumn flowering grasses (robe). Painting and tie-dyeing on silk. Early Edo Period.

7 Chinese bellflowers (robe). Resist dyeing on silk. Edo Period.

8 Chrysanthemums, wild pinks, bush clover, miscanthuses, and trailing clouds (Nō robe). Embroidery and gold-leaf imprint on silk. Early Edo Period.

9 Wild pinks (Nō robe). Gold-leaf imprint on silk. Mid-Edo Period.

10 Chinese bellflowers beside rocks (robe). Embroidery and tie-dyeing on silk. Edo Period. Tokyo National Museum.

11 Begonias against "cypress fence" diaper (Nō robe). Embroidery and gold-leaf imprint on silk. Edo Period.

12 Wild pinks (hooded outer garment). Dyework over stenciled resist on silk. Edo Period.

13 Wild pinks and pine needles (hooded outer garment). Dyework over stenciled resist on silk. Edo Period.

14 Bush clover and rabbit (*The Frolicking Animals Scrolls*). Ink on paper. Attributed to the monk Kakuyū (Toba Sōjō). Heian Period. Kōzan-ji, Kyoto.

15 Bush clover and overlapping lozenges (fragment). Tie-dyeing on silk. Momoyama Period.

16 Bush clover (fragment). Tie-dyeing on silk. Momoyama Period.

17 Bush clover beside bamboo fences (robe). Dyeing and embroidery on silk. Edo Period. Tokyo National Museum.

18 Bush clover and *Patrinia* plant beside stylized stream pattern (robe). Embroidery and gold-leaf imprint on silk. Edo Period.

19 Bush clover, *Patrinia* plant, and miscanthuses (Nō robe). Silver-leaf imprint on silk. Edo Period.

20 Chrysanthemums, bush clover, miscanthuses, and trailing haze (robe). Dyeing and embroidery on silk. Late Edo Period.

21 Bush clover (robe). Dyeing on silk. Late Edo Period.

22 Bush clover and geometric patterns (fragment). Dyework over stenciled resist on cotton. Edo Period.

23 Miscanthus (fragment). Resist dyeing on silk gauze. Nara Period. Tokyo National Museum.

24 Robe with design of miscanthus with dewdrops. Embroidery on silk. Early Edo Period.

25 Underside of habiliment box with miscanthus design. Color on wood. Edo Period. Yamato Bunkakan, Nara.

26 Autumn grasses and paulownia crests (bookstand). Lacquer and gold on wood. Momoyama Period. Tokyo National Museum.

27 Miscanthuses and plovers in flight (fragment). Dyework over stenciled resist on hemp. Edo Period.

28 Miscanthuses with dewdrops and cricket (summer robe). Dyeing and embroidery on hemp. Edo Period.

29 Miscanthuses and chrysanthemums (fragment). Painting on silk. Momoyama Period.

30 Miscanthus, chrysanthemums, and butterflies (Nō robe). Brocade on twill-weave silk. Edo Period.

31 Autumn grasses and plovers in flight (robe). Dyeing and tie-dyeing on silk. Edo Period. Tokyo National Museum.

MAPLE LEAVES AND GINKGO LEAVES
(pp. 102–3)

1 Maple and pine trees (box). Lacquer and gold on wood with mother-of-pearl inlay. Muromachi Period. Kumano Hayatama Shrine, Wakayama Prefecture.

2 Tea bowl with maple leaf design. Oribe ware. Momoyama Period.

3 Bottle with maple leaf design. Ko-Imari porcelain. Edo Period.

4 Small plate with maple leaf design. Himetani ware. Edo Period.

5 Maple leaves against vertical serpentine lines (Nō robe). Painting and gold- and silver-leaf imprint on silk. Momoyama Period.

6 Maple leaves (fragment). Dyework over stenciled resist on cotton. Edo Period.

7 Maple leaves against stripes (fragment). Tie-dyed plain-weave cotton, double ikat type. Meiji Period.

8 Maple trees (robe). Dyeing on silk. Edo Period. Tokyo National Museum.

9 Maple branch fence and plum sprays (robe). Dyeing and embroidery on silk. Edo Period. Tokyo National Museum.

10 Maple leaves (robe). Dyeing and embroidery on silk. Edo Period. ·

11 Maple leaves and flowers (fragment). Dyework over stenciled resist on silk. Late Edo Period.

12 Maple leaves, chrysanthemum spray, and paving stone patterns (Nō robe). Tie-dyeing, embroidery, and silver-leaf imprint on silk. Edo Period.

13 Ginkgo leaf crest (Nō robe). Embroidery and gold-leaf imprint on silk. Early Edo Period.

14 Ginkgo leaf roundel (wrapping cloth). Dyework over freehand painted resist on cotton. Edo Period.

GRAPEVINES (pp. 104–5)

1 Grapevine (pedestal). Bronze. Nara Period. Yakushi-ji, Nara.

2 Tiered food box with design of grapevines and squirrels. Lacquer and gold on wood. Momoyama Period. Tokyo National Museum.

3 Chest with grapevine design. Lacquer and gold on wood with mother-of-pearl inlay. Momoyama Period.

4 Interior of the lid of cosmetic box with grapevine design. Lacquer and gold on wood. Momoyama Period.

5 Grapevine and poetry card (Nō robe). Gold-leaf imprint on silk. Momoyama Period. Tokyo National Museum.

6 Grapevine (fragment). Hand-drawn detailing and tie-dyeing on silk. Momoyama Period.

7 Grapevine on bamboo fence (robe). Tie-dyeing and embroidery on silk. Momoyama Period. Tokyo National Museum.

8 Water jar with design of grapevine on trellis. Ko-Imari porcelain. Edo Period.

9 Bowl with grapevine design. Imari porcelain. Edo Period.

10 Noodle sauce cup with grapevine design. Imari porcelain. Edo Period.

11 Oil plate with grapevine design. Seto ware. Edo Period.

12 Plate with grapevine design. Imari porcelain. Edo Period.

13 Plate with design of grapevine and butterfly. Imari porcelain. Edo Period.

SCROLLING VINES (pp. 106–8)

1 Altar pendant with design of floral scrolling vines and celestial bird-woman. Gilt bronze openwork. Heian Period. Chūson-ji, Iwate Prefecture.

2 Jingo-ji sutra cover with floral scrolling vine design. Gold and silver painting on dark-blue paper. Heian Period.

3 Flower tray with floral scrolling vine design. Gilt bronze openwork, partly silver-plated. Kamakura Period. Jinshō-ji, Shiga Prefecture.

4 Tea caddy with floral scrolling vine design. Lacquer and gold on wood. Edo Period.

5 Square pot with scrolling vine design. Oribe ware. Early Edo Period.

6 Sword guard with scrolling vine design. Iron relief. Edo Period.

7 Buddhist ritual implement case with design of lotus flowers and scrolling vines. Lacquer and gold on wood. Edo Period. Ninna-ji, Kyoto.

8 Scrolling vines, paulownia, and bamboo in lozenge (Bugaku robe). Embroidery and gold-leaf imprint on silk. Momoyama Period.

9 Scrolling vines and chrysanthemums (robe). Embroidery and gold-leaf imprint on silk. Early Edo Period.

10 Scrolling vines and bamboo leaves (robe). Embroidery and gold-leaf imprint on silk. Early Edo Period.

11 Scrolling vines and roundels of crane and tortoise (gown). Tie-dyeing and embroidery on silk. Edo Period. Tokyo National Museum.

12 Scrolling vines and triple oak leaf motifs (wrapping cloth). Dyework over stenciled resist on cotton. Meiji Period.

13 Tendril scrolls reserved in a dotted ground (fragment). Fine dyework over stenciled resist on hemp. Late Edo Period.

14 Scrolling vines and roundels of cranes, tortoises, and plants (fragment). Dyework over stenciled resist on cotton. Late Edo Period.

15 Scrolling vines and wood-sorrel crests

(fragment). Dyework over stenciled resist on cotton. Late Edo Period.

16 Scrolling vines and scattered squares (fragment). Dyework over stenciled resist on cotton. Late Edo Period.

17 Scrolling vines and chrysanthemums (fragment). Dyework over stenciled resist on cotton. Meiji Period.

BAMBOO (pp. 109–11)

1 Hanging lantern with bamboo design. Bronze openwork. Muromachi Period. Tokyo National Museum.

2 Mirror box with design of bamboo grass and stripes. Lacquer and gold on wood. Muromachi Period. Dōmyōji Temman Shrine, Osaka.

3 Nō songbook cover with design of four bamboo stems. Woodblock print on paper. Edo Period.

4 Bamboo, paulownias, and birds beside water (fragment). Dyework over stenciled resist on silk. Edo Period.

5 Large footed bowl with bamboo grass design. Nabeshima porcelain. Edo Period.

6 Jar with bamboo grass design. Imari porcelain. Edo Period.

7 Rectangular dish with bamboo design. Imari porcelain. Edo Period.

8 Bamboo leaves patterned with speckles and with flowers and half-submerged wheels (robe). Tie-dyeing and embroidery on silk. Early Edo Period. Tokyo National Museum.

9 Pine, bamboo, plum, and crane (robe). Tie-dyeing on silk. Edo Period. Tokyo National Museum.

10 Bamboo and diaper of squares (fragment). Tie-dyeing on silk. Edo Period.

11 Bamboo, plum sprays, swallows, and moored boat (fragment). Dyeing on silk. Late Edo Period.

12 Bamboo and plum branches against overlapping lozenges (fragment). Dyework over stenciled resist on hemp. Late Edo Period.

13 Bamboo sprays (fragment). Dyework over stenciled resist on cotton. 19th century.

14 Oblique bamboo stems and thin bamboo stripes (fragment). Dyework over stenciled resist on cotton. Late Edo Period.

15 Bamboo, lattice windows, broken bamboo fences, and plum sprays (fragment). Dyework over stenciled resist on cotton. Late Edo Period.

16 Snow-covered bamboo grass and plum blossoms (fragment). Dyework over stenciled resist on cotton. Late Edo Period.

17 Bamboo grass and tiger (fragment). Tie-dyed plain-weave cotton, weft ikat type. Late Edo Period.

18 Pine, bamboo, and plum combination (fragment). Tie-dyed plain-weave cotton, weft ikat type. Late Edo Period.

19 Bamboo stems and overlaid measuring boxes (fragment). Tie-dyed plain-weave cotton, double ikat type. Late Edo Period.

20 Bamboo stem, bamboo shoot, hat, and

hoe against stripes (fragment). Tie-dyed plain-weave cotton, double ikat type. Late Edo Period.

21 Rounded bamboo pattern (wrapping cloth). Dyework over freehand painted resist on cotton. Edo Period.

22 Interlocking square and octagons, snow-covered bush bamboo, and sparrows (fragment). Fine dyework over stenciled resist on hemp. Late Edo Period.

23 Bamboo stripes (stencil). Fine paper stencil. Late Edo Period.

PINE TREES (pp. 112–15)

1 Kyōgen robe with design of pine trees. Dyework over freehand painted resist on hemp. Late Edo Period.

2 Crest with pine tree having three branches in a stylized composition (Nō robe). Embroidery and gold-leaf imprint on silk. Early Edo Period.

3 Noodle sauce cup with design of pine tree and sky. Imari porcelain. Edo Period.

4 Sword guard with pine tree design. Iron openwork. Edo Period.

5 Pine trees, lozenges of paired cranes, and tortoise-shell diaper in bands (robe). Tie-dyeing and embroidery on silk. Early Edo Period.

6 Pine trees with nesting cranes and tortoise (robe). Embroidery and gold-leaf imprint on silk. Early Edo Period.

7 Pine tree, cranes, tortoise, and "scattered treasures" (robe). Embroidery on silk. Early Edo Period.

8 Pine tree and cloud roundel. Brocade. Edo Period.

9 Pine trees by the sea and bridge (summer robe). Dyeing and embroidery on silk. Edo Period. Tokyo National Museum.

10 Pine trees by the sea and summer plants (summer robe). Tie-dyeing and dyeing on silk. Edo Period. Tokyo National Museum.

11 Pine trees and bamboo (summer robe). Dyeing and embroidery on hemp. Edo Period.

12 Fan with pine shoots, and drooping cherry blossoms (robe). Dyeing and embroidery on silk. Edo Period.

13 Fan with pine trees beside brushwood fence, and drooping cherry blossoms (robe). Dyeing and embroidery on silk. Edo Period.

14 Pine, bamboo, and plum combination (robe). Tie-dyeing on silk. Edo Period. Tokyo National Museum.

15 Pine trees and chrysanthemums (robe). Tie-dyeing and embroidery on silk. Late Edo Period. Tokyo National Museum.

16 Pine tree, plum branches, and cranes flying in clouds (robe). Tie-dyeing and dyeing on silk. Edo Period. Tokyo National Museum.

17 Pine branches, pine shoots, and plum spray (hooded outer garment). Dyeing on silk. Late Edo Period.

18 Pine shoots and interlocking "seven jewels" diaper (gown). Tie-dyeing and embroidery on silk. Edo Period. Tokyo National Museum.

19 Pine shoots on mountains (fragment). Dyework over freehand resist on cotton. Meiji Period.

20 Uprooted pine shoots and folded-paper cranes (fragment). Dyeing over stenciled resist on cotton. Late Edo Period.

21 Scattered pine needles and overlapping lozenges (hooded outer garment). Dyework over freehand and stenciled resist on hemp. Edo Period.

22 Pine cones and needles (fragment). Dyework over freehand resist on cotton. Late Edo Period.

23 Pine needles and cherry blossoms (fragment). Dyework over stenciled resist on cotton. Meiji Period.

24 Broken pine needle and plum blossom (fragment). Tie-dyeing on silk. Late Edo Period.

25 Scattered pine needles (fragment). Dyework over stenciled resist on cotton. Late Edo Period.

26 Old pine trees and sacred Buddhist gems (fragment). Tie-dyed plain-weave cotton, double ikat type. Late Edo Period.

27 Pines and geometric patterns (fragment). Tie-dyed plain-weave cotton, double ikat type. Meiji Period.

28 Pine, bamboo, and plum combinations (fragment). Tie-dyed plain-weave cotton, double ikat type. Late Edo Period.

BIRDS AND INSECTS (pp. 116–19)

1 Crane eating fishes (ritual bell). Bronze. Pre-Buddhist Period. Kobe Municipal Archaeological Hall, Hyōgo Prefecture.

2 Camellias and cranes (set of wooden shelves). Lacquer on carved wood. Muromachi Period. Tokyo National Museum.

3 Sword guard with rounded crane design. Iron openwork. Edo Period.

4 Crane roundel (robe). Tie-dyeing on silk. Edo Period.

5 Cranes and various plants (robe). Embroidery and gold-leaf imprint on silk. Early Edo Period.

6 Crane with pine shoot in its mouth (fragment of Bugaku robe). Embroidery on silk. Early Edo Period.

7 Lozenges of paired cranes against tortoise-shell diaper (Nō robe). Brocade on twill-weave silk. Early Edo Period.

8 (upper) Crane against bamboo leaves; (lower) crane against pine, bamboo, and plum tree (ornamental outer robe). Embroidery on silk. Mid-Edo Period.

9 Crane, pine, and plum sprays (hooded outer garment). Dyework over stenciled resist on silk. Late Edo Period.

10 Crane, the characters meaning "a thousand years," and a geometric pattern (fragment). Tie-dyed plain-weave cotton, double ikat type. Late Edo Period.

11 Alighting wild geese (robe). Dyeing on silk. Edo Period.

12 Geese and Chinese bellflowers (fragment). Dyework over stenciled resist on cotton. Late Edo Period.

13 Flying geese (fragment). Dyeing on silk. Meiji Period.

14 Two herons (Nō robe). Embroidery and gold-leaf imprint on silk. Momoyama Period.

15 Herons and willow branches (Kyōgen robe). Embroidery and gold-leaf imprint on silk. Momoyama Period. Itsukushima Shrine, Hiroshima Prefecture.

16 Birds and drooping cherry branches (Nō robe). Embroidery and gold-leaf imprint on silk. Momoyama Period.

17 Swallows and waterfall (robe). Dyeing and embroidery on silk. Edo Period. Tokyo National Museum.

18 Flying birds and drooping cherry branches (Nō robe). Twill-weave silk with brocaded designs. Mid-Edo Period. Tokyo National Museum.

19 Stylized swallow pattern (Nō robe). Brocade. Edo Period.

20 Sword guard with design of swallows and willow tree. Iron openwork. Edo Period.

21 Long-tailed bird against netting diaper (Nō robe). Embroidery and gold-leaf imprint on silk. Early Edo Period.

22 Birds and thistles (robe). Embroidery on silk. Late Edo Period.

23 Sparrows and drying nets (robe). Dyeing on silk. Late Edo Period.

24 Cock, bundles of rice seedlings, and chrysanthemums (robe). Embroidery on silk. Late Edo Period. Tokyo National Museum.

25 Sparrows, drooping cherry blossoms, and incense emblems (fragment). Dyework over stenciled resist on cotton. Late Edo Period.

26 Sparrow in bamboo roundel (wrapping cloth). Dyework over freehand painted resist on cotton. Late Edo Period.

27 Hawk on a pine branch and geometric patterns (fragment). Tie-dyed plain-weave cotton, double ikat type. Late Edo Period.

28 Sparrow against lattice ground (fragment). Tie-dyed plain-weave cotton, double ikat type. Late Edo Period.

29 Praying mantis, a cricket, chrysanthemums, and autumn grasses (robe). Tie-dyeing and embroidery on silk. Early Edo Period.

30 Sword guard with design of crickets and autumn grasses. Iron openwork. Edo Period.

31 Dragonflies (fragment). Tie-dyed plain-weave cotton, double ikat type. Late Edo Period.

MANDARIN DUCKS AND PLOVERS (pp. 120–21)

1 Comb with mandarin duck in winding stream. Lacquer and gold on wood. By Sakai Hōitsu. Edo Period.

2 Mandarin ducks in stream (robe). Tie-dyeing and painting on hemp. Edo Period.

3 Mandarin ducks in stream (gown). Embroidery on silk. Edo Period. Tokyo National Museum.

4 Plovers, rocks, and bamboo leaves (quiver). Carving and lacquer painting on bronze. Nara Period. Kasuga Shrine, Nara Prefecture.

5 Plovers (fragment). Tie-dyeing on silk. Momoyama Period. Tokugawa Reimeikai Foundation, Tokyo.

6 Interior of the lid of inkstone box with design of plovers in flight. Lacquer and gold on wood. By Hon'ami Kōetsu. Momoyama Period. Tokyo National Museum.

7 Plovers and streams (robe). Tie-dyeing and embroidery on silk. Edo Period.

8 Plovers in flight (summer robe). Dyeing and embroidery on silk. Edo Period. Tokyo National Museum.

9 Dish with design of plovers in flight and wave. Oribe ware. Momoyama Period.

10 Plovers in flight, reeds, and waves (robe). Dyeing and embroidery on silk. Edo Period. Tokyo National Museum.

11 Kyōgen robe with design of plovers in flight and wave. Dyework over freehand painted resist on hemp. Edo Period. Uomachi Nōgakkai Society, Aichi Prefecture.

12 Sequence of stylized plovers (fragment). Dyework over stenciled resist on cotton. Edo Period.

BUTTERFLIES (pp. 122–23)

1 Saga-bon Nō songbook with design of butterfly and grasses. Woodblock print on paper. Momoyama Period. Kōzan Bunko, Tokyo.

2 Ornament in butterfly shape (cover of a Jingo-ji sutra). Gilt bronze. Heian Period.

3 Swallowtail butterfly (coat worn over armor). Feathers. Momoyama Period. Tokyo National Museum.

4 Swallowtail butterfly in a circle with plum blossom spray (Nō robe). Embroidery on silk. Momoyama Period. Kasuga Shrine, Gifu Prefecture.

5 Butterflies and chrysanthemum sprays (Nō robe). Embroidery and gold-leaf imprint on silk. Muromachi–Early Momoyama Period.

6 Butterflies against chrysanthemum sprays (Nō robe). Embroidery and gold-leaf imprint on silk. Muromachi–Early Momoyama Period.

7 Butterflies, Japanese harp, miscanthuses, and bridge struts (robe). Tie-dyeing and embroidery on silk. Early Edo Period.

8 Foliate dish with butterfly design. Pottery. Heian Period. Nagoya University, Aichi Prefecture.

9 Saga-bon Nō songbook with butterfly design. Woodblock print on paper. Edo Period.

10 Butterflies, clams, and revolving "commas" (tomoe) and lattice pattern in horizontal bands (Nō robe). Painting and gold-leaf imprint on silk. Momoyama Period.

11 Butterflies (robe). Dyework over stenciled resist on silk. Late Edo Period.

12 Butterflies and interlocking squares and octagons (fragment). Dyework over stenciled resist on cotton. Late Edo Period.

13 Butterflies (stencil). Paper. Late Edo Period.

MYTHICAL BEASTS, TORTOISES, AND LIONS (pp. 124–27)

1 Ornamental tile with phoenix design. Nara Period. Minami Hokke-ji, Nara Prefecture.

2 Phoenix roof ornament. Bronze. Heian Period. Byōdō-in, Kyoto.

3 Box with design of phoenixes and honeysuckle. Lacquer and painting on wood. Nara Period. Shōsō-in Repository, Nara Prefecture.

4 Phoenix and floral scrolling vine (small water container). Gilt bronze. Nara Period. Tokyo National Museum.

5 Nimbus from an image of a bodhisattva with design of phoenix, clouds, and floral scrolling vine. Dry lacquer. Nara Period. Hōryū-ji, Nara Prefecture.

6 Fragment of crown in the shape of phoenix. Gold openwork. Nara Period. Shōsō-in Repository, Nara Prefecture.

7 Phoenix (mirror case). Bronze with lacquer, gold, and silver. Nara Period. Shōsō-in Repository, Nara Prefecture.

8 Phoenix against hollyhock pattern (court robe). Brocade. Kamakura Period. Tsurugaoka Hachiman Shrine, Kanagawa Prefecture.

9 Crossing diagonal lines enclosing two phoenixes (Bugaku robe). Embroidery on silk. Early Edo Period.

10 Phoenix and paulownia (Nō robe). Embroidery and gold-leaf imprint on silk. Momoyama Period.

11 Phoenix, flowering tree, and clouds in oblique bands (robe). Tie-dyeing and embroidery on silk. Early Edo Period.

12 Mirror back with design of tortoise, two cranes, and cherry tree on the shore. Bronze. Kamakura Period. Saidai-ji, Nara Prefecture.

13 Mirror back with design of two cranes bearing pine branches, tortoise, and fishes in the water. Bronze. Muromachi Period.

14 Mirror back with tortoise, paulownia sprays, and bamboo. Bronze. By Ietsugu. Momoyama Period.

15 Tortoise, pine trees, and bamboo grass in zigzag band (robe). Tie-dyeing and embroidery on silk. Early Edo Period.

16 Tortoise and two cranes against swastika diaper (robe). Embroidery and gold-leaf imprint on silk. Early Edo Period.

17 Roundels of tortoise and crane against scrolling vines (robe). Tie-dyeing and embroidery on silk. Edo Period. Tokyo National Museum.

18 Bowl with design of tortoise and crane. Lacquer on wood. Edo Period.

19 Plate with design of tortoise and stream. Seto ware. Edo Period.

20 Tortoises (stencil). Paper. Edo Period.

21, 22 Chinese lions (sliding doors). Color on wood. Painting by Tawaraya Sōtatsu. Momoyama Period. Yōgen-in, Kyoto Prefecture.

23 Mirror back with Chinese lion, peonies, butterflies, and birds. Bronze. Kamakura Period. Jōshin-ji, Shiga Prefecture.

24 Chinese lions against concentric lozenge diaper (Nō robe). Brocade on twill-weave silk. Edo Period. Shinshiro Nōgakkai Society, Aichi Prefecture.

25 Votive board with design of Chinese lion and peony. Color on wood. Early Edo Period.

26 Kylin and clouds (painting). Color on paper. Nara Period. Shōsō-in Repository, Nara Prefecture.

27 Sutra box with design of clouds and dragons. Gilt bronze with gilt- and silver-plated ornaments. Heian Period. Itsukushima Shrine, Hiroshima Prefecture.

28 Dragon roundels (Nō hat). Gold brocading on silk. Edo Period.

29 Stylized dragons (stencil). Paper. Late Edo Period.

ANIMALS (pp. 128–30)

1 Cosmetic box with design of hare jumping over waves. Lacquer and gold design on wood. Edo Period. Tokyo National Museum.

2 Hare jumping over waves (lining of coat). Dyework on leather. Edo Period.

3 Hare and waves (lining of coat). Dyework on leather. Edo Period.

4 Hare and miscanthuses (under-kimono garment). Tie-dyeing on silk. Meiji Period.

5 Horse and spring grasses (robe). Dyeing and embroidery on silk. Edo Period.

6, 7 Horses (robe). Dyeing on silk. Edo Period.

8 Two deer and tree (screen). Polychrome stencil dyeing on hemp. Nara Period. Shōsō-in Repository, Nara Prefecture.

9 Hanging lantern with design of deer and maple trees. Cast metal. Edo Period. Kasuga Shrine, Nara Prefecture.

10 Sword guard with design of deer and autumn grasses. Iron openwork. Edo Period.

11 Deer, insect, chrysanthemums, and maple trees (robe). Embroidery on silk. Early Edo Period.

12 Deer, insects, and trailing clouds (robe). Embroidery on silk. Early Edo Period.

13 Deer and man drawing bow (ritual bell). Bronze relief. Pre-Buddhist Period. Tokyo National Museum.

14 Tiered food box with design of squirrels and grapevines. Lacquer and gold on wood. Momoyama Period.

15 Dogs, dandelions, violets, and spring grasses (robe). Dyeing and embroidery on silk. Edo Period. Tokyo National Museum.

16 Wild boar surrounded by dogs and a man drawing a bow (ritual bell). Bronze relief. Pre-Buddhist Period. Tokyo National Museum.

17 Monkey (The Frolicking Animals Scrolls). Ink on paper. Attributed to monk Kakuyū (Toba Sōjō). Heian Period. Kōzan-ji, Kyoto.

18 Rice-planting scene (tray). Color painting on lacquer. Momoyama–Edo Period.

19 Roundels of two tigers (Nō robe). Brocade. Edo Period.

20 Tiger, sparrows, bamboo, and lattice (fragment). Tie-dyed plain-weave cotton, double ikat type. Edo Period.

21 Tiger and bamboo (fragment). Tie-dyed plain-weave cotton, weft ikat type. Late Edo Period.

HUMAN BEINGS (pp. 131–33)

1 Apsaras and scrolling honeysuckle (ritual canopy). Gilt bronze openwork. Asuka Period. Tokyo National Museum.

2 Scene with people running after flying storehouse (Legends of Shigisan Temple handscroll). Color on paper. Heian Period. Chōgosonshi-ji, Nara Prefecture.

3 Scene with people and carriages (The Tale of the Heiji Rebellion handscroll). Color on paper. Kamakura Period. Tokyo National Museum.

4 Musicians in boat (Nō robe). Embroidery and gold-leaf imprint on silk. Momoyama Period.

5 Poets (Thirty-six Immortal Poets screen). Color on paper. By Ogata Kōrin. Edo Period.

6 Watchmen at festival (robe). Dyeing on silk. Edo Period.

7 Dancing girl (tiered food box). Lacquer and painting on wood. Edo Period. Imamiya Shrine, Kyoto.

8 Rice planting (robe). Dyeing on silk. Late Edo Period. Tokyo National Museum.

9 Chinese child holding flowers (kimono). Dyeing on silk. Edo Period.

10 People dancing on a fishermen's festival day (fisherman's festival robe). Dyeing on cotton. Late Edo Period.

11 Ch'in Kao astride a carp (fragment). Tie-dyed plain-weave cotton, double ikat type. Late Edo Period.

12 Otafuku (smiling chubby woman symbolic of happiness) and geometric patterns (fragment). Tie-dyed plain-weave cotton, double ikat type. Late Edo Period.

13 Sake cup with design of Dutchmen. Imari porcelain. Edo Period.

14 Oil plate with design of man on bridge and seagulls. Seto ware. Edo Period.

15 Square bottle with design of beautiful girl looking at a garden. Imari porcelain. Edo Period.

16 Vase with design of Dutchmen. Imari porcelain. Edo Period. Cleveland Museum of Art, Gift of Ralph King.

17 Plate with design of old man holding a broom and the inscription "an easy life in retirement: eleven grandchildren." Seto ware. Edo Period.

18 Plate with design of comedian. Seto ware. Edo Period.

19 Plate with design of man hunting wild boar (scene from the play Chūshingura). Seto ware. Edo Period.

20 Plate with design of woman taking the first bath of the New Year. Seto ware. Edo Period.

21 Plate with design of rustic figure, rice field, and fence. Karatsu ware. Edo Period.

22 Oil plate with design of oil seller with sunshade and pole. Seto ware. Edo Period.

LANDSCAPES (pp. 134–39)

1 Trees and figures beside a hut (painting). Ink on hemp. Nara Period. Shōsō-in Repository, Nara Prefecture.

2 Quiver with design of rocks, bamboo leaves, plovers, and wild geese, bordered by floral scrolling vines and butterflies. Carving and lacquer painting on bronze; mother-of-pearl inlay and metal fittings in a rosewood border. Nara Period. Kasuga Shrine, Nara Prefecture.

3 Writing box with design of boat among reeds and plovers. Lacquer and gold on wood. Momoyama Period. Tokyo National Museum.

4 Saga-bon Nō songbook with design of moon and mountains with pine trees. Woodblock print on paper. Early Edo Period.

5 Saga-bon Nō songbook with design of pebble-filled embankment basket and waves. Woodblock print on paper. Early Edo Period.

6 Sword guard with design of country house. Iron openwork. Edo Period.

7 Sword guard with design of bridge, wild geese, and sailboat on waves. Iron openwork. Edo Period.

8 Dish with design of two cows, tall buildings, and mountains covered with cherry trees. Imari porcelain. Edo Period.

9 Oil plate with design of sparrows in flight, stacked rice sheaves, and clappers to frighten sparrows away. Seto ware. Edo Period.

10 Noodle sauce cup with sailboat design. Imari porcelain. Edo Period.

11 Waterfalls and two ducks among mountains covered with camellia trees (Nō robe). Embroidery on silk. Momoyama Period.

12 Houses with hoist, mountains, pine trees, and cherry blossoms against overlapping lozenges (Nō robe). Painting, embroidery, and gold-leaf imprint on silk. Momoyama Period.

13 Smoking volcano and flocks of wild geese (Nō robe). Embroidery and gold-leaf imprint on silk. Momoyama Period.

14 Mountains, pine tree, miscanthuses, and birds in flight (robe). Embroidery and gold-leaf imprint on silk. Early Edo Period.

15 Plum blossoms on overlapping mountains (robe). Tie-dyeing and embroidery on silk. Mid-Edo Period.

16 Trailing haze in the shape of overlapping lozenges, mountain, cranes, and cherry and plum blossoms (kimono). Dyework over stenciled resist on hemp. 19th century.

17 Mountains, pine trees, bridge, and waterfall (robe). Tie-dyeing, embroidery, and gold-leaf imprint on silk. Early Edo Period.

18 Eight-plank bridge and winding streams (robe). Tie-dyeing and embroidery on silk. Edo Period. Tokyo National Museum.

19 Eight-plank bridge with flowers (robe). Dyeing and embroidery on silk. Edo Period. Tokyo National Museum.

20 Eight-plank bridge, rocks, irises, hollyhocks, and various other plants (Nō robe). Painting and gold- and silver-leaf imprint on silk. Muromachi Period.

21 View of the Uji river (robe). Dyeing and embroidery on silk. Edo Period. Tokyo National Museum.

22 Eight-plank bridge, irises in stream, and overlapping lozenges (hooded outer garment). Dyeing on silk. Edo Period.

23 A famous scenic spot (robe). Dyeing on silk. Edo Period. Tokyo National Museum.

24 View of Kiyomizu Temple (robe). Dyeing and embroidery on silk. Edo Period. Tokyo National Museum.

25 Waterside scene (stencil). Paper. 19th century.

26 Flowering plant, waterfall, and cottage (summer robe). Dyeing and embroidery on silk. Edo Period. Tokyo National Museum.

27 Tea hut among bamboo (robe). Dyeing on silk. Edo Period.

28 Country houses (stencil). Paper. Edo Period.

29 Wave crests and fishnet (robe). Tie-dyeing and embroidery on silk. Edo Period. Tokyo National Museum.

30 Fishnets drying on cherry tree and wave crests (robe). Tie-dyeing and embroidery on silk. Early Edo Period.

31 Pebble-filled embankment baskets in water and cherry blossom (summer kimono). Tie-dyeing and embroidery on hemp. Edo Period. Tokyo National Museum.

32 Pebble-filled embankment baskets in water (Nō songbook). Gold painting on paper. Early Edo Period.

33 Drying fishnets (robe). Dyeing and embroidery on silk. Edo Period. Tokyo National Museum.

34 Drying fishnet and sparrows (robe). Dyeing on silk. Late Edo Period.

35 Cranes, clouds, plants, and seashore (robe). Embroidery and gold-leaf imprint on silk. Early Edo Period.

36 Drying fishnets, waves, and plovers in flight (hooded outer garment). Dyework over stenciled resist on cotton. Edo Period.

37 Waterside scene (kimono). Dyework over stenciled resist on hemp. Meiji Period.

38 Boats and maple sprays (robe). Dyeing and embroidery on silk. Edo Period. Tokyo National Museum.

39 Sailboat among reeds and streams (Nō robe). Silver-leaf imprint on silk. Edo Period.

40 Sailboat, wave crests, and plum sprays (robe). Embroidery on silk. Edo Period. Tokyo National Museum.

41 Pine trees beside water, sailboats, and plovers in flight (robe). Dyeing on silk. Edo Period. Tokyo National Museum.

42 Sailboats on waves (robe). Tie-dyeing, embroidery, and painting on silk. Edo Period. Tokyo National Museum.

43 Rocky mountain and moored boats (robe). Dyeing on silk. Edo Period. Tokyo National Museum.

44 Shinto shrine gate and autumn grasses (robe). Embroidery on silk. Edo Period. Tokyo National Museum.

45 Castle, pine trees, plum trees, and wild geese (fragment). Tie-dyed plain-weave cotton, weft ikat type. Late Edo Period.

46 Town scene, bridges, sailboats, and zigzag bands (fragment). Tie-dyed plain-weave cotton, weft ikat type. Meiji Period.

WATER (pp. 140–43)

1 Interior of habiliment box with design of pebble-filled embankment baskets, wave crests, and plovers in flight. Ink and gold painting on wood. Edo Period. Yamato Bunkakan, Nara.

2 Small dish with design of waterplants and waves. Pottery. By Ogata Kenzan. Edo Period. Nezu Art Museum, Tokyo.

3 Waves (inside of a writing box lid). Lacquer and gold on wood. Edo Period.

4 Wave patterns (robe). Tie-dyeing on silk. Edo Period. Tokyo National Museum.

5 Waves (Nō robe). Twisted silk weave. Edo Period.

6 Waterfall, drops of water, and cherry blossom (Nō robe). Gold-leaf imprint on silk. Momoyama Period.

7 Wave crests and chrysanthemums (robe). Tie-dyeing and embroidery on silk. Edo Period. Tokyo National Museum.

8 Wave crests against bridge supports (robe). Tie-dyeing and embroidery on silk. Edo Period. Tokyo National Museum.

9 Waterfalls and floral scrolls (robe). Tie-dyeing and embroidery on silk. Edo Period. Tokyo National Museum.

10 Running water and chrysanthemums (robe). Tie-dyeing and embroidery on silk. Edo Period. Tokyo National Museum.

11 Stylized stream patterns and bush clover (Nō robe). Embroidery and gold-leaf imprint on silk. Edo Period.

12 Stylized stream patterns and cherry blossom (Nō robe). Twill-weave silk with brocaded designs. Edo Period.

13 Stream and orchids (robe). Dyeing and embroidery on silk. Edo Period. Tokyo National Museum.

14 Wave crests and bits of foam (robe). Dyeing on silk. Edo Period.

15 Wave crests, reeds, and pines (gift wrapper). Tie-dyeing and painting on silk. Edo Period.

16 Stream and plants (robe). Dyeing and embroidery on silk. Edo Period. Tokyo National Museum.

17 Chrysanthemums in semicircular wave pattern (Nō robe). Twill-weave silk with brocaded designs. Late Edo Period. Ishikawa Prefecture Art Museum.

18 Semicircular wave pattern (robe). Tie-dyeing and gold-leaf imprint on silk. Early Edo Period.

Bibliography

Akiyama, Terukazu. *Japanese Painting.* 1961. Reprint. New York: Rizzoli, 1978.

Anesaki, Masaharu. *Art, Life and Nature in Japan.* 1933. Reprint. Westport, Conn.: Greenwood Press, 1971.

Doi, Tsugiyoshi. *Momoyama Decorative Painting.* New York and Tokyo: John Weatherhill, 1976.

Dower, John W. *The Elements of Japanese Design: A Handbook of Family Crests, Heraldry and Symbolism.* New York and Tokyo: John Weatherhill, 1971.

Fujioka, Ryoichi. *Shino and Oribe Ceramics.* New York and Tokyo: Kodansha International, 1977.

Grilli, Elise. *The Art of the Japanese Screen.* New York and Tokyo: John Weatherhill, 1970.

Hall, John Whitney. *Japan: From Prehistory to Modern Times.* New York: Dell, 1970.

Hayashi, Ryoichi. *The Silk Road and the Shoso-in.* New York and Tokyo: John Weatherhill, 1975.

Ienaga, Saburo. *Painting in the Yamato Style.* New York and Tokyo: John Weatherhill, 1973.

Japan Textile Color Design Center. *Textile Designs of Japan.* 3 vols. Rev. ed. New York and Tokyo: Kodansha International, 1980.

Jenys, Soame. *Japanese Pottery.* New York: Praeger, 1971.

Kuck, Loraine. *The World of the Japanese Garden: From Chinese Origins to Modern Landscape Art.* New York and Tokyo: John Weatherhill, 1968.

Lane, Richard. *Masters of the Japanese Print.* London: Thames and Hudson, 1962.

Lee, Sherman E. *Japanese Decorative Style.* 1961. Reprint. New York: Harper and Row, 1972.

_____. *A History of Far Eastern Art.* Rev. ed. Englewood Cliffs, N.J.: Prentice-Hall, 1974.

_____. *Tea Taste in Japanese Art.* 1963. Reprint. New York: Arno Press, 1975.

Mizoguchi, Saburo. *Design Motifs.* New York and Tokyo: John Weatherhill, 1973.

Moore, Janet Gaylord. *The Eastern Gate: An Invitation to the Arts of China and Japan.* Cleveland and New York: William Collins, 1979.

Morris, Ivan. *The Tale of Genji Scroll.* New York and Tokyo: Kodansha International, 1971.

_____. *The World of the Shining Prince: Court Life in Ancient Japan.* New York: Alfred A. Knopf, 1964.

Murasaki, Lady. *The Tale of Genji.* Translated by Arthur Waley. 6 vols. 1926–33. Reprint (6 vols. in 1). London: George Allen and Unwin, 1935.

Murasaki Shikibu. *The Tale of Genji.* Translated by Edward G. Seidensticker. 2 vols. New York: Alfred A. Knopf, 1976.

Naito, Akira. *Katsura: A Princely Retreat.* New York and Tokyo: Kodansha International, 1977.

Noma, Seiroku. *The Arts of Japan.* 2 vols. 1966. Standard ed. New York and Tokyo: Kodansha International, 1978.

Okudaira, Hideo. *Narrative Picture Scrolls.* New York and Tokyo: Weatherhill and Shibundo, 1973.

Paine, Robert T., and Soper, Alexander. *The Art and Architecture of Japan.* Rev. ed. New York: Penguin Books, 1974.

Rosenfield, John M. *Japanese Arts of the Heian Period.* New York: Asia Society, 1967.

Sansom, George. *Japan: A Short Cultural History.* Rev. ed. Englewood Cliffs, N.J.: Prentice-Hall, 1962.

Suzuki, Daisetsu. *Zen and Japanese Culture.* Princeton: Princeton University Press, 1959.

Swann, Peter C. *A Concise History of Japanese Art.* Rev. ed. of *An Introduction to the Arts of Japan.* New York and Tokyo: Kodansha International, 1979.

Takeda, Tsuneo. *Kanō Eitoku.* New York and Tokyo: Kodansha International, 1977.

Warner, Langdon. *The Enduring Art of Japan.* 1952. Reprint. New York: Grove Press, 1958.

Yamada, Chisaburoh. *Decorative Arts of Japan.* New York and Tokyo: Kodansha International, 1964.

Yanagi, Soetsu. *The Unknown Craftsman.* New York and Tokyo: Kodansha International, 1972.

Yoshikawa, Itsuji. *Major Themes in Japanese Art.* New York and Tokyo: John Weatherhill, 1976.

定価8,000円
in Japan